Also by Richard Cox
Published by Ballantine Books:

SAM 7

The BOTTICELLI Madonna

A NOVEL BY

RICHARD COX

BALLANTINE BOOKS • NEW YORK

Library of Congress Catalog Card Number: 78-25836

ISBN 0-345-32477-3

This edition published by arrangement with McGraw-Hill Book
Company

Manufactured in the United States of America

First Ballantine Books Edition: April 1980
Third Printing: June 1985

Acknowledgments

I could not have written this novel—in which the principal characters are of course totally fictitious—without the generous assistance of many leading figures in the art world. My especial thanks are due, in Vienna, to Dr. Georg Kugler of the Kunsthistorisches Museum, Dr. Hans Herbst of the Dorotheum, Professor Dr. Hans Mukarovsky, Baron Martin Koblitz, and Dr. Thalhammar of the Bundesdenkmalamt; in Munich to Frau Dr. Wankmuller of the Hitler-Göring Collection administration, Princess Husch von Hohenzollern, Dr. Horst Ferhle and Fräulein Ursula Poensgin, who helped with research; in London to the staff of Agnews, in particular Miss Margaret Beresford, Mr. Hugh Leggatt of Leggatt Brothers, Mr. Colin Anson and Lady Penelope Cator of David Carritt Ltd., Mr. Robert Bruce Gardner of the Courtauld Institute, Miss Joyce Plesters of the National Gallery, Mr. William Mostyn-Owen of Christie, Manson and Woods, Mr. John Baskett, Mr. Patrick Mathiesson of Colnaghi's and Chief Superintendent Warren of the Metropolitan Police; in the United States, Mr. Clyde Newhouse, Mr. Spencer Samuels, Mr. Thomas Hoving, then director of the Metropolitan Museum of Art, and Mr. John Brealey of the same museum, Miss Brenda Auslander of Sotheby Parke Bernet, Mrs. Ildiko von Burg of Christie, Manson and Woods, Miss Gabrielle Kopelmann, Mr. Jack Tanzer of Knoedlers, Mr. Walter Chrysler, Dr. Bob Jones II, Professor Elizabeth Hopkins and Detective Bob Volpe of the New York City Police Department. Finally, I must thank Miss Meriel Larken for the research she did on my behalf.

R.C.

From his helicopter, hovering above the E5 autobahn near Frankfurt, the police pilot could see the crash coming. Sunday evenings in summer were always chaotic. Long lines of cars developed in the outer "fast" lane, and, given a momentary break in one of the slower lanes, some driver would always dodge to the inside and accelerate wildly to get ahead. The policeman saw a bright blue Porsche doing that now, racing up a gap caused by cars leaving the autobahn at the Sachsenhausen exit. Some way ahead of the Porsche a large Mercedes was signaling its intention to move into the "slow" lane, presumably for the turn-off.

The policeman noticed the savage black skid marks of previous accidents. He sat there, all-seeing, yet completely powerless. Whatever happened would be over in seconds.

"Idiots," he muttered, instinctively grasping his radio microphone, ready to call up ambulances and patrol cars.

The driver of the Mercedes was a fifty-year-old man, balding, stocky, every inch the German businessman in weekend clothes. His wife was beside him. He felt enveloped in the comfort of the big car and pleased to be nearly home. "Switzerland is the answer, my love," he was saying confidently. "We take the paintings down in the car and auction them in Lucerne or Geneva. We make an arrangement beforehand with the dealer who will buy them."

"It all sounds very complicated, Horst," replied the woman uneasily. "Surely after thirty years we can sell them straightforwardly. Didn't you say there was a law about thirty years?" Her question hung in the air.

The businessman glanced in his rear-view mirror. Unknown to him, the blue Porsche, coming up fast, was in his blind spot.

1

"In Switzerland," he said with irritation, since he had been explaining this all weekend, "stolen goods cannot be recovered after being publicly auctioned. We can't bank on the German thirty-year statute. The only risk is at the frontier." He swung the Mercedes sharply into the slow lane, the positive action relieving his annoyance.

For the policeman the world went into slow motion. It was like a silent movie. As routine radio chatter echoed in his ears above the noise of the engine, he saw the Mercedes swerve out and the Porsche slam into its side at an angle. The Porsche bounced off toward the side of the road, hit a guardrail and began to roll over. The Mercedes slewed around to the left and back into the center lane, straight into the path of a truck that had been lumbering along behind it. For a long-drawn-out moment the truck plowed on, then it too went out of control. The Porsche was upside down. Another car hit it. There was sudden blossom of flame. Now there were eight vehicles in the pile-up. Ten seconds later there were fifteen. Burning gasoline was spreading across the road. As the policeman made his emergency call the entangled bodies of the Mercedes and the truck caught fire. A surge of hot air rocked the helicopter as the pilot came down to land.

The directors' boardroom at Luttrell's Gallery is on the first floor. Nothing indicates its existence to the casual visitor. There is no sign on the paneled mahogany door, any more than there would ever be price tags on the paintings hanging in the main exhibition hall downstairs. Everything about Luttrell's is patrician and discreet. Private viewing rooms allow clients to inspect possible acquisitions undisturbed. The lighting is soft—and not only because harsh light can damage the pigmentation of a painting. The carpets are deep, the hangings velvet. To step from the hustle of Bond Street into Luttrell's spacious salon is to be transported back a hundred years when great art collections were being formed in Britain, when London was a center of the

world's wealth. Today the area around Bond Street and St. James's is still the hub of the world's art dealing, but the money is in other hands. A number of famous firms remain in their original premises because they acquired or built them in the eighteenth or nineteenth centuries. Agnews are there, with the famous Sir Geoffrey Agnew as chairman. Colnaghi's are there, though in a smaller building than the one they built for themselves farther down the street. The question under discussion in Luttrell's boardroom one autumn afternoon some three months after the autobahn crash near Frankfurt was how Luttrell's could stay in business alongside its rivals. Already the meeting was stormy.

Three men and one woman sat around the elegant Sheraton table. At the head was Charles Luttrell, the senior director, and, facing him, Lucy, his wife. Between them were the company secretary, Jack Wild, and a younger director, James Constant, who was also a relation.

"I will not agree to sell the building," Lucy Luttrell was declaring vehemently. "I absolutely will not. It's part of us. It's our heritage. My grandfather received Queen Victoria here. How could we hold decent exhibitions in some pokey set of rented rooms off Bond Street?" She sat upright in her chair, gripping the arms for support, her face drawn. The movement accidentally knocked her cane to the carpet. Immediately James Constant retrieved it. She barely acknowledged the action.

"No," she reiterated. "Luttrell's stays here." She almost added that if you suffered from crippling rheumatoid arthritis, as she had for the past ten years, you learned not to give up and especially not just because things looked bad. She left it unsaid, because they all knew her feelings.

Charles Luttrell watched her, unmoved. Her stubbornness wearied him. If it was the kind that won wars, it was equally the kind that lost businesses. He himself thought with the flexibility of the true dealer, even if his appearance belied this. He was tall, ele-

gantly dressed, always with a flower in his buttonhole. Though not exactly handsome, he had a strong face and his thick gray hair was cut just casually enough to be fashionable. A quarter of a century of club lunches, country-house weekends and expensive holidays had made him a convincing replica of an English aristocrat. Outwardly he had grown into the mold Lucy wanted and Luttrell's image required. But inwardly he remained tough, cynical about himself and adaptable to the verge of unscrupulousness. It had been against all his instincts that Luttrell's had continued playing a grander role than it could afford. Now the crunch had come. They either had to cut back savagely or be closed down by the bank.

"I realize this is a shock for you, my dear," he said. "It is for all of us. Until Tommy's death and the need to value his shares, we thought we were having a better year." It was a lie but not the kind that could be challenged easily. Even the largest international corporations can experience a period of apparently successful trading and still find themselves with a loss.

"To be frank," Charles continued, edging closer to the truth, "we knew things were bad last year. In fact we are having two bloody awful years in a row. It didn't affect the dividends because the government was limiting those by law anyway."

"You never told me."

"My dear, you were ill at the time of the last AGM. I didn't want to worry you."

Lucy relaxed slightly, easing herself back a fraction in her chair. She gazed across the long table at her husband. She could never tell with him now. Was he genuinely concerned for her or merely trying to hide something? The Charles she had fallen in love with when she was twenty-three had disappeared. Then he was only two years down from the university, effervescently young, full of enthusiasm. And of course he had that magic instinct for knowing when a painting was right and when it wasn't. That was the quality that had attracted her father. He realized that the younger

generation of the family lacked anyone capable of running the business. Lucy worshipped her father, and when he approved of Charles there was no stopping her. Furthermore, Charles did what was expected of him. He took her name. He used their connections to rout out lost treasures from the attics and corridors of the nobility's country houses. He hoisted Luttrell's out of the postwar doldrums and back into the front rank of international art firms. Yet at some point in this triumphal progress she lost touch with the real Charles. Perhaps it was her determination to live in the Wiltshire manor house left by her father that did it. Looking back, she wasn't sure. She only knew from the faces around the table today that she really had lost touch. She felt physically sick at the news that Luttrell's was in trouble.

"It's not very fair on Tommy's widow," she said at length. "She believes their shares are worth a lot."

"Tommy fully agreed with the decision to keep our losses secret. One word of gossip could frighten off our best clients just when we need them most. You know that as well as anyone. This is not a time when we can allow shares in Luttrell's to be offered for public sale."

"Then we must buy the shares back."

"How? By selling Downford Manor?"

The remark hit Lucy like a hammer. Her life was centered on Downford. Their children had grown up there; she bred her horses there; the garden she loved was there.

"You know that's impossible!"

"We wouldn't be the first family who've had to sell their house to save their business," said Charles brutally. He made a small gesture with his right hand, a flick of the wrist that pointed attention to their surroundings: the crystal chandelier, the paneling, the splendid portrait of the first Sir James Luttrell in its heavy gilded frame. "All this belongs to past success. It's just veneer. If clients are fooled by it, so much the better. But don't let's delude ourselves. Our future is as good as our cash flow—no better, no worse!" He

jabbed a finger at the big portrait. "Old Sir James must have known that—he bought his title, after all."

Lucy flushed. "Must you insult my ancestors?"

"I can assure you that the old rogue would have recognized the facts," said Charles suavely. "And the facts are that more and more paintings are going to museums, so they never return to the market, while the competition to lay hands on what there is gets hotter every year. We can't afford to sell bad stuff and there's too little good around."

"Not to mention the competition from the auctioneers, Cousin Lucy," added James Constant. "When a Velasquez fetches over two million at Christie's, or a Duccio goes for a million, a host of owners conclude they'd be better off selling at auction than through us, especially if they're selling to pay tax bills and want the money fast."

Lucy shook her head. She found the situation impossible to believe. Luttrell's was too solid, too well established. She turned to the company secretary, who had been listening with growing embarrassment. If it were not that she owned the controlling interest, he was sure Charles Luttrell would be far more ruthless.

"Please, Mr. Wild," she said, "I am not completely unfamiliar with the business, but I still don't understand what is wrong."

He handed a page of accounts across the table and began to explain.

"The half-yearly figures show a further decline into loss for one main reason, Mrs. Luttrell. The overheads are rising faster than the turnover. True, our sales are up appreciably. They're running at comfortably over two and a half million." He glanced sideways at Charles, who nodded imperceptibly. "That's what led us to believe in a recovery," Wild went on. "But we'd underestimated the rate overheads were increasing. Everything from restoration work to the phone bills. They're at the rate of four hundred thousand a year now and rising all the time. So although our earnings are up, we're actually suffering a loss. The bank would

never increase our overdraft without asking for these figures, and once they saw them they'd refuse."

"How accurate is the stock valuation?" James Constant asked. In the basement stood rack after rack of paintings, with the most valuable stored in a huge safe. The stock was Luttrell's lifeblood.

Wild glanced at him gratefully. "I've put it in at seven hundred thousand because that was its cost to us."

"Surely to goodness that's enough to keep the bank happy!" exclaimed Lucy incredulously.

"I'm afraid our bankers take a pessimistic view of art as collateral, Mrs. Luttrell."

"What more can you expect if you bank with a branch whose manager comes up on the eight-fifteen from Surbiton every day?" interposed Charles acidly. "Ours wouldn't know a Botticelli from a bathroom tile."

Lucy flushed. She had insisted on staying loyal to her father's bankers against all Charles's pleas to turn to a less conventional Continental bank.

"Seven hundred thousand must be an undervaluation," said James reflectively. "There's a hell of a lot downstairs. Poussin, the little Fragonard, the Boucher lady, that huge Preti group. Our collection of prints is first-class. We've got a lot there, Cousin Lucy."

"Selling off stock *is* a traditional way of solving cash-flow problems," observed Wild. He spoke nervously because there was a look in Lucy's eye that he did not like.

The annual New Year ritual of inspecting the gallery's holdings and the Annual General Meeting were the two regular occasions when Lucy came to London. Years ago her father used to perform it over cigars and brandy with the dispassionate authority of a racehorse owner reviewing his stable. "This little Corot," he would exclaim as an assistant held up a Provençal landscape of a farmhouse by trees. "He ought to be a runner. Why, I'd give long odds he's a runner. Let's display him in the main hall and price him up a bit,

eh? No one's really seen his form for years." Sometimes he would advocate reducing the price, usually if they'd had the picture five or six years and were not saving it for an exhibition. Only as a last resort would he order a painting to be sent to Sotheby's or Christie's for auction, and then it would be blandly catalogued as "The property of a gentleman." That was a game one could play, and the auction houses would play along with you, but a firm of Luttrell's standing could not afford to do it often.

"Auction the stock?" asked Lucy, eying Wild in amazement. "Tell the world that we can't find clients for ourselves? Have you all lost your nerve?"

There was a tiny quaver in her voice, not quite masked by the harshness. Charles recognized that she was close to tears. She sat there angry and bewildered and slightly sad, a lioness whose strength was failing. She was not a businesswoman. Everything from her neatly tailored tweeds to her slightly out-of-date hairdo proclaimed a lady from the country whose life was less hurried and less savage.

She's not tough enough to cope with a depression, thought Charles, guessing that she was thinking this crisis would never have happened in her father's time, that they didn't make people like him any more. He suddenly recalled the old man counseling him in this very room. "Three things never to lose your nerve over, my boy: horses, pictures and women." And here was Lucy trying to make him lose his self-control over two of the three at once. There was a lot of her father's determination in her, Charles reflected, but he was damned if he was going to be provoked by her.

"None of us dispute the need to hold paintings until the right time," he countered. "That's half of what this business is about. Nonetheless at this moment we have very few options. As we cannot raise more capital, we must either sell our stock faster or cut our overheads dramatically, or better still do both."

"Oh. So now you want me to sack the staff, I suppose." Lucy instinctively thought of herself as being re-

sponsible for such an unpleasant task. "Or should we simply close down altogether? Have you forgotten that our employees and their families depend on us? Or don't any of you care?"

"Please, my dear," urged Charles, his patience slipping at last. "Be reasonable. No one is suggesting that. But short of an unexpected coup we will have to send some paintings to auction and we shall have to reduce our staff. We can't afford twenty-six people here." He checked them off in his mind: two porters, who also hung pictures; the receptionist; five secretaries; four salesmen; two accountants plus Wild; Samantha, the art historian; three working directors—no, only two now that Tommy was dead; Sid, who made frames; old George, the restorer; his own chauffeur . . . "I can drive myself," he remarked. "Be a bloody nuisance, but I can. We could manage with three salesmen and try to reorganize the secretaries to eliminate one of them, and I'm afraid there's no bucking the fact that we ought to pension off Sid and George. There's not enough framing to justify a full-timer, and we're only keeping George occupied by taking in outside restoration work, like the portrait from the Travelers' Club." He sighed and looked Lucy straight in the eye. "I know you don't like it, but assuming we don't replace Tommy, that would bring us down to twenty."

"I simply will not victimize faithful servants like Sid and George." She was articulating every syllable. Her bewilderment had given way to determination. "What about the alternative? We all know how profits are really made—by pulling off major deals. Isn't that what you were always supposed to be so good at?"

Charles hesitated. She was right. Although there was a limit to what she would spell out in front of the others, privately she had already attacked him for failing to bid at the great Mentmore auction when David Carritt's representative had the Fragonard knocked down to him for a mere £8,000. The truth was that, in common with many others, he had accepted the painting's attribution to the earlier and much lesser artist Carle

van Loo. Ten years ago he himself had been pulling off
Carritt's kind of coup.

"Are you sure it isn't we who are failing," went on
Lucy relentlessly, "not our staff?" It was clear that by
"we" she meant "you."

The ensuing silence was broken by James Constant.
"That is exactly correct, Cousin Lucy," he said tensely.
"If Luttrell's fails, the blame rests on all of us."

A gentle knock on the door interrupted them. They
all looked around in surprise. Board meetings were
sacred, to be intruded upon only for the most urgent
reasons.

"Come in," called out Charles.

A woman of about twenty-eight entered, dressed in a
silk blouse and a blue skirt. Lucy eyed her, noticing the
expensive clothes, catching a hint of scent and auto-
matically thinking, Charles won't be sacking this one.

"What is it, Samantha?" asked Charles. "We're
rather busy at the moment."

The girl paused in the doorway, sensing the tension
of the meeting.

"There's been a dealer called Herbstein on the
phone, Mr. Luttrell. From Frankfurt. He insists on
ringing back in a few minutes. He won't wait until
later. He sent these photographs, which he expected
you to have seen already, but they only arrived in the
second post today."

"Let's have a quick look then," said Charles, mo-
tioning her forward.

Silently she laid two black-and-white prints on the
table in front of him. James leaned over to see them
too and whistled.

"That looks remarkably like a Botticelli!" he ex-
claimed.

"In his letter Herbstein claims it's a lost version of
the 'Madonna and Child with Singing Angels' in the
Berlin Museum. Judging from the illustration in Beren-
son, it's identical, though he doesn't mention any other
versions."

Charles grunted. "And what about the second one?"

"Herbstein says it's by Roger van der Weyden."

"Did you look it up in Friedlander?"

"Only very quickly. I couldn't find one like it."

"Probably because it's not one. Go and fetch the Memling volume, will you?"

There was an abruptness in Charles's voice that made Samantha blush. She hurried out, leaving behind her a completely new tension.

"May I be permitted to see?" demanded Lucy from across the table, reprimanding the men for their neglect.

"Of course," said James quickly, rising to take her the photographs.

"The likelihood of a major Botticelli surfacing is pretty remote," commented Charles coolly, lighting a cigarette and visibly relaxing as he considered the possibilities. "A lot of fakes were done during the war. It could be one of those, or just conceivably a lost work by one of his pupils that's been tarted up a bit. If it's at all worthwhile it may need a lot of research. But the other Madonna—I suppose it's the smaller one—that's different. Could I have the photos again?"

Lucy passed them across the table. "Do you know this man in Frankfurt?" she asked.

"Never heard of him," said Charles and went on studying the prints until Samantha returned with the heavy volume. When she did, it took him only four minutes to locate the picture. He read out the caption for the benefit of the others.

"Memling. 'Virgin and Child with Angel.' Present location unknown." The same page showed two other Madonnas with angels, one in the Nelson Gallery, Arkins Museum, Kansas City, and the other in the Museo del Prado, Madrid.

He flipped through to another page. "Good heavens. It is small. Only twenty-two centimeters by thirteen and a half. We could bring it back in a briefcase."

"So it's genuine?" asked Lucy.

"Presumably, though not one of Memling's best. 'Archaic and with some restorations, hence hard to

judge.' Was in the Renders collection, which means he must have catalogued it. 'Disappeared during World War Two.' Just like thousands of other paintings. I wonder why the devil Herbstein thinks it's a van der Weyden."

"He'll be on the line again any moment," said Samantha. "Shall I have the call put through here?"

Charles nodded and continued digesting the picture. The Virgin Mary was seated on a throne, holding a pudgy Jesus with her left arm, while a kneeling angel held out an apple to the infant.

"Must you speak to him here?" demanded Lucy suddenly, looking pointedly at Samantha as though she were solely responsible. "Hasn't our discussion been interrupted enough?"

Charles rose to his feet. He would have been happy to have a blazing row over a triviality like this. Lucy was being impossible and he felt like letting off steam. At the same time thoughts were racing through his mind and he wanted to let them run.

"Come on then, Samantha," he said. "I'll take it in my office when it comes and let's hope we can get some sense out of this kraut."

When they had gone Lucy turned to James. "Now that's one member of the staff who must cost more than she's worth! How about getting rid of her?"

James expressed a surprise he did not feel. It was an open secret around Bond Street that Samantha was Charles's mistress, though whether Lucy was unaware of this or merely pretended to be, he did not know.

"Really, Cousin Lucy?" he countered innocently. "She's a competent art historian, you know, and we pay her less than a good secretary. It's lucky for us she can afford to work for a pittance." The art world was undeniably full of well-heeled girls who accepted low money because the job was glamorous.

"Do we *need* an art historian?"

"Not if we're prepared to do the research ourselves."

"So far as I can see Charles *is* doing it himself."

James shrugged his shoulders. He was in no mood

for a confrontation. Instead he followed up Lucy's remark by reviewing the usefulness and pay of all the staff, one by one, starting with the two porters. Ten minutes later Charles Luttrell returned.

"Well," asked Lucy, "what did the kraut have to say for himself?"

Charles sat down very deliberately and lit another cigarette before he answered. He felt justified in extracting a little drama from the moment. The prospect of a deal transformed him.

"Herr Herbstein," he said, "has since become aware that he has a Memling on his hands. Or rather a client of his has. These two Madonnas and four other paintings constitute a small collection that he is in a position to buy at what he calls 'a very realistic price.' Unfortunately he is a trifle short himself, so he invites us to go halves with him on the purchase and then sell them in London. He thinks they would find a better market in London than in Frankfurt."

"Quite rightly," observed James. "Do you suppose they're stolen? I mean, 'Disappeared during World War Two' sounds ominous."

"No," replied Charles slowly. "Although there is something at the back of my mind about the Botticelli, in Berlin. No. I imagine that Herr Herbstein's client is in some kind of trouble and needs money fast. In any case so long as the pictures are right and the title to them is good, who cares? We're businessmen, not confessors. This may not prove to be a great coup, but it's a step in the right direction. Even a third-rate Memling should fetch five figures nowadays."

"And how are we going to find our share, in view of this cash-flow problem?" demanded Lucy.

"Mrs. Luttrell has a point," commented Wild. "We've at the most only thirty thousand available for purchases."

"Lucy," interrupted Charles ebulliently. "Remember your father's dictum, 'The time to worry is when you can't find anything to buy.' Samantha will fly out there tomorrow. Apparently Herbstein's client is in a hurry."

"Surely you can't trust that girl on something so important," said Lucy. "She couldn't even tell it was a Memling."

Charles smiled at her again. He no longer felt any need to lose his temper. "If you insist, my dear," he said. "I'll go out myself as well."

After the meeting Lucy wanted the chauffeur to drive her back to Wiltshire immediately. She was going to buy a new colt at auction the next morning and she wanted a good night's sleep.

"Those horse copers are as fly as you like," she remarked. "One has to be wide awake to get the better of them."

Inwardly blessing the horse-trading fraternity, Charles helped her into the Daimler and kissed her goodbye with appreciative tenderness. Her London visits did not usually leave him free in the evenings.

Two hours later he was heading back to the company flat he maintained in Mount Street, just off Berkeley Square and little more than fifteen minutes' walk from the gallery. He liked to walk; it gave him a chance to observe his competitors' windows. Colnaghi's, he noticed, had a small Rubens on show. Leger Galleries were exhibiting early English watercolors. Crossing Bond Street, he turned into Bruton Street past the Time-Life building and glanced across at Christopher Wade, who were part of Frost and Reed. By God their group's sales had shot up since Harlech Television took them over. Reputedly the chairman earned a hundred thousand a year. That was the kind of backing Luttrell's needed. Charles shook his head vexedly and strode on. Traditional as the art business seemed, it was actually changing all the time. Before the war, so he was told, no dealer would call on another after 10:00 A.M. in case a client should spot "tradesmen" in the gallery. Today a fair sprinkling of dealers were aristocrats themselves, or had wives who were, while the clients were likely to be manufacturers, property developers or chain-store kings.

Although the flat had only two bedrooms, its large,

well-proportioned drawing room and separate dining room gave it the luxurious dimensions Charles genuinely needed for entertaining clients and visitors from abroad. Some of his finest smaller paintings hung on the paneled walls. Occasionally, if he was offered enough, he would reluctantly agree to part with one. The antiques he would never sell, though Americans and Germans repeatedly tried to buy them. But neither the pictures nor the furniture claimed his attention as he entered the flat now.

Samantha was half sitting, half lying on one of the pair of sofas, her long legs tucked up underneath her.

"Darling, I think we can celebrate," he called out, waving to her through the open door and going to the kitchen. A moment later he reappeared with a cold bottle of Krug, took it to the drinks tray where the glasses were set out and began easing out the cork.

"Don't I even get a kiss?" Samantha was indignant.

The cork came out well under control with hardly a pop and Charles poured the champagne before it could froth over. He carried the glasses across to her, put them on the wide glass-topped coffee table between the sofas, kissed her on the cheek and then sat down opposite.

"Here's to the Memling and our little jaunt." He sipped a few drops, savoring the taste, then said in a different tone, "I think Lucy is beginning to have suspicions."

"She could hardly have been bitchier if she tried. Does it make any difference if she knows?"

He frowned. "I'd prefer she didn't. She feels inadequate enough as it is."

"Oh, come on, darling." Samantha wasn't going to let him get away with defending his wife. "She dominates everything she comes into contact with. Including you. And it's not as though Bond Street love affairs are unheard of. Be realistic."

"Well . . ." Charles loathed emotional arguments. He needed marriage and he needed sex, if not in combination, then separately, but at all costs without

dramatic upheavals. "She's happy in the country, and at heart she's extraordinarily old-fashioned. In fact she lives in a kind of Edwardian dream."

"In that case she should be quite used to the idea of gentlemen having liaisons. What else did the Edwardians devote their time to?"

Charles laughed heartily, partly because he was genuinely amused, partly because he could now shift the topic. *"Touché,"* he said and reached for the champagne. "Have some more. We're supposed to be celebrating. Where would you like to have dinner?"

As he moved closer and leaned over to refill her glass, Samantha reached up with both arms and gently pulled him down so that she could kiss him.

"Drinking isn't the only way of celebrating, you know. Nor do we have to eat early."

She removed the bottle from his hand and placed it on the table, then slid her arms inside his coat and kissed him again.

"All you really need, darling," she whispered, "is a little more imagination. Yours obviously doesn't get enough exercise in Wiltshire."

"Fräulein Schumann! There's a friend of yours from the Stadel on the line. Something about a Flemish painting."

Karin Schumann was flicking through the index cards in the reference library of the Vienna Kunsthistorisches Museum, where she was an assistant curator. She glanced around, looking down the line of wooden filing cabinets toward the wide desks by the window. The library secretary was holding out the phone.

"Please! The wretched man's been holding on for ten minutes while the switchboard found you!"

Karin slid a marker into the card index and went to the phone, the secretary watching her tall, trim figure with a twinge of envy. Karin was an elegant, self-possessed woman of thirty-four who looked as competent as she was.

"Schumann here," she said crisply. "Oh, is that you,

Gerhard? How's life in Frankfurt, then? Raining?" She glanced out of the high window at gray clouds above the trees. "It will be here in a moment, too." She laughed. "No, I didn't really imagine you were calling about the weather. Yes, I'm listening." She hitched her skirt up with her free hand and perched on the edge of the table, amusedly aware that the secretary had not resumed her typing. The museum was a great place for gossip. So was the whole of Vienna, for that matter. Suddenly the voice at the other end of the line claimed her whole attention.

"Say that again slowly," she demanded.

"The man isn't a major dealer. Not at all. He thought this was a van der Weyden. Or maybe wanted to think it was. He didn't know. However, I did. It's a Memling. Not of the first quality, but a Memling."

"Please describe it again." Karin reached for a paper and pencil.

"Very small. Only twenty-two centimeters by thirteen. The Madonna is seated with an angel to the right of her and the Child on her lap. She wears a red gown. The angel is holding out an apple. At the left is a window with a simple landscape beyond—a dusty road winding among trees. There is a brownish-gold tapestry hanging behind her, and one of her feet rests on a blue velvet cushion. There are a lot of craquelure in the paint—in fact, the picture is in bad condition altogether."

Karin was scribbling rapidly. She had developed a system of notation for describing paintings, based on dividing the areas into quarters. But Gerhard was going too fast for her.

"Wait!" she exclaimed. "What is in the top right-hand corner?"

"Above the head of the angel? I'm not sure. Nothing particular. I saw the picture for only a few minutes. Anyway, it's in Friedlander."

Karin stopped writing. Friedlander had been an adviser to the Berlin museums in the 1920s and 1930s. His books on Memling, Gerard David, Roger van der

Weyden and other sixteenth-century Flemish painters were accepted as authoritative.

"Why didn't you tell me that in the first place?" she demanded irritably.

"Because Friedlander doesn't say much. There's a black-and-white reproduction with the caption 'Present location unknown.' I telephoned in case it was on your list."

"From memory, not. I shall have to check."

Karin hesitated. She didn't want to offend Gerhard, who had been a friend since they met at Vienna University, where he had spent a year, yet what he was saying made no real sense.

"Listen, Gerhard," she said firmly. "Perhaps I am being stupid, but this doesn't add up. Why hadn't your friend looked up Friedlander? What kind of a dealer is he?"

There was a pause. When the reply came it gave her an odd shivery feeling, a mixture of apprehension and excitement.

"A very sharp operator who believes he has found something big. This Memling isn't the only interesting work at his disposal. He told me he was advising a client who has a small collection, wishing to confirm his own judgment, et cetera, et cetera. The whole story stank. No serious collector would go near him."

Karin laughed, imagining the dealer's evasions and half truths.

"And what is his normal line?" she asked.

"Respectable wall coverings for Frankfurt businessmen. Romantic landscapes, like the Lorelei rock and Drachenfels castle by moonlight. He gets high enough prices for them too. But Old Masters, no. Even allowing for its condition, that little Memling could fetch half a million marks."

Karin nodded, as though she were face to face with Gerhard, not hundreds of kilometers away, while she translated the sum. Roughly two hundred thousand dollars. A million of her own Austrian schillings.

Karin said goodbye and hurried to her own office

below the Gemäldegalerie, the museum's picture gallery.

The Kunsthistorisches, or Fine Arts Museum, is one of the great museums of the world. Its huge main building stands by the Ring, the wide tree-lined avenue that encloses central Vienna, and as befits an institution founded by the Emperor Franz Joseph to house the Hapsburgs' private art collection, they are marble-halled and massively impressive. Franz Joseph was in many ways an enlightened man. His collection was open to the public. Soon after his death in 1916 the Great War brought an end to the Austro-Hungarian Empire. But tiny though the new Austrian republic was by comparison with the former empire, it inherited all the imperial possessions. Today the First Director, or Hofrat, of the Kunsthistorisches Museum rules over an assemblage of art that is breathtaking by any standard.

Understandably, all the departmental directors tend to be more concerned with the preservation and display of what they already possess than with the acquisition of more. Especially with her own director in the picture gallery, things were not easy. He had only four assistants, the workload was heavy and he kept a careful check on their activities. Before going to see him Karin knew she would need to have her facts at her fingertips. As soon as she reached her own office she began checking through her "computer."

Karin's "computer" was a reference system which had been thrown out of a business friend's office as valueless when he had acquired a proper electronic machine. It consisted basically of two racks of large cards. One set represented artists. The other carried the details of all the major prewar Austrian art collections. Facts were recorded on each card by tiny punched holes. Standing over the cabinet in which the cards hung, Karin thumbed through them and pulled out the one for Hans Memling. She already knew what to expect. Few Memlings were lost, and there were correspondingly few holes on the card. She laid it on top of a glass panel, switched on the light below and

began sifting through the other sets of cards. Long familiarity with her indexing saved her going through many. She was just placing one labeled "Haberditzl" on the panel when her director came in, momentarily startling her.

"News travels fast in the museum," he remarked dryly. "What are you chasing now?"

Karin swung around, her cheeks flushing. Kameier was not so much her senior, a man of only about forty, tall and thin with neatly trimmed hair brushed back, an aristocratic nose and a studiously self-deprecating manner. But Karin had little doubt that he would one day become the First Director. He had just the right blend of artistic knowledge and bureaucratic formality, deploying the two adroitly as the situation demanded.

"A Memling Madonna, I heard," he said smoothly. "Now that could be interesting."

Karin relaxed a little. Evidently he was showing the artistic side of his temperament for the moment. Nonetheless it annoyed her that the secretary in the library had gossiped so immediately about Gerhard's phone call. She remained on the defensive, addressing him formally.

"As you know, Herr Director, there were several Memlings in Austrian private collections. Stefan Zweig owned one, so did Haberditzl, so did Waldhofen. Not to mention Liechtenstein and Rothschild." Although she paid her boss the courtesy of assuming that he knew this, she was well aware that he cared little about anything that did not belong to the State.

"Amazing how many Madonnas the man painted," said Kameier knowledgeably. "Never stopped. Not that I like all that detail myself. Those jewels and lace and clothes that you feel you could reach out and pick up. Hard work doing it too."

There was an assumption of superiority in Kameier's voice that annoyed her, as though he were the final arbiter of what was, or was not, fine art. She contented herself with replying that at least Memling had been well paid by the burghers of Bruges who were his pa-

trons. It always offended her that many great artists had died penniless.

"Does this Madonna figure on your lists?"

"Let me finish looking." One by one Karin placed the art collection cards over the Memling card on the lighted panel. On two occasions a pinhole of light showed through when the holes in the cards coincided. That gave her a cross-reference to work on.

"Two possibles," she said, turning to another filing cabinet and producing two index cards on particular Memling paintings, making comments as she scanned them. "One could be. It's a Madonna and angel. No exact measurements, but it's small. Last seen in the Gluck family house in November 1939. It's extraordinary what imprecise records some of these rich families made."

"Hardly more extraordinary than your persistence," remarked Kameier, disapprovingly. Karin could see the civil servant in him displacing the connoisseur. "Seriously, Frau Doctor, what is the point?" he went on, using the title her university degree had earned and which made her automatically "Frau" even though she was unmarried. "It is more than thirty years since the war ended. Even the Italian government is reducing the financial support for Dr. Siviero—and he has made amazing recoveries."

"The Italians are crazy," said Karin brusquely. "Considering the rare paintings being stolen in Italy *now* they ought to be increasing Dr. Siviero's staff, not cutting his funds. It's big business."

"I concede the point. But loot from the last war? Nazi treasure hoards? It's finished. Anyway most of it was simply the safeguarding of genuine national treasures. Think how much from our own museum here was stored in the salt mines at Alt Aussee—and the Americans imagined it was loot when they found it!" He made a nonchalant gesture with his right hand. "It was soon returned, wasn't it?" The museums of Europe had recovered virtually everything that had not been destroyed.

Without saying anything Karin reached up to a
bookshelf and pulled out a heavy volume with the
boldly lettered title *Verlorene Werke der Malerei*.

"I know," said Kameier coldly. "Approximately four
thousand lost works of the masters are listed, are they
not? Many of them destroyed by American and British
bombing in 1944."

"And others being offered for sale in New York this
year," Karin added coolly. "Like the Dürers the Amer-
ican GI brought back from Germany and sold to a
lawyer for five hundred dollars. Don't worry, Herr
Director, I'm not running about trying to reveal Nazi
plots. What happened after the war ended interests me
more. What the Nazis stole first was often 'liberated' by
Allied soldiers later, especially works from private col-
lections, which weren't being searched for officially.
The British, Americans and French didn't rape the
women like the Russians did, or destroy for the sake of
destroying. Nonetheless, what some of them smuggled
home was part of our heritage."

Kameier sat silent considering his position. The pas-
sion with which Karin felt about this was clear. In a
way he himself was to blame. Two years ago when she
retrieved five canvases by Austrian artists, one of
which now hung in the museum, he had felt her efforts
justified, and so had the Hofrat. The Bundesdenk-
malamt—the national Fine Arts Commission—had ap-
proved too. Works by the few noted Austrian artists
were part of the national patrimony. Karin's perspicac-
ity had been applauded, though not to the extent of
granting her special funds for further investigation.
Such financial support as she received came from the
museum, and Kameier himself had sometimes felt in-
dignant at the way the Hofrat backed her up.

"Frau Doctor," he said, "I understand your feelings.
But suppose this Memling does belong to an Austrian
collection, how will it benefit us? Look what happened
with Prince Liechtenstein. He took away the lot and
then sold the Goya."

"He did have a principality there and only a castle

here. You can't blame him for having taken the pictures home."

"Even if this Memling were loaned to us," went on Kameier, neatly anticipating Karin's next point, "would it be worth exhibiting?"

That was unanswerable. From the description it would not. But Karin's search was really about the right of people to recover their stolen possessions. However, there was one private loss over which Kameier was capable of becoming excited.

"Suppose this Memling leads us to the Botticelli? My friend at the Stadel thinks this dealer had other valuable finds. Suppose they include the Waldhofen Botticelli?"

Kameier trembled slightly. She was hitting below the belt. The current Kunsthistorisches catalogue stated blandly that "as the Gallery is particularly rich in representatives of the Venetian School, the visitor is able to enjoy a comprehensive survey of Italian painting from the 15th century to the 18th century." Nonetheless there was no disguising the fact that the Florentine masters were poorly represented in the gallery. They had not a single Leonardo, Michelangelo, or Botticelli, though they did have Raphael's magnificent "Madonna in the Meadow."

"The Botticelli was on loan to our gallery in 1939 and the Waldhofens have no known heirs," went on Karin relentlessly. "If it does turn up we can reasonably claim it. Imagine the headlines—'Florentine masterpiece returns to Vienna. Triumph for Kunsthistorisches.'"

She hesitated, wondering if she had hit the right blend of inducement and flattery. One could never quite tell with Kameier. Sometimes he was open about his ambitions, at others he was the soul of modesty. She looked him in the eyes and smiled.

"Be honest, Herr Director. You would be very glad to have a Botticelli. So would the Hofrat. There are seven at Dahlem in Berlin, and how many have we? None."

Reluctantly, as if it were costing him a fortune, Kameier smiled back at her. "This is blackmail," he said. "Nothing else. Yes, I would like a Botticelli. But what do we really know about the Waldhofen one? Forty years ago experts would attribute paintings to a master which now we know were by his pupils. Was this Madonna even genuine?"

"It was authenticated by Berenson in 1923." Karin allowed herself to become indignant. "The old Count Waldhofen was a true connoisseur. If a painting was not indisputably right, he just wasn't interested."

Kameier nodded. He was wavering. The collector in him was willing to be won over by Karin's conviction. However, he still needed reassurance on the most pertinent question of all.

"Very well," he admitted. "I agree that the recovery of the Botticelli would be a major achievement. I agree that if the owner's heirs cannot be traced we could perhaps claim it because it was on loan to us. But is it still in existence? When was it last seen?"

"It was one of the few pictures Count Waldhofen kept when the slump forced him to sell his collection. He was getting old and more religious and apparently that Madonna had a special meaning for him. He died in 1929. After the *Anschluss,* when the Germans began confiscating property in Austria, his son thought it would be safer here in the museum. So he loaned it to the gallery. Nonetheless, in 1942 it was removed from here to Berlin. We still have the Nazi order in the archives."

"Outrageous," Kameier commented. "You're right about that!" She had touched a nerve. To him one of the least forgivable aspects of the enforced absorption of Austria into Germany in 1938—the *Anschluss*—was that Hitler had not respected the Austrian state museums. Paintings and sculptures had been sent to German embassies in London and Moscow, ending up being confiscated as "enemy property" during the war; tapestries had gone to the Reich's chancellery in Berlin

and were now in East German hands; even the Hapsburgs' imperial regalia were taken.

"And where was the Botticelli hung in Berlin?" he asked. "Did you find that out?"

"At the National Gallery on the Museum Island. It was last seen there in April 1943. That's when the mystery starts. It's not listed as having been destroyed either by bombing or by the fire in the Friedrichshain bunker in 1945."

"So?"

"I think it must have been 'loaned' again to one of the Nazi leaders." Karin spoke the word *loaned* with a contempt that made Kameier shiver. He had never seen her in such a mood before. It occurred to him that she would be a very dangerous opponent. "If it did go to an official," Karin went on, "then it might have been taken off the National Gallery's lists. With one or two exceptions those museum directors were more honest than their masters. They would have recorded the painting as a loan from the Kunsthistorisches."

"In such a case," observed Kameier, "it would be a relief for them to strike it off their records again. You have a plausible theory."

"Thank you," said Karin simply. "Nothing proves that the painting survived and yet I am convinced it did. Strange things happened in 1945." She paused. She could know about the twilight of Germany's defeat only through research. Nor was it a time Germans talked about much, at least not those who had been there.

"A strange time indeed," agreed Kameier. "When I was seven and you . . ." Tactfully he left the sentence incomplete.

"When the war ended I was ten months old and an orphan," said Karin remorselessly. "Luckily my godfather looked after me."

Instantly Kameier was all sympathy. A readiness to listen to his staff's problems was among the attributes which he believed would take him to the top.

"I am so sorry," he said. "I had no idea."

"Why should you?" Karin shrugged her shoulders. "Our lives are our own. As a matter of fact it was my godfather who saw the Botticelli in 1943." She paused, choosing her words carefully. "He was concerned about the fate of the painting."

"Something of an expert, was he?" remarked Kameier patronizingly.

"Yes," said Karin, suddenly deciding that if she was going to persuade her boss, she might as well do it properly and reveal what was not common knowledge among the staff. "He was also the last Count Waldhofen, the man who lent this museum the Botticelli."

So that was why the Hofrat supported her! Kameier almost lost his composure as he appreciated the undertones to Karin's search. He was a fool not to have guessed there was something deeper in all this. The last Count had been a noted connoisseur before the war, just as his father the old Count had been, and although his declining years had been spent in obscurity, the Hofrat would certainly have known him. Kameier drummed his fingers on the table, swiftly balancing the desire to keep his subordinate in her place against the sympathy the Hofrat must have for her, then he rose abruptly to his feet, his mind made up.

"Paintings have come out of the East before now," he said. "Even if we have had little success in getting ours back, I am prepared to say the gallery would like to inspect the Memling with a view to possible purchase. Of course I shall need the Hofrat's approval, but I'm sure he'll agree."

Karin gasped with relief.

"Go and sniff out this Frankfurt dealer's establishment," went on Kameier, enjoying his own decisiveness. "Write a brief report on the Memling. Find out if there's any news of the Botticelli. For the Lord's sake keep the expenses down and don't be away too long. You also have a job here, remember."

That evening, instead of walking directly home to her apartment in the 8th District, not far from the Kunsthistorisches, Karin disregarded the rain and made a

deviation to the Maria Hilfer Strasse, where she ducked away from the traffic into the quiet gloom of the *kirche*. This had been the family church both of her parents and of her godfather. She lit three candles to the glory of God and to their memory. Then she stood in prayer for a few minutes before a small marble memorial. The inscription on the plaque read: "Near this spot lies in peace Captain Werner Schumann, Hoch und Deutschmeister Regiment No 4, executed by the Gestapo, August 11, 1944. Also his wife, Elisabeth, killed August 7, 1944."

It was a rare privilege to be buried in a Vienna church, as all the cemeteries were outside the city. Her father and mother had earned it. He had been among the Austrian officers involved in the July 20 plot to assassinate Hitler. Her mother had been shot at their front door, trying to prevent the Gestapo from arresting him. There were not many memorials to Nazi victims in Vienna.

After a few minutes she left the church and went on to the turn-of-the-century mansion block where she lived in her former godfather's apartment. A forbidding list of house regulations hung in the hallway, and she had to put a schilling in a slot to operate the aged elevator which rose up to the stairwell. No matter, the accommodation was spacious, it faced over a small garden, and the rent was subject to statutory controls. The furniture inside was heavy and comfortable, lightened by a few acquisitions of her own. On a side table stood a silver framed photograph of her father in his army uniform, her mother smilingly holding his arm. It appeared to have been taken at someone else's wedding. She didn't really know. All her living recollections were of her godfather, whose portrait hung over the fireplace. He gazed down at her, his beard silvered by age. She remembered how delighted he had been at her decision to study art, which had been his own principal passion. He would be pleased about this expedition, too, she thought, and so would her parents.

Suddenly she remembered she must telephone Ger-

hard in Frankfurt. By the time she had told him her
news, it was time to cook herself supper and pack. She
had an early start tomorrow.

⟋⟍⟋ chapter 2

The clerk who brought the letter was both obsequious
and smug. It was Friday morning, the weekend was
welcomingly close, and he had laid his hand on some-
thing of unquestionable private value to his superior.
He stood in front of the wide desk, confronting a heav-
ily built man with a strong, solid face, deep-set eyes
and thick brown hair only lightly flecked with gray.
Colonel Raeder was basically a man of action and he
still looked it, despite more years spent on paperwork
than he cared for and the ordinary dark suit he was
wearing.

"The letter is marked 'Personal,' Herr Oberst," ex-
plained the clerk ingratiatingly. "When I saw that I
brought it straight along."

Raeder held out his hand for it. What the clerk's
words implied, of course, was that the letter had not
been through the registry, had not been opened, read
and its contents noted along with the official mail. Thus
the clerk was conferring a small privilege on him, a
bonus that would one day have to be repaid. In East
Germany, where the bureaucracy rules supreme, where
no official can ever be at a loss for guidance because
there exists a rule for every possible situation, small
privileges figure large in a man's life.

All this flashed through Raeder's mind in a second
before he actually looked at the envelope. When he did
he realized with a shock that this privilege was not so
small. The letter came from West Germany, the Bun-
desrepublik. The typewritten address was to an apart-
ment he had left ten years ago, and it had been
redirected here. Ordinary citizens of East Germany, the
Democratic Republic, were allowed correspondence

from the West. It was likely to be opened, but the volume of mail was too great for everything to be seen by the security service. Anyone who had access to state secrets, however, was obliged to submit Western letters for scrutiny. Even a colonel in the Ministry of State Security itself. Perhaps especially such a man.

As an officer in the Staatssicherheit, known colloquially as the Stasi, Raeder enjoyed considerable standing. The Stasi maintained the authority of the regime, smelled out spies and would-be defectors and themselves organized espionage abroad. Its chief was the Minister, ranking as a general. Beneath him the two main departments, concerned respectively with internal and external matters, were headed by major generals. Raeder worked for the former. Though not at the very top, he had come a long way. He consciously enjoyed the fruits of being a senior officer at the Stasi's huge concrete headquarters block on East Berlin's Normannenstrasse. That rank gave him a three-room apartment close by, larger than he and his wife really needed, now that their children had left home. He had a Polski Fiat car and could even obtain spare parts for it. He was served politely in shops and restaurants. But he could not be trusted to receive unscrutinized letters from the West. He glanced up at the waiting clerk.

"Thank you," he said noncommittally, wondering if the letter had already been opened, read and resealed.

The clerk gazed mournfully down as though handing it over had involved him in actual personal loss.

"Shall I draft a routine covering minute for the security section?" he asked, crudely emphasizing the word *routine*.

Raeder examined the envelope. It was long and made of expensive paper. In one corner was printed the name of a lawyer in Frankfurt/Main, the business capital of West Germany. The top was marked *"Personlich."* The clerk must have been sorely tempted, damn him.

"I shall inform security myself," he said. "When I

have had time to read this. I shall not forget your thoughtfulness on my behalf. Thank you."

"*Bitte schön*, Herr Oberst," muttered the clerk, accepting the unmistakable dismissal and wondering if he might not have profited more immediately from the situation. Most organizations have routes to advancement which the Personnel Department does not mention. But then again the colonel was not a man to cross. Definitely not.

The greasy rat, thought Raeder as the clerk left the room. Creatures like that gave spying a bad name. He slit open the envelope carefully. Inside were a legal letter on similarly expensive paper and another, smaller, envelope addressed in a bold handwriting to "Herr Wolfgang Raeder" with "*Personlich + Vertraulich*" underlined. For a moment Raeder scrutinized the writing. It was familiar, but he could not immediately think why. "Personal and Confidential." That was stupid. A plain envelope would have been safer. Methodically Raeder read the lawyer's covering letter first. It was dated *16 Oktober*. "*Sehr geehrter Herr Raeder,*" it began. "Enclosed a letter from Herr Horst Schneider, who died in a car accident on 21 July on the autobahn. This letter was to be delivered only after his death." The text ended with the conventional "*Mit vorzüglicher Hochachtung*" and an illegible signature.

Communications from the dead are by their nature dramatic. Wolfgang Raeder was a hard man, schooled successively by the Waffen SS as a stormtrooper in the closing years of the war and for three decades after that by the Stasi. He had enjoyed few close friendships, but those few he cherished. Although he had not seen Horst since 1952, this news shocked him. He balanced the unopened envelope on his palm for a moment, then reread the lawyer's words: "accident on 21 July on the autobahn." He murmured, "Poor bastard." Then another thought struck him. Today was October 22. "God in heaven. It's taken them long enough to forward this." He looked again at the envelope, wondering if it might have been opened. The flap was not

perfectly sealed. With a curse he tore it open and began reading his friend's last message. The first thing that caught his attention was the date: April 1965. So long ago! There was no address.

Mein Freund.
When this reaches you I shall be dead. Because what I have to say is for you alone. I have instructed my lawyer to check that you are alive before sending it. Otherwise he is to destroy it.

Wolfgang paused. Possibly that explained the delay. He read on.

You will understand what I mean when I say there is a bond between us such as few men share. As a blood brother you helped me in 1952 in spite of the danger. Now I have to confess that to an extent I deceived you. When I left I took also another painting I had acquired. I thought it might be valuable, but only recently have I realized how valuable. It appears to be by the Florentine painter Sandro Botticelli. My plan was to sell both it and the small one. But although I bought it from a family near Potsdam, there is no doubt that it must have been looted, as we know the other had been. Therefore, to offer it for sale could result in a serious scandal. I dare not risk wrecking the business I have built up in Frankfurt. In ten years' time, when thirty years will have elapsed since I acquired it, it may become possible to dispose of such treasures safely under the Statute of Limitations. Should I die before then I am bequeathing the small one to my wife. As my oldest friend I want you to have this Botticelli. Should you ever decide to follow me to the West, then its value could provide for you. It can be claimed by simply showing this letter to my wife. She also knows the truth about my "little art collection." I enclose a photograph so that you can recognize it.

In conclusion I wish you to be happier in a longer life than mine.

Wolfgang examined the signature and involuntarily shivered. He could only pray his clerk had not heard this voice from the dead. This message could land him in serious trouble. Not only was there the suggestion that he, Wolfgang, might want to defect. It was made obvious that he had helped Horst across to the West. Back in 1952 the Berlin wall did not exist; it would not be built for another nine years. East Berliners could legally visit their relatives on the other side. But the gray-green-uniformed Volkspolizei searched them rigorously, and they could carry little more than a shopping bag. If they left forever they did so with only the clothing they wore. As a policeman in the security service Wolfgang had been able to help an old friend take out a lot more—a carload to be exact. And Horst was an old friend. The term "blood brother" summed it up. In 1944 they were both SS corporals, both eighteen years old; they had been called up together and trained together; they were old comrades in everything except age. They had fought side by side as the Americans swept through southern Germany in the closing battles of the war. Its conclusion had shaped both their lives. Wolfgang gazed at the letter and remembered.

The snow had melted on the lower slopes of the mountains when the battalion was ordered south to defend Munich. Wolfgang felt the mountains were the only constant reality in a world that was collapsing. The peaks around the Zugspitze reared white and hard against the spring sky, unconquerable. At eighteen he was no sentimentalist, and there was little call for sentiment in a corporal of the Waffen SS anyway. But he felt he understood why Hitler had long ago established a retreat up at Berchtesgaden, overlooking both Germany and Austria, as though the soul of the nation was there among the snows and the pine forests.

More practically the mountains of Bavaria and the

Tyrol were capable of holding many secrets, of which the SS were the guardians. A complete SS division was concentrated around Alt Aussee in the Salzkammergut east of Salzburg, where the lofty chambers and galleries of old salt mines had been converted into storage for works of art from the Kunsthistorisches Museum in Vienna and the Alte Pinakothek in Munich. Wolfgang's and Horst's battalion had been stationed there through much of the winter, checking in convoy after convoy of trucks that lumbered up the track to the mine entrance, set unobtrusively by a low white building on the steep wooded slope above the village. They had heard that treasures from Belgium, France and other conquered countries had been brought to join the German heritage, stacked on wooden racking in the pure, dry air of the salt mine. But as gray-uniformed Waffen SS they had never been inside. That duty belonged to the black-uniformed SS proper, the ultimate protectors of the Führer's political power.

The Waffen SS were soldiers, and the new year of 1945 had brought them new priorities. The Fatherland itself was now being invaded. On March 7 the American First Army had seized the Rhine Bridge at Remagen and was fighting its way across central Germany to meet the Russians on the Elbe. On March 23 General Patton's Third Army crossed the Rhine south of Mainz and raced through southern Germany toward Munich, capital of Bavaria, birthplace of the Nazi party and one key to the National Redoubt which the Americans believed Hitler was establishing in the mountains. In fact he was doing no such thing. He was in his bunker in Berlin. But on his orders the SS battalions were sent to defend Munich.

All that Wolfgang and Horst were told about this was that their Führer depended on them to defend the Fatherland to the last man and that, especially, this meant holding the road around the south of a large lake between Munich and the mountains, called the Starnberger See.

The lakeshore was dotted with gracious villas which,

before the war, had been the weekend retreats of fashionable Munich families. A little river fed the lake at the southern end and was crossed by a stone bridge. It was this pleasant spot which Wolfgang's company commander chose for a delaying action against the tanks of General Patton's army, and it was here that Wolfgang's life began to change.

Horst was the explosives expert in the company, and when the commander ordered him to fix charges beneath the bridge Wolfgang volunteered to help his friend. Preparing a bridge for demolition was routine. Nonetheless a man didn't want clumsy helpers on the job. They had strapped the gelignite to the stone arches and laid the wires back to the detonator box some two hundred meters away when the sergeant major demanded to know if the explosives would be visible from the enemy side. Accordingly they crossed again to satisfy him, doubling along toward the nearest bend in the road, from where the leading American jeep driver or tank crew would first see the river.

"Crazy," Horst muttered as they ran, the sweat in beads on his face, his waterlogged boots squelching. "The Yankees will guess it's mined anyway."

As he spoke the roadway rocked, a tearing blast of air threw both men on their faces, and monstrous noise cracked their eardrums. Seconds later a cascade of stones and grit showered on them, large lumps hitting the road. A spray of water fell. Then there was silence, dizzying and unreal.

Wolfgang stayed still for a moment before pushing himself up onto his knees, cursing at sudden pain. His palms were scored and bleeding. He must have put his hands out in front of himself instinctively. He managed to stand up and turned to Horst, who was also scrambling to his feet, his steel helmet awry and gray uniform shrouded in dirt.

"What fool did that!" he heard Horst shout, the voice sounding distant and distorted. His right ear was beginning to throb. "Crazy fools."

Twenty meters away a cloud of smoke and dust

hung over the river, slowly shifting with the wind. Beyond, Wolfgang thought he saw soldiers disappearing among the trees. He felt himself swaying. Slowly he began to understand that they were alone.

"The bastards have left us," he said. "The filthy bastards have left us."

He felt Horst catch him by the arm. "Are you hit?"

"I don't think so. My ear hurts."

"My God, what do you think you are! A kid in the Volksturm! Snap out of it."

Wolfgang put a hand up to his ear. It was wet. His fingers came away bloody. He shook his head as though to dispel the dizziness.

"What the hell happened?"

"Either some fool touched the wires or they reckon the Yankees are coming. Either way they've abandoned us. Thought we must be dead most likely." He paused. "We could swim back."

Wolfgang gazed at the river. Thank God his eyes were all right. Yes, the river would stop a tank, but it could be swum easily enough. He heard Horst's voice in his uninjured ear.

"The question, my friend, is whether we want to."

The idea of deserting caught Wolfgang unprepared.

"Want to?" he asked, uncomprehending.

"As you said, the bastards have left us."

A bullet sang past them and thudded into a tree.

"Quick," yelled Horst. "Get down."

Wolfgang found himself being pulled into the bushes by the road. He felt groggy and was glad to sit down.

"Bastards," said Horst. "I bet that's the sergeant. He'd shoot his own sister if she was in the way." His voice dropped conspiratorially, as though they could be overheard. "Listen, my friend. For whatever reason they've blown the bridge and they're finished with us. The Yanks crossed the Rhine three weeks ago. They'll be here any moment. All we have to do is get out of these uniforms and go underground for a few days."

Wolfgang remembered the execution of a deserter a few weeks previously.

"I can't think straight," he said.

"Quiet! You're not in the barrack room. Let's try to hear what's going on, then make a move."

Wolfgang nodded. Sitting still suited him fine. He decided he must be slightly concussed. They waited tautly, straining to hear any significant noise. Around the road the dust from the explosion gradually settled. A squirrel scampered across dead leaves, making a crackling sound and bolting up a tree when it noticed them. A duck quacked. The only sounds of war came from the air when a pair of fighters raced low over the lake with a sudden roar. Later Wolfgang thought he heard heavy guns in the distance, faint dull thuds.

"Those could be thirty kilometers away," commented Horst. Otherwise there was nothing.

"How do you feel?" Horst asked.

"Groggy. Not too bad if I don't stand up." He was sitting against a tree, quite comfortably.

"Well, we can't sit here all day. I'm going off to find clothes for us. Then we'll have to move."

Wolfgang grinned weakly.

"Don't worry. See you later."

He watched Horst disappear at a fast walk around the bend in the road and thought, He's a good comrade, Horst. What a crazy thing to happen.

After that he must have fallen asleep, though only lightly because a faint noise woke him. Someone was moving along the road. There was an intermittent squeaking sound, accompanied by slow footsteps. Wolfgang peered through the bushes, tense, clutching his submachine gun. Slowly an old man came into sight, pushing a bicycle, its handlebars laden with baskets. He halted short of the blown-up bridge, staring at it in dismay. He turned and looked around. Suddenly a pantomime of fear passed across his face as he noticed the recumbent soldier.

"Hey you," called Wolfgang, not too loudly.

The old man wavered, then set off desperately back down the road, dropping one of the baskets in his haste.

Hell, thought Wolfgang, I suppose if I was a Yank he'd rush up and kiss me. He struggled to his feet and retrieved the basket. It contained at least five kilos of sausage. He ate a chunk and felt better. That was good luck, as all their kit and food were on the wrong side of the river.

Half an hour later Horst returned, riding a bicycle, a bundle under one arm. He was in high spirits.

"First I bought some clothes at a farm. Next I met the proud owner of this." He held out the bicycle. "Obviously his need was less great than mine. And he was wearing far too much for such fine weather. 'Summer's coming,' I told him. 'You won't need a coat.'" Horst roared with laughter at his own joke.

"No wonder everyone loves us," said Wolfgang sourly.

The remark cut into Horst's joviality. "Let's get these on, anyway," he said, undoing the bundle. "We haven't much time. They think the Yanks are at Schongau, about thirty-five kilometers away. That would square with the firing." As he spoke a loose formation of eight fighters swept overhead, climbed suddenly and then peeled off one by one into a dive toward the far side of the lake. They heard the chatter of the planes' guns.

"It's going to be very unhealthy here," said Wolfgang. "We need to hide somewhere."

"You're damn right! There's supposed to be an empty castle not far off, quite out of the way. Let's find it."

Twenty minutes later the two corporals had concealed their uniforms in the reeds on the lakeshore and were dressed much as farm labourers might be. Their only argument was over the guns.

"If we're caught with these we're as good as dead," said Wolfgang.

They threw the guns out into the water and kept the long-bladed black-handled SS bayonets that doubled as knives for silent killing. Then they began making their

way west around the lakeshore, keeping away from the road, Horst resolutely pushing the bicycle.

The castle stood on a wooded bluff overlooking a village. By the time they got there the evening sun left it in the gloomy shadow of the trees around it. Avoiding the village, they climbed a path up the side of the bluff and found that a whole complex of farm barns lay behind the castle. They stopped under a stone arch leading to the courtyard, carved with the date 1899.

"Looks deserted enough," commented Horst.

Wolfgang surveyed the high walls and massive windows. There was a cold, eerie quality about the place.

"Let's try the barns," he said. "I don't want to be cooped up in there."

They settled on a long wooden barn about a hundred meters farther along the ridge. Its upper floor was a hayloft made like a gallery encompassing a central space for farm carts, now empty. Through cracks in the planking they had a fair view toward the valley and beyond to the mountains. They made themselves comfortable in the hay, ate some sausage and fell asleep.

The Americans came through the next day, and the valley below reverberated to the noise of war. Tanks rumbled through the villages, their tracks churning up the fields, while strafing fighters passed so low that they were often beneath the level of the hill. Occasionally there were long bursts of machine-gun fire, the ominous rat-tat-tat indicating last-ditch resistance somewhere. But the American advance was inexorable, while high overhead great formations of bombers droned steadily in the direction of Munich.

Although a main road to Munich ran near the village, the castle was away from it and totally secluded. Horst and Wolfgang crouched in the hay, chewed sausage intermittently and listened.

"The Yanks must be going flat out," said Horst. "Thank God we're not defending that riverline."

The second day was quieter. The advance columns of American tanks had swept past, and from what the

two men could see from their limited viewpoint the
main movement was of trucks, presumably taking sup-
plies of ammunition, fuel and rations to the forward
units. In the countryside little else stirred; it was as
though the native population had vanished or taken to
their burrows like rabbits. Only occasional plumes of
smoke from cottage chimneys told of cooking and do-
mestic fires. Wolfgang and Horst themselves decided
against venturing out. In theory at least the "were-
wolves" of the Führer's resistance movement, young
teenagers most of them, frightened and trigger-happy,
would be sabotaging the enemy. The corporals had no
desire to be shot in error at this stage in the war. "Our
business is surviving," declared Horst. "The death or
glory game's over."

Nonetheless they instinctively reached for their bay-
onets when the huge barn doors creaked open that eve-
ning and a gruff peasant voice called out, "You can
come down now."

Wolfgang shifted slightly to see the intruder. There
was a faint rustle of hay as Horst did the same.

"I said you can come out. We know you're there."
The speaker paused. "The Americans have gone."

Wolfgang felt the tension in himself subside fraction-
ally. From his accent the man in the doorway could
only be a local and no youngster either. Wolfgang
twisted around to look at Horst in the gloom of the loft
and jerked his thumb toward the door. Horst nodded.

"Are you the farmer?" demanded Wolfgang quietly,
his words almost swallowed up in the vastness of the
barn.

"*Ja, ja.* Who do you suppose I am? You can come
down."

Warily the two men descended the ladder. A burly
man stood silhouetted in the high doorway. He wore
tattered trousers and a Bavarian green felt hat, faded,
but still with a traditional feather in its band.

"We thought you were still there," he said, a note of
triumph in his voice at having outwitted these strangers.
"My wife saw you go in two days ago. Since then

we have been hiding in the cellar, she and I." He gestured at the farmhouse two hundred meters away. "We are the only people here. Come to the house. She is making soup." As they followed him he said, "At a time like this all sensible people must be friends."

When they had eaten and were sitting around the table in the farmhouse kitchen Wolfgang asked about the owners of the castle.

"The SS took them," said the farmer shortly. "Last autumn." Suspicion flickered across his weathered face. "You *are* soldiers, you two?"

"Yes."

"Not SS?"

Wolfgang felt that in many ways the Waffen SS had made him. If he now stood six feet three in his socks and was as fit, hard and unafraid as an eighteen-year-old could be, that was the gift of SS training, SS discipline and superior SS rations. He and Horst saw themselves as respected and feared for their fighting qualities. It had not occurred to him before that other Germans might have only fear and hate for them, but that was what he saw now in the farmer's eyes.

"We're infantry," said Wolfgang coolly. "Sixty-third Regiment," he invented, relying on the farmer's ignorance.

"You got lost?" queried the farmer, irony thick in his voice.

Horst took the remark at its face value. He was always quick off the mark.

"Due to absurd orders from a nincompoop officer," he explained.

"I expect a large part of the Wehrmacht is losing itself just now," observed the farmer, "and will be melting away like butter in the sun."

Soon, thought Wolfgang, he will actually insult us. What then? Do we kill him, take what we want and vamoose? To his relief the farmer surveyed them both for a long moment, then leaned forward, his elbows on the heavy pine table.

"So. What are you two boys going to do? Go

home?" He paused. "Take an old man's advice. Don't try. Someone's bound to catch you and you'll spend your next years in a prisoner-of-war camp. At the best. I have a better suggestion. Stay here and work for me. In return I'll give you food and shelter."

"We have money," said Horst.

"Money!" echoed the farmer. "Nazi Reichsmarks! You think those will buy anything now? You should have been around after the Kaiser's war, like I was. Tomorrow money will buy nothing. We'll be back to barter. But I need farmhands and you need food and safety."

"It's an idea," conceded Wolfgang.

"Perhaps," said the farmer, "we could even obtain new papers for you. I wouldn't want to lose two new farmhands simply because some American demanded your papers and all you had were Wehrmacht passes." He scratched his cheek reflectively. "Have you many cigarettes?"

"Two packs," said Horst, who had been bemoaning the fact that all their kit had been on the other side of the river when the bridge blew up.

"Possibly the clerk at the Landkreis office in Weilheim likes cigarettes—and he might even still like money. Maybe I give him some eggs too. Then you can both have identity cards as farmworkers."

Wolfgang and Horst exchanged glances. "We accept," said Horst. "But we shall continue to sleep in the barn in case the Yanks come."

Years later Wolfgang would look back on their seven weeks at the farm as among the best of his life, though at the time he was impatient to go. As the spring sun grew warmer, bringing flowers to bloom in the grass and melting the snow on the distant Zugspitze, they learned the routines of the farm, all but unaffected by the chaos of the Third Reich's collapse. Where people in the cities starved, they ate. While the roads were cluttered with footsore refugees, they slept secure. Although normal business was at a standstill, they assisted the farmer in the curious deals by which

he disposed of produce. One man even brought an armchair on a handcart to exchange for eggs.

"This can't go on," the farmer would say. "What happens at the harvest? Someone will have to organize things."

"When they do," commented Horst, "our little holiday will come to an end."

It was the thought of losing them that spurred the farmer to trek the eight kilometers to Weilheim and obtain new identity cards from the corrupt clerk. On his return he was triumphant. "Now," he said, "you are workers in a reserved occupation. You need not worry about being stopped by a Yank."

In fact the American presence was not onerous. Ten days after the fighting units swept through, the occupation troops had arrived. To avoid "fraternization" they were billeted in special camps. Their main interference with the life of the village was their establishment of a drinking-water distribution point, manned by four GIs who lived in a tent close to it. There was considerable surprise when people realized that the water was for them, not the invading army. So they smiled cautiously and collected enough daily to satisfy them, though because the purification chemicals made it taste unpleasant, they used it only for washing.

"It doesn't sound like Patton's army," commented Wolfgang incredulously. General Patton, with his pearl-handled revolver and his riding breeches, was an enemy they had heard about.

"I told you the Yanks were soft," said Horst.

On May 8 the war was officially over. Posters in the villages announced the unconditional surrender of the High Command. Two weeks later, after work, the two men were resting when they heard a vehicle drive up outside.

An American voice said, "Get the jeep out of sight."

"Sure thing," said another.

Suddenly the big double doors of the barn were wrenched open. Afternoon sunlight flooded in. Wolfgang and Horst shrank back into the shadows. They

had taken to sleeping on opposite sides of the loft, with the central space between them, reckoning it was safer. Now it precluded conversation.

Outside someone gunned the jeep engine and a moment later a GI drove the vehicle into the barn.

"Guess you'd better close one door, O.K.?" said the first voice. "Now you stay with it while I check the castle."

The driver dismounted, pulled one of the doors closed, then lit a cigarette and lounged against the jeep. After a while he fetched a magazine and began reading. Above him the two men did not dare move.

About half an hour later the driver walked outside to relieve himself. Wolfgang took the chance to shift his position so that, while still in deep shadow, he could see below. He unsheathed his bayonet. He was puzzled by this pair of Yanks. What in damnation were they up to? Opposite him Horst also prepared for action.

The GI returned and so, eventually, did the other American. He had two silver bars on his cap and on his shirt collar, which Wolfgang supposed meant he was an officer. Under his arm he carried a small painting in a gilt frame.

"Should have guessed," he remarked to the driver. "Nothing worth liberating."

"How come?"

"No kind of a real ancient *Schloss*. Most of the contents are crap. Let's put this in the box with the rest."

The driver moved around the jeep and Wolfgang could hear him fumbling with what sounded like a metal case.

Then Horst sneezed.

"What the hell was that?" shouted the officer, pulling a gun out of his holster and stepping back. "Christ, there's a guy up there. You! Hands up!"

Horst had been a fraction too slow, though he was out of sight now. Wolfgang's skin prickled. He could see the officer's head, with its khaki "fore and aft" cap. Both Americans had their backs to him.

"A count of three and I'll shoot," called out the officer, adding to his driver. "Jesus, what luck! We'll have to fix this bastard."

Wolfgang wondered what the words meant. He had understood only "Hands up." There was a dull crack as the officer fired. Wood splintered in the floor in front of Horst. Shit, thought Wolfgang. There's a silencer on that gun. These two are dangerous.

"Let's go get him," said the driver, starting toward the wooden ladder.

Wolfgang could wait no longer. Shouting "take the nearest" to Horst, he rose, ran forward and jumped down on top of the officer, driving the bayonet hard into his back. The gun cracked again and a bullet plowed into the floor as the officer collapsed.

Three meters away Horst kicked the driver off the ladder, vaulted down and stabbed him twice. It was all over in seconds. The two corporals straightened up and looked at each other.

"That bastard would have shot me," said Horst incredulously.

"Exactly," said Wolfgang coolly, surveying the bodies. "Make sure they're dead, will you?" He walked to the door, looked around, saw no activity and returned to the jeep. In the back was a large ammunition box, its lid partly open. He lifted it onto the floor, swung the lid back and exclaimed in surprise. The box was full of pictures, mostly rolled-up canvases, though some smaller ones were still in their frames.

"Damned looters," he said angrily. Horst came across and whistled, then saw another smaller box still in the jeep and pulled it out.

"Christ alive," he gasped. "Look at this."

Wolfgang leaned over. The smaller box was stacked with gold ornaments—vases, plates, saltcellars and small statuettes.

"You know what?" said Wolfgang at length. "This is probably part of the stuff we were guarding in the mountains. They can't have found this in deserted houses. What the hell are we going to do with it?"

"Wait," commanded Horst, turning toward him, the light catching a new and calculating expression on his young face. "These two boxes could hold more wealth than we shall earn in a lifetime, in ten lifetimes. That stuff we were guarding, it was the best. I heard it came from museums all over Europe. They called it the greatest art collection the world has ever seen. Hitler intended it for a new museum in Linz. If this is some of it, we're rich men once things settle down."

"And do we sell the dead Yanks too? We have to hide the corpses and get out of here. That's our first priority." Wolfgang looked again at the bodies and then at his friend.

"I have an idea," he said and began stripping off the dead driver's clothes, explaining as he did so. "You're about the same size. You dispose of the jeep; it's important that the farmer see it go. I'll explain our quitting."

"What about the gold?" demanded Horst.

"Leave it in the jeep for God's sake. Or do you want to give the farmer a farewell present?"

Reluctantly Horst put on the GI's blood-soaked clothes. They propped the dead officer in the passenger seat and roped him to it. The GI's corpse they threw in the back. Then they pushed open the other barn door and with much revving of the engine Horst reversed out and drove away down the farm track toward the nearest woods.

After stamping dust and straw over the bloodstains, Wolfgang walked down to the farmhouse and hammered on the kitchen door. The farmer's wife appeared. It was no problem to sound agitated.

"They took my comrade," he said. "It's not safe for me to stay."

"We heard them. We were coming to see what had happened. Here, come in a moment. You can't leave empty-handed." She bustled about agitatedly, finding an old rucksack and filling it with bread, cheese and dried meat. Then she shook hands fervently.

"*Grüss Gott,*" she said. "May God go with you."

"*Wiedersehn.* I enjoyed it here." He was careful not to say where he was going. Indeed he did not know if Horst would agree to the rest of his plan.

By the time he caught up with Horst in the woods it was evening. There were at most two hours of daylight left. Horst had put on his own trousers but not his shirt. "Never again," he muttered, swearing methodically. "I stink of death. We must find a stream to wash in."

"The sooner we move on the better."

"I have made one decision," said Horst, his voice hard, as though anticipating a fight. "I'm not leaving this loot for another damned Yank to steal."

"If we're caught with it, that could pin the killing on us."

Horst seized his arm. "Then we must bury the gold. Come back for it in a year or two."

Reluctantly Wolfgang assented, although his instinct was to leave some of the valuables with the jeep. That might just persuade the Americans to hush up the killings. Their posters had said they would respect private property.

"You can't bury the pictures," he suggested. "In any case they probably do belong to museums. Our own museums even. Leave them."

"You think the Yanks would give them back?" asked Horst sardonically. "Forget about our great national heritage, will you? It's *kaputt.* I've chosen a picture to keep." He showed Wolfgang a small painting of a Madonna on a wood panel without a frame, and then rewrapped it in a piece of cloth. "It's so small, I can tuck it away in a knapsack. It's like one I saw in a book at school. It could be worth something."

Wolfgang shrugged his shoulders and handed over the rucksack. "Put it with the food then. Now, let's go."

They found a stream, washed and afterward buried the box of gold and silver ornaments, using their bayonets to dig with.

"We ought to bury these too," said Wolfgang. "Especially if we are going to Berlin."

"Berlin? You mean toward the Russians? Have you gone mad? They shoot SS men on the spot."

Wolfgang had expected this reaction. The long and brutal campaign on the Russian front had left not only the SS but every soldier in the Wehrmacht with one clear idea about defeat—that at all costs one should surrender to the British or Americans, never to the Russians.

"We have to get clear of the Yanks. We live in Berlin. We have papers to prove we have been farmworkers. We shall be returning home from forced labor."

"So that's why you didn't want the gold! Those Russians would kill you for a gold ring."

"We are workers now and they will need workers," said Wolfgang implacably. "Someone has to build a new Germany. I've been thinking about it for weeks. If you don't want to come, I'll go alone. Neither owes the other anything. We're quits."

"No," said Horst abruptly. "We are brothers. Let's start walking."

Colonel Wolfgang Raeder sat in his office in the Stasi headquarters, holding Horst's letter and remembering. God in heaven how they had walked. For six weeks. Living off berries and vegetables stolen from fields, sleeping in hedgerows and haystacks, they had become indistinguishable from the thousands of other refugees clogging the roads of Germany that summer. They were stopped and questioned frequently. Sometimes it would be just a couple of jeeps parked across the road and a Yank sergeant, sometimes a more permanent checkpoint with a thorough examination of papers. From rumors they heard the Americans were particularly hunting for ex-SS men. But their farmworkers' identity cards were always accepted, and their time in the mountains and on the farm, the sun, wind and snow had given their faces a convincing tan. They looked like the *Landarbeiter* they were claiming to be,

and their hands were rough from the farmwork. Eventually they reached a big river and what amounted to a frontier post. At one end of the bridge the Stars and Stripes flew by some temporary huts; at the other were barricades and the red flag of the Soviet Union. The Americans waited until a small group of refugees had collected, then let them through to trudge across together, watching their reception by the Russians through binoculars.

It was being first in the group that saved them. The Russians were acutely suspicious of men of military age. An officer was summoned who spoke a few words of German. He seized their papers.

"*Landarbeiter,*" said Wolfgang, earnestly making digging motions with his hands. "*Landarbeiter.*"

"*Fascisti?*" the officer asked Horst, pointing at Wolfgang.

"*Nein, nein. Landarbeiter.*"

Suddenly a minor commotion farther back in the line claimed the officer's attention. He lost interest and waved them through. As they moved away they heard him putting the same question—"*Fascisti?*"—and then a querulous woman's voice denouncing someone. "*Ja, Ja.* Nazi!"

Barely ten minutes later they heard a volley of shots from the direction of the bridge. They quickened their steps, not daring to look back.

"The first thing we have to do when we get home, my friend," said Wolfgang, his face suddenly pale, "is join the Communist party."

That was over thirty years ago, Raeder reflected. But whereas he himself managed to become a policeman and determinedly adopted the politics of his bosses, Horst became progressively more morose. Horst was a natural entrepreneur, a man who liked to seize opportunities and exploit them. East Germany is a country where the only category of worker specifically excluded from health and social-security benefits is the self-employed, where you can only run a corner tobacconist's if you join a co-operative of several such

shops. In 1952 Horst decided to flee to the West while it was still possible, and, although their lives had grown apart, such was their old bond of comradeship that Wolfgang helped smuggle his personal possessions out. Now, out of the blue, that act had brought Horst's final bequest. He reread the relevant part of the letter.

". . . to an extent I deceived you at that time. I took also another painting I had acquired . . . appears to be by the Florentine painter Sandro Botticelli . . . although I bought it from a family near Potsdam there is no doubt it must have been looted . . . possible to dispose of such treasures safely under the Statute of Limitations."

Horst's command of language had improved with age, thought Wolfgang, even if his morals hadn't. What a hell of an inheritance! For all he knew this painting might be one of the great lost treasures from the National Gallery on the Museum Island. Nor did he relish showing this letter to the security branch. Two million East Germans might have chosen to go West, the idea of defecting one day might be at the back of every official's mind, but it would not make the inevitable interview with the brash young major in the political security section any more pleasant. Horst's letter implied that he, Wolfgang Raeder, a colonel in the Stasi, might have it in mind to defect. In fact he did not. He had long ago accepted that the frustrations and restraints of the Communist state were the price he had to pay for a comfortable life. Whether the major would choose to believe that was another question. Worse still, his long-forgotten service in the SS might be resurrected to condemn him. It would not be easy to explain the bond between him and Horst without mentioning it. All in all, he could find himself right back where he had been in the autumn of 1945: unemployed and desperately trying to convince people that as a teenager he did not even understand Nazism; he had simply done what he was told. What an inheritance!

The obvious solution was to destroy the letter and

forget about the painting. Wolfgang considered this, then realized that his clerk had undermined that possibility. Two courses of actions remained. He could defect, hoping to sell the picture in the West. Or he could retrieve it for the state and hope to gain sufficient kudos for his superiors to disregard the security aspect. After briefly considering these two alternatives, Wolfgang decided to call on his friend in the external branch, Colonel Marklin. He could trust Marklin. They were both men of the old school, not like the jumped-up university graduates the Stasi had been recruiting recently who thought of every problem in terms of either national or individual psychology. Marklin and he had worked together in the days when if the Stasi wanted something out of West Germany they went there and got it, regardless of political or physical risk. Nowadays the bosses wanted things handled more subtly, although the Stasi still ran many hundreds of agents across the border.

Fortunately Marklin was in. He waved Wolfgang to a chair. "Nice to see you. Coffee? Smoke? And what can I do for you today, Comrade Colonel?" Marklin's bonhomie was partly natural, partly professional. He had spent a period as a "diplomat" abroad, which had softened his approach to problems.

Wolfgang explained about the picture. He had no need to skirt around the embarrassment of his war service in the SS. Marklin knew about it anyway.

"May I see the letter?" demanded Marklin. He read it through, grunting to himself and tactfully not asking in what way Horst had been helped. "Well," he said finally, "there's nothing illegal about inheriting property from the West. Happens all the time."

"One requires a permit to go and collect it, though," observed Wolfgang, "and we are short of time. Horst died on July twenty-first. It is now October twenty-second. I must make my claim."

Marklin looked at him keenly. "Let me ask you one question, Comrade Colonel. Are you going to collect this inheritance and then defect?"

Wolfgang had expected this, in fact depended on his colleague to come straight to the point. He looked across the desk.

"No. I'm too well established here for that."

Marklin laughed. "Don't want to face the lines in capitalist shops, eh? I agree. You wouldn't find privileges in the West like those we have here."

"Exactly. And recovering this picture for the museums might earn me a few more. I don't put my chances of getting them through promotion very high."

Marklin rubbed his chin with the back of his hand briefly, then evidently came to a decision.

"I'd do the same in your shoes," he said. "But first let's find out if anyone knows about the Botticelli. After all, your dead friend was only guessing."

He picked up the telephone and demanded the Directorate of the Staatliche Museum. Then, holding his hand over the mouthpiece, he added to Wolfgang, "Give me that photograph again, will you? If this is as good as it sounds, they ought to be delighted."

The ensuing conversation was protracted. Wolfgang sat sipping his coffee and smoking impatiently. At last Marklin rang off.

"A curious story," he remarked, and Wolfgang could tell he was intrigued. "From the description this could well be a Botticelli which hung in the National Gallery on the Museum Island until late 1943, when it was removed on the order of Martin Bormann for the Führer's museum at Linz. It has not been seen since."

"So!" exclaimed Wolfgang. "It could be important."

"My informant at the Staatliche tells me our collections here in East Berlin do not include any Botticellis. By contrast there are seven in the Dahlem Museum, where so many works evacuated during the war are illegally held by the West Berlin authorities." Marklin smiled again. "In plain language, they'd give their eye teeth to have this one. Funny people, these curators." He reflected. "They seem to be as jealous as cats when another museum has something they haven't. Nothing would please them better than to see a major work re-

trieved from under the noses of the West German government."

"What do you advise, Comrade?" Wolfgang had served long enough in the Stasi to recognize the value of responsibilities being shared.

"I think, Comrade Colonel," replied Marklin, suddenly formal, "that you are right. There would be considerable acclaim for the recovery of this work. I am sure my major general would agree to sponsor a short trip to the West for you. As for the security section, we can probably persuade them to accept our judgment on the grounds of operational urgency. After all, you have shown the letter to us."

"I'll leave today," said Wolfgang, "and go straight to see the widow in Frankfurt."

"Let the Staatliche brief you first. They don't want you bringing back a fake."

This possibility had not occurred to Wolfgang. "Give me the name," he said.

Marklin scribbled it down on a slip of paper and handed it over. "There is one other thing, Comrade Colonel. Please do not fail. And for God's sake be discreet. Detente has made our operations much more sensitive than they were. You and I may not like the psychological approach, but we have to live with it, and I don't want to find myself doing traffic duty in the Karl Marx Platz after thirty years."

It was a joke, but Marklin was not smiling.

chapter 3

Charles Luttrell stood with Samantha by his side in the late-morning sunshine surveying the Romerberg, the old town center of Frankfurt. This was where the German art dealer Herbstein had his gallery, and Charles wanted to get the feel of its surroundings before going in. He glanced briefly at the great brownstone cathedral, which had miraculously survived the bombing,

and at the newly created walkways in front of it. The whole area was barred to traffic.

"It's an odd mixture," commented Samantha, "all that concrete next to old houses that they've obviously restored, and the little church looking like a stranded ship."

Charles nodded. The St. Nicholas Church, with tiny dormer windows in its steeply pitched tiled roof, did seem uncomfortably isolated in the pedestrian mall around it. But his eyes were on a shop beyond, where elegant gold lettering across the plate-glass window proclaimed "HERBSTEIN KUNSTHANDLUNG." A group of tourists wandered past it, clutching cameras, but did not stop.

"Not exactly Bond Street or Fifth Avenue," said Charles, "though there's plenty of money around, I imagine." He gazed across at the shop. "Let's hope we're not wasting our time."

"I'm cold," said Samantha abruptly. "Catching early flights must be bad for the circulation. Please let's either tackle the monster or go and get a coffee."

Charles murmured an apology and led her across to the shop, pausing outside to examine the paintings in the window. One was a watercolor of a lake with mountains and a castle. A discreet sign announced "ARTISTS OF THE RHINELAND."

"Just what I expected," he said. "Nice romantic landscapes for kraut businessmen to hang in their parlors. Can this man really have laid his hands on a Botticelli and a Memling?"

"We may discover if we go in," said Samantha pointedly. She was not pleased with this expedition so far. They could have arrived the evening before and had a night out on the liberal expenses Charles normally allowed himself, instead of making a hurried day trip. Irritated and impatient, she pushed open the glass door and entered.

The gallery was narrow and not very long. Paintings and prints hung on both sides, while a table bore catalogues of recent exhibitions at the Stadel and other

museums, together with a leatherbound visitors' book.
A door in the far wall was ajar, and they could hear
the clacking of a typewriter from beyond it. The door
swung open and a slightly plump middle-aged man ap-
peared.

"Ah, Herr Luttrell, no?" he said. He spoke in a
thick accent.

"Herr Herbstein?" queried Charles.

"*Ja, ja. Natürlich.* I am pleased to welcome you.
And Frau Luttrell." He stepped forward and bowed
conventionally to kiss Samantha's hand.

"Fräulein Walker," she said with emphasis, glancing
sideways at Charles as her fingers were raised to within
the regulation inch of Herbstein's lips and then re-
leased. Charles half smiled. "Unfortunately my wife
could not come," he explained. "Miss Walker is my as-
sistant."

"Ah, so." Herbstein straightened up, a suspicion of
regret on his fleshy face, as though he had expended
civility unnecessarily. He turned to Charles and shook
hands. "It is good of you to come quickly. There will
be great interest in the works I have for offer."

"We even came straight from the airport," remarked
Samantha.

"You would like to wash?"

"No, but I would like some coffee."

"Of course, of course. And a cognac against the
cold."

Herbstein darted back to the office behind the gal-
lery, and they heard the typing stop as he rattled off in-
structions to the unseen secretary.

"Funny little man," whispered Charles. "One mo-
ment practically telling us he has other buyers lined up
and the next scuttling out for coffee. He seemed disap-
pointed that you were not my wife."

Before she could reply, Herbstein reappeared.

"Five minutes," he said. "Would you like to see the
paintings straightaway or after?"

"I think straightaway," replied Charles unexcitedly.
"Why not?" He spoke as if it was of little concern to

him, and Samantha thought how extraordinarily cool he was as a crucial moment approached. He could be foul over trivialities, such as a mistyped letter. Yet in bidding at an auction he would be totally calm. She had seen him in action many times and was always fascinated.

"The paintings are in another room," said Herbstein. "Come with me, please."

He led them through the office, where a woman of about forty was busy with a coffeepot, and into a tiny gallery hung with red damask. He snapped a switch and spotlights flooded on.

"For special clients," explained Herbstein.

Charles did not bother to reply. He was completely absorbed by the large painting facing him, encased in a heavy gilt frame and dramatically set off by the dull-red wall hanging.

"That is something," said Samantha amazedly. "That really is."

In the painting a Madonna sat holding her Child on her lap, surrounded by a group of eight angels, one of whom held a Bible, while the other seven bore tall white lilies. The interplay of the figures, in gold-embroidered costumes, counterpointed the serene posture of the Virgin, while the fluid lines of the whole composition were further set off by the simple background of pale-blue sky with a golden radiance above the Virgin. But what was most striking was the limpid serenity of the Virgin's face, both tranquil and ecstatic at the same time.

"She is marvelous," breathed Samantha. "So many of Botticelli's women look completely goo-goo, whether they're Madonnas or Venuses. But she's beautiful. She's sensual and pure all in one."

Herbstein watched her, smirking.

Charles made no comment. If it was a fake it was the most brilliant he had ever seen and, if not, well, none of Botticelli's followers achieved this quality. It was a masterpiece in the truest sense of the word. Almost mechanically he ticked off some obvious points in

his mind, such as the slight tinge of green beneath the flesh tones where the lower pigment now showed through, because the Florentine masters reproduced the subtle coloring of faces and hands with layer upon layer of semitranslucent paint. He noted the steeply sloping shoulders of the Madonna: Botticelli gave his women a silhouette so graceful as to be completely unreal, if you thought about it anatomically. He moved around to the side of the picture so that he could examine its surface and see whether it was much damaged and touched up. It certainly had been worked on in a few places. With the light on them sideways the spots of repaired damage were immediately visible. There were the tiny cracks in the paint that he expected—the craquelure—and also a crack in the panel itself. Briefly he examined the back. At first sight the joined wooden panels the artist had used appeared genuine, though they had been reinforced with a grid of newer struts, indicating that the owner had called in an expert restorer to "cradle" it when the crack developed.

Even as he made these and other checks Charles knew they were all but irrelevant. There was no two ways about it. This painting was indisputably "right." All his experience and instinct told him it was genuine and extremely valuable. He felt the prickling of excitement deep in his stomach which he always experienced when a big deal was materializing. The game now was to beat Herbstein down. The less money Luttrell's actually had to raise, the better. He turned to the German.

"Very nice," he said disparagingly. "How did you find it?" Did the direct question embarrass the dealer? Charles thought he saw a flicker of apprehension in the man's eyes. He waited for an answer.

Herbstein smiled, though his lips barely parted. He obviously took the question as a compliment.

"Perseverance," he said in a self-satisfied voice. "For many years I have been adviser to one of our industrialists. He has made a fine collection. Now all at once

he is afraid. So, naturally, he turns to someone he trusts."

"Afraid? I don't understand."

"Thefts, kidnappings, ransoms. His collection is private. Completely private. Only his friends know. Still he is afraid it will make him—what do you say?—a . . . target. Was not your Sir Alfred Beit attacked in Ireland?"

"True, though he wasn't badly hurt and his collection was recovered."

"It is different here. Here the terrorists kill for much less than the value of such a work." Herbstein gestured to the Botticelli, magnificent against the damask. "Oh, I know what you are thinking. How do they market such a priceless possession? That does not enter their head. They kill first and worry afterwards!"

Charles nodded. It was all plausible enough, although some art thieves were becoming more professional, like the raiders of Italian churches, who had an organized sales route out through Switzerland. Yet would anyone steal this? God in heaven, he thought suddenly, I would—once I'd seen it in the flesh. But if I hadn't, then I'd react exactly as I did in London and not be much interested in what was apparently a copy of another picture in a famous museum.

"Valuable perhaps," he observed cautiously, judging the moment ripe to savage the German's self-confidence. "I would certainly not say priceless. As School paintings go, yes, it's valuable. But it can only be a follower's version of the one in Berlin-Dahlem." This was a major denigration of the picture. A work by a follower or by "the school of the master" would be far less worthwhile than one executed in Botticelli's studio under his supervision and possibly in places by him, which would make it "part autograph."

Herbstein spread out his hands in a gesture that indicated the bargaining had begun.

"Naturally if we are going to buy in partnership we do not wish to overvalue," he said smoothly. "But as

far as we are concerned it is authenticated as a Botticelli."

"Nonetheless the Staatliche in Berlin catalogue theirs as by Botticelli." Charles caught Samantha's eye and nearly gave himself away. She had done some further research, which established also that Berenson considered the "Madonna and Child with Singing Angels" in Berlin to be a studio version. So there was a conflict of expert opinion, which had considerable implications. Conceivably the picture they were now gazing at was a lost original. Was Herbstein aware of such a possibility, and, more important, what was he advising his client to believe? "School of," "Studio of," "attributed to" or "autograph"?

"The Waldhofens," remarked Herbstein doggedly, "were discerning collectors. It was in their possession for at least a century."

"Who were they?" asked Samantha before Charles could stop her. Sure enough Herbstein stormed into the breach.

"My dear Fräulein," he said with reproving condescension, "the Waldhofens were famous Austrian nobility. Their collection was dispersed in the early nineteen-twenties."

"That's quite right," Charles admitted, forced to concede a tactical defeat. His own acquaintance with the Almanac de Gotha was almost as extensive as his friendships with English families out of Debrett. The great collectors of the sixteenth to nineteenth centuries had been the nobles of Europe. They had taken over from the Church as patrons and now, hag-ridden by taxation and socialism, were yielding in their turn to museums and Americans. "Waldhofen was a prince of the Austro-Hungarian Empire, a contemporary of Metternich. The family lost almost everything when the empire collapsed in the 1914–18 war." A fragment of half-forgotten gossip came back to him. "Something to do with the closure of the frontier between Hungary and Austria. Their investments were all on the wrong side."

"How do you do it?" asked Samantha amazed. "How do you always know?"

Charles shrugged his shoulders disparagingly, his annoyance unmollified. "I'm sure Mr. Herbstein doesn't need to be reminded of how important it is to know which families are hard up and want to sell heirlooms." He turned to Herbstein. "How did the Waldhofen catalogue list this picture?"

Again embarrassment showed in Herbstein's eyes, so brief Charles almost missed it. "As a Botticelli, naturally."

"Who authenticated it?"

This time the German hesitated noticeably. "Regrettably the authentication does not seem to have been sold with the painting in 1923."

"Far more likely that it never was authenticated. How could it be when the original was in Berlin?"

Herbstein flushed with annoyance. "My dear Herr Luttrell, I would not offer a man as distinguished as yourself a share in acquiring a painting in which I did not believe."

"Well, I don't rate it better than School of Botticelli. You can tell your client . . ."

A timid knock on the half-open door interrupted him.

"*Kaffee, mein Herr,*" said the secretary's voice.

"*Ja, ja. Moment.*" Herbstein swung around again to face his visitors. "But I have not yet shown you the Memling." He moved and pressed a switch. Slowly the damask hangings in the side wall parted and drew back to reveal a shallow alcove with a small, black-framed Madonna hanging in it. Charles chuckled in spite of himself. That was a nice trick, keeping the second picture hidden so that it did not detract from consideration of the first and then dramatically revealing it. He felt a twinge of reluctant respect for this dealer's salesmanship.

"Very neat," said Samantha approvingly. She scrutinized the picture for half a minute, then stepped back.

"It's the one in Friedlander, all right, though it's not in very good condition, is it?"

"May I see?" said Charles, taking his turn. She was right. There were extensive cracks, and the surface of the paint was worn by careless handling over the centuries. Nonetheless, it had the minutely finished detail characteristics of Memling. Even the tassels on the red cushions beneath the Virgin's feet were scrupulously observed, each strand so delicate that one could think it real.

"Those Flemings may have been well paid," he commented, "but by God they earned it."

"It is very beautifully done," remarked Herbstein sententiously.

"What made you think it was a van der Weyden?" asked Charles suddenly. This was the question that puzzled him more than anything. The smug satisfaction vanished from Herbstein's expression.

"The Flemish art is not, what you call it, my field. It is not my specialty. The two painters have much in common, yes? My client has always believed it was of van der Weyden. I only discovered when I asked the Stadel for an opinion."

Charles reflected on this briefly. If the man was an expert solely on nineteenth-century German painters, he could be excused such a lapse, but in that case who on earth would employ him to dispose of such important works? "Forgive my asking, how did you become adviser to this client?"

Herbstein smiled thinly. "Let us take coffee and I will tell you." He opened the door and extended a pudgy hand toward Samantha. "Please." She walked through into the office, Charles following, and they sat down at a table in the corner. There was a soft click as Herbstein locked the door behind him, and a moment later he was fussing around pouring them small glasses of brandy.

"*Prosit!* Or, as you say, bottoms up!" He drained his in a gulp, not noticing Charles wince at the vulgar expression. "So, let me tell you. Originally this client was

interested in art only as investment. Quite soon after the war he realized there were fantastic opportunities. Many noble families had been ruined and had to sell their possessions. He had started a construction business . . . well, you can imagine."

Herbstein spread his hands in his favorite gesture. "What did we Germans do with Marshall Plan aid after the war? Reconstruct, of course. He became rich. The Botticelli Madonna he bought in, I think, 1948. The owner had not made a correct assessment of the economic opportunities." Herbstein laughed unpleasantly.

"Who is your client?"

"His name is Schneider. Later he became interested in German artists and visited my gallery. That is how we became friends."

"I'd like to meet him."

"Impossible." Herbstein blinked. "I told you, he is now a frightened man. I am empowered to find him a buyer and his name is to be kept out of any publicity."

"Have you documents proving the pictures' ownership?" demanded Samantha.

Herbstein glowered at her, as though she had said something indecent, shuffled through a folder and handed over three bills. The oldest was a slightly creased piece of thick antique woven paper headed GREGORIAN KUNSTHANDLUNG MÜNCHEN. Under the word *Rechnung* it stated in German " 'Madonna and Child with Angels,' attributed to Sandro Botticelli. Tempera on wood panel. Diameter 143 cm. Ex-collection Waldhofen." Further down the price was given as two thousand marks. The date was September 24, 1923.

"What about the Memling?" asked Samantha.

"There I am afraid we have only a 1946 document. What a price he paid! Laughable. One thousand marks. Chicken feed. Today it should fetch four hundred thousand at least."

This time Samantha glanced at Charles for guidance. She was about to mention the Memling coming from

the Renders Collection, but he motioned her with his hand to keep quiet while he made a quick mental calculation. "Roughly a hundred thousand pounds or two hundred thousand dollars, give or take a few points."

"Personally I think such a figure is conservative."

Charles took a quick gulp of brandy. This was the first hurdle, as old Luttrell, his father-in-law, would have said, and while Herbstein had been talking he had planned his run up to it. Furthermore, giving priority to the Memling would reinforce his apparent disdain for the Botticelli. He put down the glass and leaned across the table confidentially.

"Frankly, a receipt dated 1946 is not satisfactory documentation for a late-fifteenth-century painting. Not when it belonged to the Renders Collection in Bruges and was lost during the war. Are you quite sure there are no claims on it?"

"I have made a check with the Innenministerium in Wiesbaden. It is not on the list of works prohibited to be exported."

"On their list as a van der Weyden?" asked Charles softly.

The German flushed again. "I shall check on Monday. In any case, may I remind you we have a Statute of Limitations in the Bundesrepublik. Even in the worst situation, if it had been stolen, it cannot be claimed back after thirty years. We are past that time limit."

"Not in London. We have no such statute."

"But why should it be stolen?" Herbstein was becoming angry. "In 1946 thousands of officer prisoners of war were released by the Americans and British. They found themselves with no jobs. They sold possessions to eat."

"I daresay," observed Charles coldly. His stratagem was succeeding and this was the moment to be tough. "How much does your client want?"

"He would accept one hundred and fifty thousand dollars."

"And for the Botticelli?"

"Perhaps three quarters of a million."

Charles rose to his feet. "My advice is to auction them. Good day, Mr. Herbstein. Come on, Samantha. We might catch an earlier plane."

The tactic succeeded. Herbstein bounded up with surprising agility and interposed himself between Charles and the way out.

"Please," he insisted, "you do not understand. I am under an obligation to deal fairly with my client. Even though you and I buy together and later divide the profit, I must be honest with him. He is also my friend."

Charles made a show of hesitation, though he remained on his feet. "I appreciate that you have a moral obligation," he said. It was nonsense, of course. Herbstein was the kind who would put his grandmother on the streets.

"All the same"— the German made his now familiar gesture—"my client is anxious to sell." He emitted a tiny laugh. "Every picture has its price."

"And those are ludicrous," declared Charles trenchantly. "An authenticated Botticelli could make a million, maybe more, in which case we could perhaps buy at three quarters; a studio work if it was first class could touch a third. That one of the 'Wedding Feast' went for one hundred and five thousand pounds at Christie's in 1967, and we all thought it was as much studio work as autograph."

"The price would be double now," insisted Herbstein.

"All right. Four hundred thousand dollars. But this one's unrecorded and more likely to be by a follower." Charles deliberately gave a little ground, as he did not want to kill the negotiation. "I admit it's exceptionally good."

"So," demanded Herbstein, suddenly decisive. "What do you offer?"

"We. I say we, assuming I am involved, could suggest two hundred thousand dollars between us. The most I am prepared to risk is two hundred and fifty

thousand dollars jointly, plus at the outside eighty thousand for the Memling. Subject to proof of ownership and provenance. Luttrell's has a reputation to maintain."

"That is absurd. It's far too little."

"He's your client," retorted Charles brutally. "Think about it." He consulted his watch. "We'll take a walk, have a quick lunch and telephone you at about three o'clock. Will you be here then?"

"I keep open Saturday afternoon," replied Herbstein unhappily. "I shall wait for you."

Charles led Samantha out, waving *auf Wiedersehn* to the middle-aged secretary, who had been tactfully busying herself in the main gallery.

"I need a drink after that," he said as they emerged onto the Romerberg. "What do you think of Mr. Herbstein?"

"I don't. I mean he's a creep. How ever did he get hold of two such glorious pictures?"

"Don't worry. We'll relieve him of them. But we will have to find out more of where they came from. Now, let's escape from this wind." Charles took her arm and guided her into an old-fashioned restaurant by the St. Nicholas Church.

Karin Schumann had taken the Prinz Eugen express from Vienna because it was cheaper than the airline and Frankfurt's main railway station, the Hauptbahnhof, was just across the river from the Stadel. She was following Herr Kameier's demands for frugality seriously, though leaving soon after dawn meant paying for both breakfast and lunch on the train.

The long journey gave her time to reflect. Inevitably she thought about her godfather, who had lost most of his possessions during the war, yet had spent more than he could afford on bringing her up. His passion for the arts had educated her more deeply than schools ever could. The losses he had borne inspired her own crusade to recover looted paintings, like the Botticelli, even though there was no family left to whom it could

be returned. She sighed to herself. At least to recover it for the Kunsthistorisches would fulfill the family's wish. The whole idea of the loan had been to save it from Nazi confiscation.

After the stop at Salzburg, Karin watched the mountains slip away with impatience. She made matters worse by starting to read a book by Thomas Hoving on collecting for the Metropolitan Museum called *The Chase, the Capture*. Finally she went to the dining car. It was a relief when the express ground into Frankfurt exactly on time at 2:13 and the lanky, tousle-haired figure of Gerhard was waiting on the platform.

"Let's go straight to the dealer." Karin could not suppress her energy and excitement. "Is it far?"

"Five minutes—and another fifteen to find parking space! Saturdays are no better than other days." Gerhard hesitated. "I haven't told him we're coming."

"So much the better. Let's go."

Negotiating Frankfurt's traffic took more than five minutes, but Gerhard was lucky with a meter, so it was not yet three when he pushed open the glass door of the gallery on the Romerberg.

A solitary couple was going around the exhibits, holding hands and occasionally giggling. Herbstein himself was standing by the office door, making a poor pretense of taking his visitors seriously. Karin, tall and elegant in a suede leather coat with fur collar and cuffs, looked more like business. He stepped forward, smiling ingratiatingly and bowing perfunctorily to greet her. Then he recognized Gerhard entering behind her and his expression immediately became both more obseqious and more wary.

"May I present Fräulein Schumann from the Kunsthistorisches in Vienna," said Gerhard formally.

"A pleasure." Herbstein bowed properly and kissed Karin's gloved hand. "And to see you again, Herr Balck. How can I assist you?"

"The Fräulein chanced to be in our city and I mentioned your recent acquisitions. She insisted on seeing them."

"Ah so!" declared Herbstein, glancing swiftly at the loving couple to check what they were up to and then gesturing expansively to the paintings on show. "There I had real luck. This little exhibition"——he displayed the palms of his hands self-deprecatingly——"this collection, if I may call it that, would not have been possible otherwise. The artists of the Rhineland are much in demand nowadays, much in demand, especially those of the earlier nineteenth century. Take this by Adolf Hoeffler." He pointed to a landscape in oils. "A magnificent composition. Reminiscent of the great Claude Lorrain, is it not? Its calm, its quietness! And did you see the little Caspar Friedrich in the window? Oh, I was extremely fortunate to find that! The spirit of Schubert in a painting!" Speaking his native language, he achieved a fluent blend of old-fashioned phrases and pseudoscholarship that impressed local clients. It did not impress Karin.

"Surely Caspar David Friedrich worked in Dresden?" she said bluntly. "In any case, it is the Madonnas that I came to see."

"The Memling you brought to the Stadel," interjected Gerhard gently. "And I had the impression there was another. You talked of seven paintings in total."

Charles Luttrell's remarks had made Herbstein ponder the origin of the Memling. Could it rightfully belong in Vienna? Inwardly he cursed himself for having wanted to impress this expert from the city's museum. But he was accomplished enough to react with barely a pause.

"What a pity you did not give me warning, Herr Balck. The Memling was sent only this morning for inspection by a client."

"Just our luck!" Gerhard turned to Karin. "That's really too bad, isn't it?"

"Is there nothing else?" demanded Karin.

Herbstein hesitated fractionally, thoughts racing through his mind of a sale without Luttrell's participation. It might be safer to sell in Britain or America, but it would cost him half the profit. And he felt badly

in need of a second opinion on the Botticelli's value. His own purchase of it had been legitimate, and the immediate postwar receipt found attached to it appeared genuine.

"Come, come," urged Gerhard. "Last week I gave you an authentication for nothing. The least you can do is show us what else you have."

"There is one other. Whether it's by the master himself or his studio, I do not know. That is why I am hesitant. You may see it if you wish."

He led them through to the inner display room and switched on the spotlight. It took all Karin's self-control not to exclaim out loud, so intense was the impact of the Madonna on her. She remembered her godfather's phrase about the spiritual quality that Botticelli only rarely achieved. This had to be the Waldhofen picture. It fitted the description. Yes, eight angels, one holding a Bible, just like the Berlin one.

"You like it?" asked Herbstein nervously.

Karin remembered the book she had been reading on the train. The author, Thomas Hoving, had been director of the Metropolitan Museum in New York and famous for his acquisitions. When you want something badly, he had advised, don't express too much interest. When he was hoping to be allowed to bid more than five and a half million dollars for Velasquez's portrait of Juan de Pareja, he had let himself be overheard criticizing it.

She examined the picture closely for a minute, then stepped back. "I should say the faces and hands are by Botticelli himself and the rest by his pupils. As much a studio picture as one by the master himself. Of course, I will tell my curator about it, although I doubt . . ." She let the sentence die away. "But I know he would like to see the Memling." Gerhard stood tactfully silent. Herbstein's face showed bleak disappointment.

There was a knock on the door and the secretary called out, *"Telefon, mein Herr."*

Herbstein excused himself, carefully closing the door

behind him. Immediately Gerhard produced a miniature camera from his pocket.

"What a break!" he whispered and hastily began photographing the picture.

Outside in the office a disconsolate Herbstein picked up the call from Charles Luttrell.

"I have contacted my client and with reluctance he accepts the figures you suggested: two hundred and fifty thousand dollars for the Botticelli and eighty thousand for the Memling. But at such low prices he allows only one week for payment, otherwise I must return the paintings." Herbstein paused, hoping the threat would not be regarded as the bluff it was. Karin's remarks a few minutes ago, unhappily confirming Luttrell's opinion, had frightened him. Whatever subsequent sale did or did not take place, at least he was still the winner by the difference between Luttrell's half shares and the measly thousand marks he had actually paid Schneider's nephew for both pictures.

"If you insist." Charles's plummy, upper-class English voice sounded even deeper on the telephone. "I will make the bank transfer next Friday afternoon."

"Good. Then may I make one suggestion? Your assistant should stay in Frankfurt until Monday. On that morning I shall collect the export licenses. The pictures will be packed and she can then fly with them to London. Is that in order?"

Luttrell agreed and asked for the names of hotels.

"The Frankfurter Hof is the best, or the Intercontinental. They are both close to here. . . . The Interconti—? Good. If anything should arise I will contact her there. Thank you, Herr Luttrell. *Auf Wiedersehen.*"

In the seven minutes of Herbstein's absence Gerhard photographed not only the front of the Botticelli, but he also got Karin to hold it so he could snap the back, with its latticework cradle of wooden supports.

"I never dreamt you were so practical!" she exclaimed.

He grinned, suddenly as pleased as a schoolboy who

has successfully played hooky. "You're onto
stakes with this one. Get your Vienna restorers to
a look at the way the cradle is made. Different crafts-
men tackle the support of a panel in different ways.
Someone might recognize the technique."

When Herbstein came back Karin made a polite
show of thanking him and, mindful of her bosses'
willingness to be interested in the Memling, asked
again when it could be seen.

"This particular client likes to live with a picture be-
fore he decides. It could be a month before it comes
back. You understand that when such a treasure is on
approval one cannot ask for it back to show other po-
tential buyers."

After this evasive rebuff they left to find Gerhard's
car and drive across the river to the Stadel.

"Do you think that's definitely the one?" he asked.

"It fits the descriptions."

"Has anyone proof of ownership?"

"The Kunsthistorisches has the Nazi order transfer-
ring it to Berlin. Of course it was on loan. We are not
the true owners. Maybe we could claim it on behalf of
them."

Gerhard fell silent for the rest of the short trip to the
Stadel, an impressive stone building looking across the
River Main to the skyscraper blocks of the business
center. He took Karin in by the side entrance to the
staff offices, unlocked his own room and picked up a
folder off the table.

"These are the basic laws governing stolen property.
It's a hell of a subject, even for an attorney. The best
thing would be to stay until Monday and then take ad-
vice. If there's any kind of a case we can then go to the
Innenministerium or the police."

"Is there nothing we can do over the weekend?"

Gerhard smiled. "Only make you welcome. And if
it's any encouragement, I can show you the Cranach
Venus which was recovered from a luggage locker in
the Hauptbahnhof after an anonymous phone call to a
newspaper. It was missing since just after the war. We

also lost twenty-five paintings looted by an American colonel from a storage bunker."

"You're joking. You knew who he was?"

"Absolutely. But neither we nor the Yank authorities ever found him. We know where most of the paintings are, too: with collectors in France, Holland, America. It's not so easy to get them back, though. We recovered a Rubens in 1960 and also an early Liebermann. They were both well known as having been here before the war."

Karin sighed. "That does make a difference, doesn't it? The Botticelli was in the Kunsthistorisches such a short time, though it was catalogued. I'm amazed Herbstein showed it to us."

"I've been wondering about that," replied Gerhard thoughtfully, "and it puzzles me. Everything he's said suggests that he obtained the Memling, the Caspar David Friedrich and the Botticelli from the same source. Maybe he's selling them on commission. But no one in their senses would take such good stuff to him. There's something wrong, and I don't think he suspects the Madonna could be stolen. He's in for a very unpleasant surprise on Monday."

When Charles Luttrell returned to his table in the restaurant only one shadow spoiled his delight at clinching the deal with Herbstein—namely, explaining what it entailed to Samantha. She looked up expectantly from her coffee as he sat down.

"He gave way," said Charles. "Very sensible of him, too. He wouldn't begin to know how to sell those two Madonnas."

"Congratulations, darling. I was afraid you might have been too tough this morning." Nonetheless the steel beneath Charles's suave exterior excited her.

"No point in playing the gentleman there, sweetheart." He allowed himself the endearment, as they were alone. He felt it was bad form to acknowledge his love affair publicly, and in the gallery he was likely

to be more abrupt with Samantha than with other employees.

"Now," he went on practically, "all we have to do is air-freight the pictures back and find a buyer."

"So we can finish our coffee and leave? At least leave Frankfurt. Mission accomplished. I can't say I'll be sorry. But couldn't we go to Würzburg for the night or out to Heidelberg? Go somewhere nice and pretty, enjoy ourselves a little and fly back tomorrow?"

Charles reached out and held her hand across the tablecloth.

"There is one snag. Well, two snags." He sighed heavily. "This deal is make or break for us. Herbstein can't obtain the export permit until Monday morning, though he swears it's a pure formality. All he needs is a couple of signatures. However . . ." Charles paused to emphasize his argument. "Once he has got them we'll need those pictures in Bond Street double quick."

"I might have guessed," she said. "You want me to stay and bring them back while you slide off home." His expression told her what he was going to say next. She suspected him of yielding to pressure from his wife and was bitterly resentful. Somehow spending two or three nights a week together made their rare weekends even more desirable than if she saw him less. She had assumed his telling everyone that they were taking a day trip was purely for Lucy's benefit, and he would find an excuse for remaining.

"No, no." Charles protested. "You haven't understood. If we're to pay Herbstein by Friday we need to move damned fast. There's one natural buyer for the Botticelli: Tom Hanson with his Westhampton Museum in Massachusetts. If I fly to see him, he'll believe us." Charles paused, hoping he had mollified her. "My love, there's nothing I'd rather do than spend this weekend with you. It was what I'd planned. But now I must catch the next plane to New York. Straight from here."

"Charles Luttrell," said Samantha very deliberately, "you're a bastard. Bringing me here and then ditching

me." She eyed him angrily. "Why don't you take me to New York with you, then? We can afford it with this deal going through. I can fly back Sunday night. You can't just dump me for thirty-six hours in this dreadful city."

"Hanson is something of a puritan, literally. Church on Sundays and grace before meals. He's a very decent and understanding fellow, but he would not approve of my bringing a girl friend."

"Are you ditching me, Charles? Is that what you're really doing? Not just for the weekend, I mean? You don't have to stay with Hanson. There must be hotels in Westhampton." She leaned forward, earnest and appealingly, her anger suppressed by sudden fear. "Don't fob me off, please. Give me a straight answer. I want to know."

"No, darling, I'm not." He held her hand across the table. In his heart he wasn't so sure. If Luttrell's did go into liquidation he would far rather be in the comfortable Wiltshire manor house with a middle-aged wife whom he had ceased to love than camping in a rented London flat with a mistress, however young and pretty.

"I see," retorted Samantha, regaining confidence. "It's just that you're putting business first as usual. We can make love any old time."

"Samantha, darling, you're the only person I can trust. You bring the paintings back while I'm selling the Botticelli and we'll be pulling off the coup of the decade." He smiled, seeing her softening. "I promise you a full-scale celebration then. Meanwhile, try and make the best of it. Have some decent meals on the house. Here." He slipped out his wallet and handed her a sheaf of notes. "I'll take care of your bill at the Intercontinental with a credit card."

"And a car." She was only partially mollified. "I ought at least to be allowed to escape from this city tomorrow, even if I have to go alone."

"And a car," he agreed. "Thank you very much, my love."

"You're still a bastard," said Samantha. "Even if an attractive one."

"If you could bring me this Botticelli, Colonel, I would be overjoyed." The director of the Bode Museum in East Berlin spoke earnestly, his thick spectacles emphasizing his seriousness. "Over there in Dahlem they have seven Botticellis. We have not a single example of the master's work. We have some Florentine paintings, of course. There's the Uccello I showed you. But our collection is only a shadow of what it was before 1945."

Wolfgang Raeder looked out of the window. Through it he could see a section of wall, its stucco covering badly cracked, and below the dark oily water of the river Spree. From the look of the place the Bode Museum was short of funds.

"Can we ever buy things back?" he asked.

"I believe some manuscripts have been purchased at auction. But the things that matter, like the Rembrandt of the 'Knight in the Golden Helmet,' they are likely to remain in Dahlem. The Bundesrepublik would never let them go." The director shook his head sadly. "What angers me is that it's not one picture. It's many hundreds. They were all here on the Museum Island before the bombing forced us to store them in bunkers. By the accident of the way Berlin was divided, some of the most famous ended up with French, British or Americans. Then four hundred and seventeen of the ones we had got were lost in the fire. Our city has had appalling luck."

"So this Botticelli is worth taking risks for?" demanded Raeder.

The director nodded. "Definitely."

"I'm not after money, you understand. Equally I don't want to waste my time."

The director looked at Raeder, suddenly feeling the potential importance of this conversation and weighing his words pompously. "If you could bring me this Botticelli, Colonel, the Berlin Museums and the Ministry

of Culture would recognize your efforts. I can guarantee you that." He handed a thick envelope across the desk. "I have prepared some documentation for you."

"Thank you." Raeder rose to his feet.

"Exact as the records are, I still advise you to spend an hour in Dahlem. Study an actual Botticelli. Try to get the feel of the work. It would be a pity if someone passed off a fake on you."

"It would be a pity for them," said Raeder harshly.

Raeder walked down the broad stone staircase, nodded to the woman at the ticket counter in the circular entrance hall and strode out. It was only a few minutes' walk to the station. He stopped on the Monbijou Bridge and looked back at the line of museums along the river. Tourist buses from West Berlin were unloading outside the Pergamum building. Beyond rose the huge ruin of the classical Neues Museum, called new but already a century old when bombing gutted it. Saplings had seeded in its fire-blackened porticoes, and shrubs were enveloping its walls, as though it were some ancient temple being taken by the jungle. Yet this was the center of the one of the great cities of the world. Raeder felt sudden resentment at the price his country was still paying for the war, though whether in his heart he blamed the Americans or the Russians most it would have been hard to say. He turned and walked on.

Ten minutes later Raeder was passing through the police checks at the Friedrichstrasse S-Bahn station. One of the curiosities of Berlin is that the elevated railway—the S Bahn—passes from West to East and back. On the western side there are no controls. The East is different. Raeder carried only a briefcase containing a toilet kit and clean shirt. For an ordinary citizen to take more would invite trouble, and from this moment onward Raeder was becoming one.

There was a line of some twenty people at the checkpoint. An old woman in front of Raeder cracked a joke about Saturday shopping when the policeman behind the grille questioned her. He laughed and let her

through. We're not so inhuman, thought Raeder. Then it was his turn. He showed a West Berlin identity card at the grille. The *Personalausweiss* is colored green and constitutes a tiny folder, inside which the holder's photograph is secured by a metal eyelet. It is stamped in mauve ink with the bear which is the symbol of West Berlin, to whose citizens it gives remarkable privileges. It is valid as a passport throughout Western Europe, a symbol of the city's special status, giving a freedom of movement unattainable with any East German papers. The Stasi's many operatives in West Berlin had little trouble obtaining them. The only unusual feature of the doctored document Raeder carried was that it bore his real name. It had to if he was going to be claiming an inheritance.

The policeman was young and fair-haired. His light-gray shirt had silver shoulder boards with three gold stars on them. His eyes flicked from Raeder's identity photo to his face and back several times. After a final hard stare he released the gate. Raeder said nothing, just moved through and went upstairs to the platforms to wait for a train. There were many ways of passing into the West if you were on a mission for the Stasi. This was the simplest, now that West Germans had fairly free access to relatives in the East.

As the train rattled its way above the city Raeder gazed down at the almost deserted streets. This part of East Berlin was too close to the wall to be attractive, except to Western tourists, who came through Checkpoint Charlie to gape, small groups of American college girls always prominent among them. Then a swath of open ground cut through the housing came into sight. Wire fences, watchtowers manned by graygreen-uniformed police, a broad empty strip which all Berliners knew was sown with mines and finally the wall itself, a dull gray surmounted by a round concrete coping like a drainage pipe. From above, its ten-foot height did not look so much of an obstacle. But Raeder knew how the would-be escapee's hands slipped on it. He smiled to himself.

The western side was even more desolate, a waste-
land of ruins and unreclaimed bomb sites. He saw a
rabbit scampering through the grass on one. The lack
of redevelopment surprised him. Then the new build-
ings of West Berlin came into sight. When he descend-
ed from the train at the Zoo station it was to another
world of noise and bustle, of taxis, crowded pavements
and glittering, neon-lit shops.

However, Raeder had a plan and it did not include
eating cream cakes or ogling pretty girls in jeans, rare
as the latter were in East Germany. His prime require-
ment was a long-distance telephone. Although one can
dial foreign calls from the East, he had hesitated to do
so. The less people knew about his intentions the bet-
ter. The snag was that, it being Saturday, he would
probably have to track down the attorney at home and
it was already midmorning. Walking hurriedly along
from the Zoo station, he found a post office where he
could pay for calls across the counter instead of pour-
ing pfennig pieces into a coinbox. The attendant gave
him a line, and he started dialing. He proved to be in
luck.

Although the lawyer's office in Hamburg was offi-
cially closed, one of the partners was catching up on a
backlog of papers. Raeder's greatest attribute was an
all-persuasive determination. The partner, reluctant to
give his colleague's home telephone number, consented
to look up the relevant documents. After an intermina-
ble delay his voice came on the line again.

"I see from the file that the crash which killed Herr
Schneider also caused his wife injuries of which she
later died."

Raeder glanced down at the lawyer's letter he had
received. "But I have correspondence from your office
which says nothing of that." There was a brief silence.

"Ah yes, ours of October sixteenth enclosing a fur-
ther letter."

"Do you realize what it contained?"

"No, sir. Why should I?"

"In it Herr Schneider bequeathed me an item of his personal property. A painting."

"I am sorry. There is nothing about that in the file. Perhaps you can telephone again on Monday."

"To hell with Monday. What happened to Herr Schneider's possessions?"

"One moment, please." The partner sounded apologetic. There was another pause. "It appears Frau Schneider left everything to her nephew. She and Herr Schneider had no children."

"Who is he?"

"I am not sure if . . ."

Raeder cut short the lawyer's protestations. "You've already caused enough problems by sitting on the dead man's letter from June to October. Do you call that respecting a client's wishes? Herr Schneider was my oldest friend. Give me the name."

"Hans Dietrich. He lives in Hamburg at . . ." The partner gave a long address.

"Telephone?" snapped Raeder.

Reluctantly the partner revealed it.

"Thank you for your help. Nonetheless you can assure your colleague he'll be hearing from me!"

Angrily Raeder rang off and dialed the new number.

"Dietrich here."

"My name's Raeder. I was your uncle's oldest friend." The explanation that followed was brief to the point of terseness and omitted any mention of his rank and job.

"This is the first I've heard of such a bequest."

"I can come to Hamburg with the letter if you doubt me."

"I'm very sorry, that would be no use." Dietrich sounded worried.

"What do you mean?"

"Please understand, Herr Raeder. My wife and I live in Hamburg. My uncle was in Frankfurt. It's a long way. We seldom saw him. Apart from a few personal bits and pieces, like my aunt's jewelry, there was nothing we wanted from his house. Here we have only two

and a half rooms, and they are already furnished. We decided to sell his house as it stood."

"You sold everything in it?" Raeder tried to keep the concern out of his voice but failed. "Even the pictures?"

"I am so sorry. You must understand we have only a small apartment. We did keep a photograph of my grandfather."

"I'm talking about painted pictures, oil paintings, proper pictures in frames. This one measured nearly a meter and a half in diameter. You can't miss a thing that size!" Raeder fumed.

"Ah!" There was relief in Dietrich's reply. "You mean the ones stacked in the storeroom. Don't worry, they were almost valueless. We got an expert in to look them over." He laughed. "We weren't so stupid, Herr Raeder. No, they were just copies of old paintings. He told us about it. A century ago people had bigger houses, and they were more religious. They liked the style of former days, and artists who painted in that way were very popular."

"So what did you do with them?"

"I am sure you could buy your one back from him," Dietrich went on. "In fact if the lawyers have made a mess of things we'll refund you. My uncle left quite enough for us to honor his wishes properly."

Raeder gritted his teeth. "Please," he demanded, "where are the paintings?"

"The expert valued them at five hundred marks. Well, as I pointed out to him, the frames were worth that much. In the end he gave us a thousand. He took them away in his car to save delivery costs. Everything else was auctioned the next day."

"When was that?"

"Two weeks ago. We weren't allowed to do it until both the wills had been proved." Suddenly Dietrich's voice became more excited. "But of course, your letter is the one we passed to the lawyer. It was among a bundle of papers found in my uncle's desk. I thought your name was familiar! If you are ever in Hamburg,

please come and see us. And don't worry. I'm sure that when you explain you'll get the picture all right."

Raeder had control of himself again now. Wondering if Horst had known his eventual heir was such a nincompoop, he concentrated on the vital issue.

"Who was this expert, then?"

"That's easy. A local Frankfurt man called Herbstein. The auctioneers recommended him. I have his card somewhere." Raeder waited impatiently. "Yes, in the Romerberg."

Raeder scribbled down the address and phone number, thanked the imbecile nephew and rang off.

The taxi took twenty minutes to reach Tegel Airport's circular terminal area. Air connections between Berlin and West Germany are still subject to the quadripartite control established after the war, and only the aircraft of the victorious Allies are allowed in. Frankfurt had been in the American zone.

"Pan American," Raeder told the taxi driver.

At the ticket desk he asked for an economy return.

"That's sensible," commented the girl. "That way you get the federal subsidy." Raeder knew all about the federal aid given to cheapen communications between this beleaguered city and the Bundesrepublik. He restrained himself from commenting cynically about it. "When do you come back?" she asked.

The query made him think. He had wanted to be at his desk again on Monday, but in the circumstances that was now unlikely.

"Open date," he said reluctantly.

She glanced at the clock and then at him.

"Hand luggage only? You'll just catch the two-thirty flight."

He paid her, then asked, "What time are flights back on Sunday?"

"From Frankfurt? The last is at seven-thirty P.M. Up to then you needn't worry. It's practically a shuttle service."

Raeder thanked her and walked to the passport con-

trol. Being in a hurry was good; it automatically explained any betrayal of nervousness. The policeman gave his identity card only brief scrutiny, slapping it face down over an automatic photocopying machine and handing it back in seconds. Raeder passed through to the departure lounge, reluctantly acknowledging to himself that this was an efficient system. Half an hour later the Pan Am jet was heading south down the airspace corridor over East Germany. It flew low, and Raeder glimpsed the frontier between the clouds, a broad ribbon of barricades cutting through fields and woods. They landed at 3:25 P.M. By 4:15 P.M. he was in Frankfurt, standing outside the shop on the Romerberg. It was closed.

Raeder swore. His thoughts during the flight had confirmed the wisdom of confronting this dealer without prior warning. He was unarmed—to have attempted to carry a gun through West German security checks would have been ludicrous when the country was in a fever over terrorism. But he had no doubt of his ability to make Herbstein hand over the picture, once they were face to face. Now he would have to find the man's home. He was just noting down Herbstein's initials, resigning himself to a session with the local telephone directory, when the door lock rattled and clicked. A woman was coming out.

"I am so sorry," she said, "the gallery closed at four o'clock. I was clearing up."

"Is Herr Herbstein available?"

"It is important?" She had caught the intensity in Raeder's voice.

"I have come from Berlin to see him," he lied. "I tried to phone."

"Yes, we were busy this morning with clients. But anyway on Saturdays he leaves punctually to visit the thermal baths." She smiled weakly. "He is very concerned about his heart."

Thermal baths, taking the cure and health-center treatments were a national institution. Raeder had

heard a West German could even claim weeks off work
to attend a spa clinic at state expense.

"Which one?" he asked.

"Always Bad Nauheim. And in the mornings he
walks out in the woods near his house before break-
fast." She smiled. "Frau Herbstein needs exercise more
than he. She is really fat. But she won't . . ."

Raeder let the woman talk on. By the time she had
finished he had decided to damn the extravagance and
take a taxi straight to Bad Nauheim.

Bad Nauheim's waters were long established for
treating arthritis, heart and kidney complaints. The
houses in the small town had a faded elegance, but the
baths were new. Raeder paid for his entrance at the
modern building and lined up to be given a small plas-
tic tray for his valuables. The attendant reprovingly in-
sisted on his renting a white-and-blue bathing cap,
because he had not got one, when he realized he did
not have bathing trunks either. It was some minutes
before he was ready to emerge through a shower of
tepid water to the faintly steamy atmosphere of the big
indoor pool.

A high glass wall enclosed one side, beyond which
was a further outdoor pool reached through a glass-
roofed tunnel. Both were championship size, the indoor
one crowded with middle-aged swimmers, paddling
ineffectually or holding onto the sides like limp por-
poises. A notice quoted the temperature at 32 degrees
C. and warned against staying in for over twenty
minutes. Raeder lowered himself in, swam a few
strokes, accidentally caught a taste of the bitter salty
water, spotted the supervisor and then hauled himself
out again. The supervisor was lithe and young and
looked like a tennis coach, in white trousers, shirt and
sneakers. He was encouraging a fat middle-aged
woman to swim. Raeder reflected that almost everyone
here was running to fat and middle-aged, himself in-
cluded. He was well camouflaged. If his quarry was as
flabby as the rest, he would have no problems with
him.

"I'm searching for a regular of yours, Herbstein the art dealer," he said. "I was to meet him, but I'm late."

The supervisor observed Raeder's age and build, guessed he had been an athlete once from the way he held himself and replied in a friendly way.

"It's not so easy to recognize people here. But I think I know who you mean."

"He comes every Saturday."

"Right. He usually visits the solarium afterwards. If I'm not mistaken, he's up there now."

Raeder followed the man's gaze to a mezzanine floor overlooking the pool.

"The tokens are three marks."

"Damn," said Raeder. He had not brought money in with him. He thanked the man, hurried back to obtain a red plastic token, then mounted the stairs to the solarium. It was unexpectedly luxurious. Reclining chairs sank into a deep off-white carpet. The late-afternoon sun streamed in through one range of glass while the other surveyed the pool. Along the wall a line of black leather-covered beds stood beneath ultraviolet lamps. The farthest was occupied by a couple, lying head to toe, ingeniously getting two suntans for the price of one. A middle-aged man was recumbent in another. Raeder selected the next-door bed, pushed his token into the slot, lay down on his belly, felt the comforting warmth of the lamps build up, then raised his head and spoke softly.

"Herbstein?"

The man turned abruptly on his side.

"Yes." There was surprise and hostility in the voice. This session was sacred. It was his most treasured relaxation.

Raeder propped his cheek up with his hand.

"I have a deal for you."

"Please! I do not want to talk businesss."

Raeder stayed silent for a long moment, letting normal curiosity do its work. The heat felt good on his back, though he needed a shower again to remove the faint stickiness the mineral bath had left on his skin.

"Well, what kind of a deal?" asked Herbstein at length.

"A prudent one!" Raeder kept his voice low but harsh. "You have a Botticelli which belongs to me. Return it and I'll let you keep the others."

Herbstein wriggled over completely and lay on his back, keeping his eyes closed against the rays. He always toasted both sides of himself. In order to appear composed, he stuck to this private routine, but he felt very small inside. First the woman from Vienna, now this stranger. His greatest fear was that someone would establish a claim on the pictures before he could get them out of Germany. He had spent many hours faking prewar bills of sale because, although all seven paintings had postwar bills attached to them, his instinct told him that some had to be suspect, and anyway "provenance" needed to stretch back into the mists of dead generations.

"Kindly explain," he said. "What Botticelli?"

"The Madonna with eight angels."

Herbstein swallowed involuntarily. So this man knew!

"When you were called in to give a value on it and some others you defrauded the owner. A thousand marks for the lot!"

The scorn made the dealer wince but gave him an opening.

"I bought them legally," he insisted.

Raeder glanced over the length of the pudgy body opposite him, flesh bulging around the tight edges of the swimming trunks. More than thermal baths and morning walks would be needed to protect this slob from heart trouble; indeed, his next card should bring that appreciably closer.

"Unfortunately the late Herr Schneider bequeathed the Botticelli to me. It was not his nephew's to sell. Herr Schneider and I were wartime comrades." Raeder let this information sink in, then added softly, "In the SS." He wondered for a moment if their subdued conversation was being overheard, but the couple at the

end lay motionless. However, the effect on Herbstein was immediate.

The dealer sat up, his breath suddenly coming in gasps. Of all bad dreams, this was the worst. At the end of the war there were still a third of a million men in the SS. Despite the official denials, he knew they remained in communication with each other. And he had heard about transactions which he was certain involved passing valuables down the SS chain to South America, the organization known as the Kameradenwerk. His short legs swinging over the side of the leather bed, he looked at Raeder's heavy, broad-shouldered torso and determined face. The sight did not improve his morale.

"The organization wants it back," said Raeder, not troubling to move, his head still propped casually on his hand.

"We can talk downstairs." Herbstein stood up nervously.

"Don't leave without me. That would not be prudent. In any case you'll be driving me back to Frankfurt."

Raeder rolled over onto his back and closed his eyes, terminating the conversation. He had won, and he did not intend to waste his three marks' worth of sunlamp. When a loud click announced the end of the time and the warmth faded, he descended and dressed. Herbstein was waiting in the foyer.

"Let's go to your car," Raeder ordered.

Once they were out on the main road Herbstein suddenly became voluble with explanations, ending up by saying, "Naturally I have been showing these paintings to clients. Most unfortunately the Botticelli is being examined by one this weekend."

"Stop talking and drive to the Romerberg. You can show me your gallery in person.

"By the way," said Raeder when they arrived, "this is the relevant bequest." He handed over Schneider's last letter. Herbstein read it and then watched apprehensively as Raeder began a search that lasted half an

hour. There was nothing hanging in the private display room, nor behind the curtain.

"If you are double-crossing me," said Raeder finally, "you'll regret it. How soon can you recover the picture?"

"On Monday morning. You can have it midday Monday."

"What's wrong with tomorrow?"

Herbstein spread his hands. He was in confusion, plans and fears jostling in his mind. He wanted time to think. "To demand it back would arouse suspicion." He risked a further lie. "It's at the house of an important industrialist. I dare not offend him. His secretary will return it on Monday."

"Remind her," said Raeder at length. "Midday will be the deadline."

ᓚᕬ chapter 4

It had been a long time since Charles Luttrell gambled so heavily on his instinct. At Frankfurt airport, while waiting for the London flight, he had decided to telephone Tom Hanson in Massachusetts. He knew the Botticelli would make an appropriate purchase for Hanson, who both liked religious paintings and, more importantly, was in the process of establishing a Museum of Art in his own name at Westhampton College. Normally he would have written, enclosing photographs. He would not have pressed for an answer. Above all he would have checked the provenance and authenticity of the painting itself beforehand. These were as much unwritten rules of the business as the axiom that one never bought a picture with a particular client in mind. But he was hugely excited over discovering the Botticelli and felt impelled to act.

"I certainly would wish to see it," Hanson had said immediately. "I most certainly would. It's too bad that

I'm going to Australia on Monday and won't be back for a month."

"I could bring photographs and other details for you to see tomorrow. With luck I could make a connection to Boston this evening."

"You could?" Hanson had sounded agreeably surprised. "Well, I can meet with you Sunday. Why not? Call me when you arrive."

So Charles had hurriedly made reservations to go on from London and then telephoned his wife Lucy at home in Wiltshire. She didn't like precipitate decisions.

"It never does to rush one's fences, Charles," she said in a worried tone. "If he's really interested he'll send an expert over anyway."

"I promise you, he's crazy about his new foundation. He's in a buying mood. He'll be flattered at my dropping everything to dash across the Atlantic."

"Well, I don't know Hanson myself," she conceded. "But if it was Jock Whitney or Paul Mellon I should keep that picture until he was ready to come across. Meanwhile, I'd talk to his London advisers."

Charles thought of Paul Mellon, with houses in New York and Washington and Cape Cod, the Art Center at Yale and his habit of waiting to visit Europe until there was a big sale or he had a horse running. He and Whitney and Norton Simon were in a class apart. Hanson was not necessarily a lesser personality, but he was indisputably a lesser collector.

"Hanson's a different animal. He's going to Australia—to open another subsidiary of his computer business, I presume—and he won't want to miss such a chance because of that. And, Lucy, my dear, this is one. We've made a great find."

It was on the tip of her tongue to ask if the "we" meant him and Samantha, but she bit back the impulse. She was almost certain the girl had become his mistress, and yet she had decided to duck the subject unless it became unavoidable. Charles had physical needs which she knew she could not meet adequately herself. She was prepared to compromise if he satisfied

them with someone else, so long as he was discreet. Nonetheless, she had badly wanted to talk to him about the firm's predicament, which had overwhelmed her thoughts since the board meeting.

"So you won't be here for any of the weekend?"

"I'm afraid not, my love." The disappointment in her voice softened him a little. "But if I can hook Hanson it'll be worth it. Meanwhile, Samantha will be taking the pictures back to London."

"Well," said Lucy, relieved by this news. "Don't overplay your hand. Don't frighten him off."

"I certainly will not. If there's one thing I know in this game, it's when to stop because the sale's already made." He inquired about his daughters, promised to telephone as soon as he was back, said goodbye and rang off with relief. The success when he pulled off the coup would be all the sweeter because she doubted he could do it.

Nonetheless, as the jet landed at Boston he began to have qualms that in trusting to his instinct he was trying to put the clock back, perhaps dangerously. A good eye, a phenomenal memory and the courage to back his intuition had restored Luttrell's to fortune twenty years ago. But recently he had made mistakes. He was as certain as he could be about the Botticelli. Yet the salesman's approach was almost as important as the painting's quality. Everything would depend on Hanson's first reactions.

Inside the terminal Charles heard his name called over the loudspeaker system and learned to his pleasure that Hanson had sent a limousine to fetch him. That was good. Not only did it save him the trouble of finding a hotel, then hiring a car and driving himself, but it showed that Hanson was in a receptive mood. On the way the chauffeur told him he would be Hanson's house guest.

It was long dark when they arrived, and Charles was beginning to feel the strain of traveling. It might be only 10:00 P.M. Daylight Savings Time, but by his

stomach it was 3:00 A.M. Sunday. He had been up nearly twenty hours.

As the car stopped outside the big, white mansion, its tires crunching the gravel, Hanson came to the door—a tall, well-built man in a tuxedo who had made a fortune in his thirties and was now a young-looking forty-six, though his thick dark hair was graying. He stepped forward and greeted Charles under the porch light.

"Nice to see you again. Come in." He ushered Charles into the hall. "We have company this evening. Dinner's over, but I'm sure we can fix you something."

"That's all right. I ate on the plane."

"Well, then join us for a drink if you're not too tired."

Fighting off fatigue, Charles made polite conversation for half an hour until Hanson rose to his feet. "I guess Charles here must be pretty tired. I'm going to show him to his room."

They went upstairs to a large and comfortable bedroom where a manservant laid out the pajamas and spare shirt from Charles's overnight case.

"Traveling light," remarked Hanson.

Charles came straight to the point. "This is one of those rare occasions when a picture takes one by storm."

"So I gathered. Let's see the photographs."

Charles found his briefcase and pulled out an envelope.

"Two black-and-whites and a transparency." Handing them over, he added, "Not a big enough transparency really, but the others tell one plenty." He let Hanson peruse them for a moment before going on. "It's not only that a Botticelli of this quality hasn't come on the market for a generation. I can think of a dozen museums from the Kimbell at Fort Worth to the Met itself that would be glad to have it. It could be the centerpiece of your Florentine room here at Westhampton. Isn't your motto 'Art that teaches'? Hang this on the long wall and move the Filippo Lippi close

by. You couldn't hope for a more educative juxtaposi-
tion. That fine carefully observed Virgin of Lippi's and
this outstanding work by his famous pupil."

"Both from Luttrell's," remarked Hanson wryly.

"With respect, Tom, your business is computer tech-
nology. Mine's art. You have a good eye for a painting,
a very good eye if I may say so. But you are as un-
likely to unearth lost masterpieces as I am to patent
an invention. And make no mistake, this one is a
masterpiece."

"I will say you have a damn good memory. How
long since you were last here?"

"Three years. And in that time I haven't seen one
work so right for your collection. Believe me, there
have been other possibilities I just haven't bothered
you with because one could hope to do better. But you
can't do better than this."

Hanson nodded. He knew it was true that Luttrell's
were genuinely concerned about what would or would
not suit a particular client. He held the transparency up
to the ceiling light, squinting awkwardly at it."

"Hell," he said, "it certainly looks good. How big did
you say it was?"

Charles gestured with his hands. "It's circular, a
tondo, roughly four and a half feet across, one hundred
forty-three centimeters, to be exact. It's an important
painting."

"And the price?"

"We can discuss that," Charles said silkily, "but
around two million. Of course, you'll want to have
your own assessment made."

"I'm sure as hell going to need some tax deductions
this year, but maybe not on that scale." Hanson sighed.
"Though it is our anniversary. Ten years since I
started. Mind you, one thing has changed since you last
came. The college is taking a more active part in run-
ning my foundation. So I'll ask Webster to lunch to-
morrow. We can talk before the meal. Webster's made
quite a reputation of late."

A memory of Webster, the curator of the West-

hampton College Museum of Art, flickered through Charles's mind. It was not pleasant.

"He has a big say in purchases these days," added Hanson.

Charles looked straight at his client. He knew him well enough to be frank and he felt tired enough to be outspoken.

"Don't fall for it, Tom," he said. "As a major benefactor you've got them by the balls and they know it. You've learned enough to trust your own judgment, whether you're buying from me or Agnews or Clyde Newhouse or at auctions. All great collections bear the stamp of their originators."

Hanson grinned. "Nice to hear someone who can speak his mind. I appreciate that. Now I must get back to my guests. May I take the photos to brood over?"

"Naturally."

"Good night, then. It's a pleasure to have you here."

As Hanson closed the door, Charles was left uncertain whether those last remarks were a typically polite American brush-off or whether Hanson really was doubtful about his advisers. He was inclined to think the latter. If so, the Botticelli might be as good as sold, because when all was said and done its quality was undeniable. But he could still foresee a conflict with Webster. Men like him earned their reputations through controversy. Charles dismissed this unhappy thought, undressed and fell into bed, the longest day's work he had done for many years over at last.

On Sunday mornings during the college semester Mervyn Webster practiced an effective routine. He attended the service at the tall, steepled colonial-style church near college, chatted briefly afterward with any of the senior staff who happened to be there and then offered sherry to a few select friends in his apartment. Usually he managed to entice some minor figure of the art world frow New York for the weekend to add luster to the occasion. As well as being young and ambitious, Webster was shrewd. When he had first

been invited to leave as an assistant at the Frick Collection in New York and develop the Westhampton College, he had realized that in an Ivy League establishment he would need a social reputation. That was five years ago. He had been twenty-nine, even then physically portly and tending to be pompous with it. But the affectations he had acquired during a postgraduate course at Cambridge University served him well at Westhampton. He had become known as a character and was tacitly allowed the freedom of speech and action which went with it.

In consequence, when Hanson called him the previous evening and demanded his presence, he had accepted the lunch invitation but flatly declined to arrive early.

"Why don't you bring Mr. Luttrell for a drink at my place first, sir? Johnson from the Frick will be here."

In fact Johnson came because he liked riding in the autumn, a time when the wooded hills around Westhampton were especially beautiful in their fall colors, and he was able to use the college stables. Hanson had guessed as much and only reluctantly agreed to attend the sherry party himself.

"I'll show you what's going on at the museum after church," he told Charles at breakfast. "We'll cut most of Webster's drinks." It was as good a chance as Charles had hoped for. He had slept late, felt refreshed and was prepared to admire the foundation's achievements appropriately.

"We completed the new wing since you were here," Hanson said, waving his hand at a concrete-and-glass structure with a group of modern sculptures outside. "Houses three hundred and forty-two paintings right now, not to mention the storage and workshops. All done by the foundation."

"So I heard."

"Mind you, the tax advantages aren't what they were."

Charles commiserated, reflecting that there are few

unhappier creatures in the world than a millionaire deprived of tax relief.

"At least we've got the alumni hooked into it now it's a foundation," Hanson went on. "There are some damn rich guys among them, too. If we want something badly enough they subscribe to match what I put up."

"Tell them about the Botticelli," said Charles instantly and as quickly regretted it. God knows he didn't want to wait while a subscription list was built up.

"Well," Hanson temporized, "Webster will need to check its provenance. No disrespect to you, Charles, but the foundation has changed matters. I wouldn't want to donate a picture they weren't happy with. The other trustees might want to see it, too, though usually if Webster's happy, so are they."

"Don't let them linger too long over it. That Getty Museum down at Malibu may not want to disrupt the art market with its seven hundred fifty million to spend. But it won't exactly make good works less saleable." Charles spoke half humorously, confident now that Hanson was as good as hooked, and determined not to let Webster's evident influence defeat him.

As they approached the curator's apartment, the converted ground floor of an 1890s weatherboarded house, with a splendid view over lawns toward a small lake, Charles remarked casually, "We don't want this to become cocktail-party gossip. It's not in your interest or mine."

"Agreed," said Hanson shortly. "I haven't told Webster yet."

Their caution was justified. The gathering was exactly the kind of artificial affair Charles had anticipated. The man Johnson from the Frick was being lionized, and the name Luttrell had barely been mentioned when one of the college lecturers asked with outright rudeness, "And what are you selling the museum this time?"

"I never sell," replied Charles coldly. "I merely advise people what to buy."

"From your own stock, huh?"

"Frequently not."

Webster overheard this exchange and interrupted suavely.

"You're talking to a very distinguished dealer, you know." The inflection of his voice made the remark border on the sarcastic.

"In my opinion professionals are the last people who ought to be trusted with art," said the lecturer.

"And likewise with education?" asked Charles.

"*Touché!*" exclaimed Webster. "My dear Mr. Luttrell, I do believe you've made an enemy."

Charles had forgotten how bitchy academics could become within their own circle. He had the impression Hanson was as glad to get away as he was.

Over lunch it became clear that Webster was deeply entrenched in the affairs of the Hanson Foundation. He aired his views on the way it should be run, peppering the argument with throwaway references to other collectors.

"Of course Walter Chrysler doesn't interfere too much with the museum at Norfolk. Very wise." He turned to Hanson ingratiatingly. "You see, sir, they're within easy access of colleges right from Richmond down to North Carolina and Tennessee. We've a similar advantage to exploit here in the heart of New England."

"Yours are rather more sophisticated students, aren't they?" suggested Charles, seeing a way of introducing the Botticelli.

"I wouldn't say that, Mr. Luttrell, not at all. Although I am always considering ways of refining our collection. Maturing it, perhaps I should say."

"Well," said Hanson bluntly, "Charles here has a Botticelli that might prove a star exhibit." He reached across to a sidetable and handed Webster the photographs.

Webster examined them briefly. "Very nice," he

said, more out of deference to Hanson than appreciation, Charles thought. "Of course one can hardly tell if it's merely a studio work from these."

"The composition is outstanding," said Charles defensively.

"True," admitted Webster grudgingly. "But really one needs to see it in the flesh. I should want a very detailed examination before I was prepared to commit mself. Is it in Berenson?"

"No. The family who owned it for many generations apparently only catalogued it in 1897, a year or so after Berenson's book on the Florentine painters appeared."

This was a slight embroidering of the German dealer's provenance but not unreasonable. If Charles's presumptions about Webster and his ambitions were correct, it left an attractive possibility open.

Webster grunted, poring over the photographs.

"I'm still surprised Berenson never published it. After all, he was still annotating his records pretty well through to his death. And that was 1959." Webster paused, a slightly dreamy look in his eye. "A great man, Bernard Berenson. I had the privilege to meet him once."

You must have been ten years old at the time, thought Charles. Aloud he said smoothly, "Naturally if the foundation were to acquire it, then the publication would be left to you." In other words, Webster could claim the credit for discovering a lost masterpiece by publishing the authentication, which Luttrell's would have to research. If that didn't tempt him, Charles thought, nothing would.

"I agree we should look at it," he agreed pompously.

"Good." Hanson liked clear decisions. "Then you fly across to London while I'm in Australia. Let's not waste any time. Will you hold this painting exclusively for us, Charles?"

"Of course." He hoped the relief was not too evident in his voice.

Webster made a show of consulting his diary.

"Perhaps Wednesday or Thursday. At least I can make a preliminary inspection."

"It will be in Bond Street tomorrow. From then on it's at your disposal."

"Let's drink to that," said Hanson enthusiastically. "The Botticelli Madonna."

Charles raised his glass and prayed that Samantha would bring the painting back successfully from Frankfurt. A few minutes later he decided that prayers might not be enough on their own and used Hanson's telephone to send her a cable.

Colonel Raeder spent the weekend wondering if he had made a fool of himself. After leaving Herbstein in the Romerberg he had walked across the river and found a small hotel on the south bank of the river in Sachsenhausen, where prices were lower. Then he set about killing time. He dined on Saturday evening in Wagner's, a convivial restaurant with long scrubbed pine tables where the staple items on the menu were huge pork chops, washed down with glass upon glass of cider from the cask. The place had a good, friendly feeling about it, and the general laughter swept him into chat with the others at his side. His Berlin origin prompted both jokes and commiseration.

"Better than the East, though," cracked one man.

Raeder grinned tactfully. He was enjoying himself in a way he had not done for years, and he didn't want to spoil it. He could never relax like this at home. The buxom waitress called him "*du*" and leaned enticingly against him every time she refilled the glasses, which was often. But he did not get drunk, and he declined her implicit invitation to join her later. He was nagged by fears that the dealer had outwitted him. He always warned his subordinates in the Stasi that the word *failure* was not in their vocabulary. He did not intend to fail himself.

By Sunday morning he could kill time no longer. The dealer's home address was on the outskirts of Sachsenhausen, barely two kilometers from the hotel.

Raeder walked there and found an area of new houses, close up against the Stadtwald, literally the city's forest. The front gardens were well tended, and there were enough Mercedes parked in driveways to indicate the wealth of the residents. Herbstein's home was a three-storied detached house, stuccoed, with elegant long windows on the ground floor. Raeder remembered the secretary at the gallery mentioning his early-morning walks.

The route to the woods was obvious. Raeder followed it and found a rustic café in the shadow of a tall wooden observation tower. A sign proclaimed that this was the Goetheturm, 131 meters high and built in 1931. In fact there were wooden signs everywhere, all carved with appropriate designs. A horseshoe indicated paths for riding. A dachshund on a lead made its own point. There was a children's playground, while another sign announced VITA PARCOURS, which proved to be an exercise route through the woods, sponsored by an insurance company. At its start a warning notice declared, PLEASE! NO OVEREXERTION!

Raeder laughed out loud. Clearly the insurers didn't want people dying of heart failure through trying to get fit. Intrigued, he followed the Parcours. Every hundred meters or so there was a clearing dedicated to some form of gymnastics. One had logs with a notice demonstrating how many times one should lift the log above one's head; another had parallel bars, another leg exercises. This must be where Herbstein took his morning constitutional. The Parcours led deep into the woods, gradually circling back to end near the Goetheturm.

Suddenly an idea that had been forming in Raeder's mind took final shape. He strode to the tower and mounted the flight of steps to the platform at the top, well above tree level. On one side the woods stretched as far as he could see, a sea of tawny autumn color. On the other, skyscrapers of the city glinted in the sun. Much nearer he could see the road on which Herbstein lived. There was definitely only one way from it to the Stadtwald. Still chuckling at the insurance company's

warning, he hurried back down the tower, the planks vibrating under his heavy tread, and set off briskly for his hotel. He wondered if Herbstein was insured with the Vita Parcours company. That would make an even better joke in view of the shock he was about to receive.

Seven-thirty on Monday morning found Raeder seated in his overcoat on a bench at the side of the fifth clearing on the Vita Parcours route, where a sign nailed to a tree depicted a man swinging his arms and touching his toes. Families were counseled to do this exercise four times and sportsmen ten. Raeder stamped his feet and waited. It was cold and misty. Fallen leaves crackled as a squirrel scampered over them.

The squirrel chirruped and suddenly bolted up a tree. He looked around and saw why. A dog was padding along the path toward him, an English spaniel. Behind it came Herbstein, dressed in a dark-blue track suit, ambling along at a slow jog trot. Raeder swore to himself. He had not anticipated a dog. Inevitably it spotted him and began barking. He sat still, huddling in his overcoat, his felt hat firmly on his head, hoping he would not be recognized immediately. Herbstein slowed to a walk, panting a little, as he reached the clearing. "Heel," he shouted at the animal. "Heel. Excuse me. He is not dangerous."

Raeder rose to his feet deliberately and turned to face the dealer.

"What are . . . ? Why are you here?" Herbstein stared at him, first in amazement, then questioningly.

"Good morning," Raeder said. "Please continue with your exercise. I shall enjoy watching."

This was how he had planned it, even to the way fear would replace surprise in the dealer's expression.

Herbstein hesitated.

"Continue," Raeder repeated, his voice harsh and sardonic. "Touching the toes ten times is recommended for sportsmen." He kept his right hand firmly in his overcoat pocket. It would do no harm for Herbstein to

imagine he had a gun, though he depended far more on his physical presence and tone of voice.

The dealer embarrassedly placed his feet apart and began swinging first his right arm and then his left down in a futile attempt to touch the opposite foot.

"The toes!" ordered Raeder. "Touch the toes."

Panting, Herbstein tried harder until he was exhausted, stopped and staggered to sit down on the bench, his breath coming in gasps.

The dog stood impatiently watching its master, eager to be off.

"I have been thinking," said Raeder calmly. "It will be more satisfactory if you sign a release for the painting now. I can then collect it from your assistant whether you are there or not." He reached inside his coat pocket and pulled out an unsealed envelope, from which in turn he removed a sheet of paper. Then he carefully took out a pen.

"I thought you had a gun," muttered Herbstein, shivering, incongruous in the athlete's track suit.

"Not necessary. If we want to kill you we can always do so. Do not imagine you would escape." The words were intentionally melodramatic. He knew Herbstein would react to them.

"This document authorizes me to collect the Botticelli and acknowledges my ownership of it by inheritance. You will sign at the bottom."

The letter was on a sheet of Herbstein's office stationery, which he had pilfered on Saturday. As he handed it over he saw a flicker of resistance in the dealer's eyes.

"Sign," Raeder said bluntly, "before I lose my temper."

Herbstein's face crumpled. He accepted the pen, laid the paper on the bench and wrote his signature falteringly. The wind blew up the edge of the sheet as he finished.

Raeder sat down at the other end of the bench, took back the document, replaced it in the envelope and smiled.

"Congratulations," he said. "You have saved yourself a lot of trouble. The painting is being returned this morning, correct?"

Herbstein nodded. He was cold and his mind was only working slowly. Since the encounter at the thermal baths he had been gnawing at the question of whether he dared ship the Botticelli out of Germany as he had planned. He had already taken steps to safeguard the picture. Was the huge profit worth the risk? Yesterday he had concluded that if the worse came to the worst he could probably buy off this SS man. Now he was not so sure. The only constructive thought his brain could produce was that up to the moment the girl from London left with it, the painting could certainly be handed over and that, in the meantime, if he could get warm and think properly he might come up with a solution.

He felt unbelievably tired.

Raeder pulled out a pack of cigarettes.

"I suppose you shouldn't," he said. "Bad for the heart, though they say it helps the nerves."

Herbstein wavered, then accepted one. Raeder lit it for him, studying the dealer's ashen face. There was no doubt he had been given a very bad fright.

"Remember, if you play the fool with us, it will be the worse for you." Raeder straightened up and walked calmly away. As he disappeared among the trees Herbstein was still sitting on the bench, mechanically stroking the dog and staring at the ground.

An hour and a half later, Raeder arrived at the Romberberg as the gallery opened. The secretary recognized him.

"Did you find Herr Herbstein at Bad Nauheim?" she asked.

"I did. I'm most grateful to you. We returned here later and he gave me this authority to collect a painting today."

As he spoke he handed over the release. "Unknown to him it had been bequeathed to me by the gentleman

from whose executors he bought it. He generously permitted me to buy it back."

The woman looked worried. Raeder wondered how much she knew. "I don't think it's here," she said nervously, "not now."

"But you are fetching it this morning, correct?" He smiled soothingly. "From the client who has been considering it over the weekend. Your boss told me all about it."

"He will be here any moment," she said. "I think you must ask him." She was puzzled. Herbstein had not confided anything about the batch of seven paintings he had bought last week. Only from the way they were hung and the London dealer's visit did she conclude they were valuable.

"I haven't much time," remarked Raeder, allowing an edge of impatience to show through his urbanity. "I was hoping you would have this picture back soon."

"I don't know about it," she insisted. "Two of the paintings were packaged up and taken away on Saturday. Not long before you came. This must have been one of them."

"But you know the client of course?"

Suddenly Raeder realized that something was wrong. He could read it in the woman's expression.

"No," she stuttered. "I don't know about the client and nobody has told me to fetch anything. All I know is that a London dealer was interested. Please, you must wait until Herr Herbstein comes. I am only the secretary. I don't know about these things."

Raeder's face hardened. "Listen. I am the legal owner of this picture. That is why Herbstein is releasing it to me. I have all the documents. He himself told me you were bringing it back from a client today. Now kindly tell me, where is it?"

"I swear I don't know." She was on the edge of panic. "I wrapped the pictures on Saturday and he took them away. He didn't say where. To his car, I suppose."

"He didn't say anything at all?"

"Excuse me," she said as a telephone started to ring in the back room, and left Raeder standing in the gallery. He caught fragments of conversation. When she came back she was visibly upset.

"He isn't coming. He's ill." She sat down on a little gilt chair by the catalogue table. "They think he may have strained his heart on his morning run. His wife has put him to bed and called the doctor."

"What about his partner? Surely someone else must know where this painting is."

She glanced at him, mystified. "Partner? He has no partner. Please. I can't answer all these questions." She looked at Raeder as though his demands were incomprehensible.

"Get him on the telephone." It was an order, curt and unrefusable. Reluctantly the secretary went through to the office.

"His wife will never let you speak to him," she said.

"Never mind that."

But for the first time since his arrival in Frankfurt he found himself up against a person as iron-willed as himself. Frau Herbstein was adamant. Her husband could not take the call.

"In that case, give him a message. Tell him I must have the picture by tomorrow morning."

"It it very unlikely that my husband will be attending to business so soon," said the woman implacably. "If the doctor permits I will pass the message. Otherwise you must wait."

Defeated, Raeder rang off and told the secretary that he would return the next morning.

"If the painting is brought back, keep it for me."

She shrugged her shoulders, disliking his bullying, and escorted him to the door.

He walked across the Romerberg to a restaurant, ordered a coffee and sat down to think. He had a score to settle with Herbstein, of that there was no doubt. Equally his claim on the Botticelli was doubly binding, consisting as it did both of Horst's letter and the dealer's release. But he might need a lawyer. He

couldn't stick around here waiting day after day. And the lawyer would have to proceed discreetly. For one thing, his West Berlin address would not stand up to serious investigation. Luckily he knew of a man who had assisted the Stasi before. He finished the coffee and went to find him, furious with himself for having misjudged Herbstein.

When she returned to Frankfurt late on Sunday evening, Samantha was in a decidedly more agreeable frame of mind than when she left. She had danced attendance on Charles through all his changes of plan at the airport on Saturday, but he had indeed hired her a Volkswagen on his credit card. As soon as he was safely on board the 747 she had buzzed away in the little red car and, after nearly losing her way in the complicated Frankfurt Kreuz autobahn interchange, headed south for the Black Forest. As she had told Charles, she was damned if she would sit around the Intercontinental all weekend just to be at the beck and call of that pudgy little dealer in the Romerberg. She had reached Baden-Baden in time for dinner, found a modest hotel, gone to the casino and been picked up by a man passable enough for her to accept dinner from him, though that was as far as the acquaintance went. It improved her morale and reinforced her wisdom in quitting the city. She spent Sunday up in the hills, lunched in an old inn by a lake and drove back thoroughly pleased with herself.

When she collected her key at the desk the porter said reprovingly, "We have been worrying about you, Fräulein. A gentleman was searching for you yesterday. You could not be found."

"Oh!" She had no idea who that could be. Nonetheless she felt a prickling of guilt at being absent.

"He left two important packages. They are in our strongroom. Do you want them sent up?"

Samantha hesitated. "Yes, I suppose so," she said. "Was that all?"

"There is a letter and a telegram." The porter

handed it over with her key. "And messages." He gave her two slips of paper. Both stated that Herbstein had telephoned. She tore open the telegram. It read: VITAL PICTURES REACH LONDON TUESDAY. LOVE, CHARLES. The letter was undated and brief.

> Dear Fräulein,
> I think it is better if the two articles are in your keeping now that we have come to agreement over them. I will expect you at ten on Monday morning when we will conclude the paperwork.
> > With greetings and respect
> > Hans Herbstein

The messages had been received at 10:00 P.M. on Saturday evening and at noon today. Both asked her to call him. She glanced at the clock over the desk. It was 11:08 P.M.

"What time do businessmen go to bed here?" she demanded.

The porter looked amused. "On a Sunday night? Early if they are respectable people. On Monday they must work."

She supposed Herbstein came into that category and it was too late to ring him. "Send the packages straight up, please," she said and went to the elevator.

In her room she opened them carefully, untying the string so that it could be reused. Neither parcel provided a surprise. The Memling and the Botticelli were without frames, though the edges of the panels were protected. An envelope with each contained the earlier bills of sale, but there was no record of the transaction with Luttrell's. That was normal enough, she reflected. A spoken agreement was invariably regarded as binding, and very likely Luttrell's would not bother with invoices but simply transfer their half share in the purchase to Herbstein's bank account. Anyway, the little German might ask her to sign a receipt for them tomorrow. She wrapped them up again, had a bath and went to bed.

On Monday morning Samantha felt uncertain whether she ought to be bringing the paintings with her. Would Herbstein have to show them physically in order to obtain the export permit? Perhaps he would, and that was why he had telephoned twice. At 9:45 she rang the gallery to find out.

"He is not here," answered the secretary.

Samantha thought she sounded upset. "You remember," she said, "Mr. Luttrell and I visited you on Saturday. I have an appointment with Herr Herbstein at ten."

"Oh." The voice was almost a wail. "But he is not coming."

"What do you mean?" asked Samantha, irritated. "We have to get the export permits."

"You cannot. Herr Herbstein, he is ill." In her agitation at being pestered by yet another person, the secretary's command of English slipped. "He strain himself. When he is running. His wife say I close the shop."

"But . . ." Samantha did not want to believe what she had heard. There she had been in the Black Forest when the dealer was urgently trying to contact her, and now! "You are serious?"

"He becomes ill in the Stadtwald when he is running. They think he does, what do you call, exert himself too much and have a heart attack."

"Listen!" Samantha tried to sound as calming as she could. "You know the two pictures he showed us? Well, we must have all the documents about them."

"Oh God, that is another problem."

"You must find them, please. I'll come straight down. Don't go, don't close the shop. I'll be ten minutes." She slammed down the phone, seized her coat and rushed for the elevator. If necessary she must obtain the export permits herself. Surely the secretary would know what to do. It was one thing to resent Charles's leaving her alone here. But he would never forgive her if she failed to bring the paintings back.

When she reached the Romerberg the gallery was shut. She knocked on the glass and eventually the

secretary appeared and let her in, religiously locking the door again afterward.

"You know the paintings I mean?" asked Samantha. "I don't want to seem unsympathetic, but I have to take all the documents back to London today. I absolutely have to."

"I don't think we have any documents." The secretary was flustered. "There were some receipts, but I cannot even find them now. Nothing. Herr Herbstein, he is a very secret man, never telling anything. He took away the paintings on Saturday and I don't even know where they are. He is as secret as that."

Samantha made sympathetic noises, her thoughts whirling. "If we could find them, do you know how to obtain the export permits?"

"You must go to Wiesbaden, to the Kulturministerium. But the owner has to do it, and Herr Herbstein is the owner. His wife says he cannot see anyone today."

"But I must have the permit! Hasn't he a partner? Can't anyone else sign?"

"No, no. Impossible. He is the director." The secretary dabbed at her eyes with a tissue. "Oh God, it is a terrible morning."

"And you don't even know where the paintings are now?"

"How can I?" The secretary was becoming hysterical. "He never tells me. Now everyone is asking questions!"

"I'm so sorry," Samantha said. "I'll just have to go home without them."

She walked out of the pedestrian mall and took a taxi back to the hotel. At least Luttrell's knew both what the Botticelli was and where it was. The question was what to do next. Charles was either in America or on the plane coming back. The chance of reaching him by telephone was remote. No one in Bond Street would make a decision in his absence, at least not on this problem. But the telegram was categoric.

Suddenly she had an inspiration. Herbstein's keeping things to himself might have its advantages. She

wouldn't fly back at all. She would simply put the paintings in the back of the Volkswagen and drive home. To hell with the export permit. The customs wouldn't search the car, and even if they did, how many customs officials would recognize a Botticelli or a Memling? She'd talk her way through. To hell with the car-hire firm, too; they'd get their vehicle back in the end.

"It's a considerable risk for a dealer to handle a painting that has been in a museum." Gerhard Balck was showing Karin around the Stadel and in particular two pictures recovered from an auction in New York. One was a view across the river from Sachsenhausen toward the cathedral. Karin went to the window and gazed briefly in the same direction. The sun was shining on the autumn trees and on the cathedral. A barge moved down the river, past the gaily painted old houses on the far bank. Things hadn't changed so much since 1850.

"I see why you were pleased to have it back," she said. "But it must have been an amazing bit of luck."

"In a way, yes. But once a painting is in the open, so to speak, and people talk about it, then the bush telegraph begins to operate. I'm surprised there's no local gossip here about the Botticelli or the Memling."

Gerhard had spent much of Sunday making discreet inquiries from friends, but without success.

"Perhaps it's too early. It does sound as though that dealer obtained them only a week or two ago."

Karin laughed. "I'm beginning to feel like a detective."

"Let's go down and check the lawbooks. They should have been brought by now."

Gerhard led the way down the black marble stairs. On Mondays the Stadel was closed to the public, and their footsteps echoed in the empty building.

"We owe this to the Yanks," he said cheerfully, waving at the modern galleries on either side. "If they hadn't bombed us we'd still have the 1877 interior."

He held open a side door to his office. A young man was standing inside, and a small pile of books was on the desk.

"Excuse me, please," said Gerhard apologetically, "I did not realize you had brought them yourself." He introduced the man to Karin as being from the Oberfinanzdirektion, the Provincial Treasury Department, and explained, "They still have an Office of Restitution."

"The task is not yet finished," said the official. "I understand you may have a claim."

They all sat down, and Karin told him what she knew about the Botticelli. He picked up the largest of the volumes and opened it where a slip of paper marked a page.

"This is the Civil Code of the Bundesrepublik—the *Bürgerliches Gesetzbuch*. Paragraph 935 states that the owner may claim his property which was stolen or taken away from him from whoever holds it but not"— he flipped quickly to a previous page—"but not more than thirty years later, according to paragraph 195. And then paragraph 937 states that after ten years of continuous possession you are usually to be regarded as the legal owner."

"However one looks at it," remarked Karin, "more than thirty years have gone by. I imagine that the sequence of events was roughly that it was taken from Vienna to Berlin in 1939, removed from the museum there in 1943 and probably looted in the spring or summer of 1945."

The official tapped the desk. "In a case like this I imagine the Dahlem Museum would put some pressure, on the grounds that everything in the Berlin Museum was part of the German national heritage."

"But it belongs in Vienna!" Karin wasn't going to stand for that argument.

"Have you the proof?"

She ferreted in a thin leather document case she was carrying and produced a photocopy. "This was the order transferring it from Vienna to Berlin. Surely it's a

clear case for restitution. It was part of the Austrian national heritage, not the German." She was becoming heated now. Suddenly the historic antagonism of a loyal Austrian to the enforced union of 1938 came to the surface. "To all intents and purposes Hitler stole it. I was told that even the works of art he bought had to be returned."

"Steady," interrupted Gerhard diplomatically. "We must consider this dispassionately." He turned to the official. "Assuming for a moment that the authorities accepted Fräulein Schumann's argument, would this be a matter for the Office of Restitution?"

Karin listened, white-faced. It had never occurred to her that the German authorities might not see things her way.

"The whole process of restitution is legally enshrined in an agreement of May 5, 1955, called the *Überleitungsvertrag*," said the official. "It overrules the time limits where works of art had been taken from other countries: from France, Poland, Italy, Belgium, Holland and so on. The countries occupied in the war by the Nazis."

"So," said Karin, "we can claim it."

"I'm not so sure," said the official, tapping the desk embarrassedly. "Legally Austria and Germany were one country in 1939. You may not agree," he went on hurriedly. "I know many Austrians objected to it."

"Our government does not recognize the *Anschluss* as having been binding. Hitler's troops occupied Austria by force."

"Well, I am not an expert on that." He suddenly became noncommittal. "I shall need to get higher advice." He thought for a moment and then went on in a more friendly tone. "Look, maybe there is another law we can invoke. If this picture has been in a private collection it will be in the list of paintings that cannot be exported. Could that give us something to go on?"

"Unfortunately not," said Gerhard. "I already checked with the Kulturministerium in Wiesbaden. It's not on the list." He glanced at Karin. "Nor, funnily

enough, is the Memling. Whoever had possession of them kept it very quiet. That list covers all the paintings considered nationally important. Not ones that belong to museums, of course. But then as far as we know, the Memling didn't."

The official nodded. "Correct. The law of August 6, 1955, specifically excludes them."

"God in heaven!" exclaimed Karin in exasperation. "What a mare's nest of laws! Gerhard, there must be something we can do. The slightest rumor will put the wind up that dealer, and the Botticelli will vanish again."

"She's right there," said Gerhard, who had become increasingly unhappy at the conversation. "Look, I have a suggestion. Why don't we go to the police, make a statement and ask them to take possession of the paintings as a precaution, until the legal position can be clarified. We can quote the *Überleitungsvertrag*. Karin has the Nazi removal order. If we are wrong, then they'll return it."

"Herbstein has friends," cautioned the official. "He'll kick up a fuss."

"We're not laying any charge against him," Gerhard pointed out.

"True." The official's reluctance was patent.

"You got to," said Karin passionately. "You must. This picture's been lost since 1943. If we delay it will disappear again."

"Very well." He gave way to their combined arguments. "I'll warn the police we're coming." He took the telephone, dialed a number and asked for an officer by name.

"At least he knows the ropes," whispered Gerhard.

After a few minutes' conversation the official said, "Wait a moment," put a hand over the receiver and spoke to Karin.

"He is prepared to meet us at the gallery in an hour. Is that all right?"

Karin nodded. She could not have hoped for more.

Gerhard drove them across the river bridge to the

Romerberg. A policeman in gray-green uniform was stationed at the gallery door when they arrived, a gun hanging on his belt and a walkie-talkie crackling. He checked their identities and motioned them past. Evidently the police did not waste time.

Inside were a police captain, a tearful woman whom Karin recognized as the secretary and a dark-suited man who was introduced as the dealer's lawyer.

"Herr Herbstein is unfortunately ill. I am representing him. I must insist that all this is most irregular. My client is a respected and well-known citizen. We absolutely deny the accusations being made against him."

"I would not make them if I had not seen a painting belonging to the Kunsthistorisches Museum here," said Karin coldly. "On Saturday. With Herr Balck as a witness."

"You can look around," said the captain. "But there's nothing like a Madonna here." He turned abruptly to the secretary. "You are certain there is no hiding place?"

She shook her head. "Only behind the velvet curtain."

"That's where they were," said Karin instantly, "in the back room."

"They?" queried the captain. "I thought there was only one."

"There was also a very small Madonna."

It took a little time to establish that, although the Casper Friedrich landscape was still in place, both Madonnas were indeed gone.

"Everyone's been asking about them," lamented the secretary, "and I don't know where they are."

A swift cross-examination by the police captain elicited descriptions of Raeder and Samantha.

"The painting can hardly be with the man, since he had come to collect it," he commented. "You say the girl wanted the documents? Then it is possible she has the painting. Do you know where she went?"

"I . . . I don't . . ." The secretary was about to reiterate her ignorance when she remembered overhear-

ing a conversation. "She and her boss flew in from London on Saturday, and they were going back there."

"London!" exclaimed Karin. "Then it could have been exported. Listen, Gerhard." She was so anxious that she caught him by the arm. "Earlier on you were saying the Madonna was not on the list of pictures forbidden to be exported. But don't you need a permit to take any Old Master out whether it's on that list or not? We do, the British do, surely you must."

Gerhard caught his breath. He'd been thinking in terms only of stopping the Botticelli from leaving Germany. If it had already left, then they were in a completely new situation. Gently disengaging himself from Karin, he faced the police captain.

"Fräulein Schumann is right. A committee of experts here has to give approval. Herbstein would have had to submit an application and obtained signatures. Normally it's no problem. But he could not possibly have done the paperwork over a weekend. If the Botticelli is being exported without the forms, then the law is being broken. Both the law of Hessen and of the Bundesrepublik."

"You must do something quickly," pleaded Karin.

For a second the captain wavered. He did not want to antagonize Herbstein without good cause.

"The girl could be on her way out with it now," urged Karin.

"All right. We will warn the airport. We will also inform the federal authorities." The captain's decisiveness was bolstered by the sudden realization that it would of course be the English girl who was arrested, not Herbstein. The blame would fall squarely on her. "You do understand," he cautioned Karin, "we are the Hessen police, not a national force. What the federal authorities do is up to them." He looked at her suspiciously. "What's more, I find it an odd coincidence that so many people are searching for this picture on the same day. I would like a notification of your claim in writing and please inform me before leaving the city."

Karin gazed back at him unperturbed. She had won

her point. "You needn't worry. I shan't go back to Vienna until you've made your checks." She took Gerhard's arm. "Come on," she said eagerly. "Herbstein's wife may be a terror, but we're going to make sure the picture isn't at his house."

It wasn't easy fitting the Botticelli into the back of the Volkswagen. Wrapped up, it was round and bulky, and Samantha was terrified of damaging it. However, with the aid of the hall porter she maneuvered the package so that it was upright behind the front seats. The Memling and her own overnight case went on the back seat. Soon after 11:00 A.M. she checked out of the Intercontinental and began making her way to the autobahn. The porter had advised her to go past the railway station and then out toward the Wiesbadener Strasse, but she became lost in the one-way system and the traffic was heavy. At last she saw the blue autobahn signs for Köln and Koblenz. She reached the Wiesbadener Kreuz and headed north at much the same time as her description was being noted down by the police at the Frankfurt airport.

Samantha was by nature impetuous, and it was only as the small car drummed comfortably along the autobahn that she really began to think about the frontier crossing. As she saw it there could be a problem only if a customs official insisted on opening the parcels and on being shown an export permit. The more she looked like a tourist the better. That raised the question in her mind of whether there was a particular tourist route into Belgium. After an hour's driving she decided to stop at a café and examine the map more closely than she had done at the start. Over a cup of coffee she traced the single main autobahn running from Köln toward Belgium, which divided near the frontier, one route going north of Aachen, the other south of it. But there were other roads as well. She scanned the area of the Rhineland farther south near Koblenz and suddenly noticed the name "Nürburgring." Of course, the famous racing circuit which many drivers regarded as a

killer. She snapped her fingers in delight, causing a flurry of interest from two truck drivers at a neighboring table. If she was questioned she would say she had been visiting the Rhineland, wanted to call on friends in Belgium and decided to go via the Nürburgring because she was a car fanatic. Everyone knows that girls fall for racing champions. Feeling thoroughly elated, she went back to the Volkswagen.

West of Koblenz she followed the winding route through Mayen to the Nürburgring. It was beautiful rolling countryside, with woods and vineyards, but it was comparatively slow-going. For the sake of her story she stopped at the circuit, where the long concrete grandstands were deserted apart from a few men watching a lone driver practicing. She also had more coffee and a sandwich before continuing. The road seemed interminably twisting. Each village was more drab than the last, and she began to realize that although the normal autobahn journey to Brussels would have taken about six hours, she would be lucky to reach the border before dusk.

At last the road began to wind down from the hills, passing through thick forests and emerging in a small town called Monschau. Beyond it a turn-off was signed EUPEN and LIÈGE. These were in Belgium. She swung off and found herself on a narrow road, not much more than a country lane. The sun had set. Suddenly there were lights ahead and signs saying "ZOLL—DOUANE." With a sick feeling in her stomach she realized that she was in a long line of cars. No cheerful waving to the customs as she slid past now! The line was barely moving. In fifteen minutes she progressed perhaps twenty yards. They must be questioning everyone. With a dry tongue she rehearsed her speech as she waited.

A light drizzle began to fall as the line of cars moved yard by yard toward the customs post. By the time Samantha eventually drew level with the small building it was completely dark, with all the makings of a miserable night. She prayed it would dampen the police's enthusiasm and was winding down the window to show her passport when she was blinded by a beam of light. It shone straight into her eyes, then flicked around the interior of the Volkswagen, settling in turn on her belongings and the parcels. She could only see the shape of the policeman behind it because his body blotted out her view.

"*Wobin fabren Sie?*" he demanded curtly, shining the flashlight in her face again. Where was she going? In preparing for this she had completely forgotten that, driving a German-registered car, she would be taken for a German. She decided to play the bewildered tourist.

"*Nicht Deutsch*," she said nervously. "English."

The policeman grunted and stepped back, flashing his light on the car number plate.

"*Engländerin?*" He sounded about as convinced as if she had claimed to be an Eskimo. He held out his hand. "*Pass!*"

She had deliberately put her passport on the passenger seat together with the car-rental documents. Even so, she fumbled as she reached for it. He examined it briefly. The rain seemed to have no effect on him at all. Then he grunted again, snapped the passport shut and gave it back.

"*Wohin fahren Sie mit diesem Wagen?*" he barked.

Samantha realized that her helpless-foreigner ploy was not going to work. She decided to struggle with the little German she knew.

"*Ich fahre nach Brüssel*," she said haltingly, strug-

114

gling to remember her schoolgirl conversation lessons. *"Dort habe ich ein Freund."* What if he asked for the address of this invented boyfriend in Brussels? She was barely able to see his expression in the dark and felt like a prisoner in a cage being interrogated as he looked down at her through the car window.

But the explanation seemed to satisfy him, or perhaps it was her attempt to speak his language. He flicked the beam over the parcels again, then demanded, *"Dokumente!"*

She handed out the car-rental papers. He checked them, glanced at the car number plate again, scribbled briefly in a notebook, gave her back the forms and said with unexpected friendliness, imitating her English accent, "O.K. *Nicht Baader Meinhof, hein!"* Then he waved her through.

In her relief Samantha almost stalled the engine driving off. So that was it. There was another terrorist scare on and they were searching for someone. She should have guessed. A moment later she passed the Belgian post, where there was no such rigmarole. She headed through Eupen for the highway, uncaring about the clouds of spray thrown up by trucks and overtaking cars flashing their headlights at her. She was through. But now what she needed was advice on the next stage. Would there be problems taking the pictures out of Belgium? It was after seven when she came to the first restaurant, with its international telephones. Hoping against hope that Charles would be back from America, she decided to try the office number first.

In Luttrell's spacious boardroom three of the four people who had argued so fiercely the previous Friday were meeting again. Charles himself had flown back from Boston that morning, which with the time change of five hours meant he reached London only in the early evening. But his apparent success with Hanson so keyed him up that he had cabled the others to stay in the office until he arrived. He had not expected his

wife Lucy to come, and she had indeed remained down in Wiltshire.

"So that's the story," he concluded ebulliently, facing Wild, the accountant, and James Constant across the broad mahogany table. "We have half shares in a Botticelli and in a Memling plus a probable buyer for the former."

Wild leaned over a notebook, neatly jotting down figures. "To sum up, we and the German have jointly paid two hundred and fifty thousand dollars for the Botticelli. If Mr. Hanson does come up with one and a half million dollars, rather than two, that means the total profit on the picture is one million two hundred and fifty thousand. Is that correct, Mr. Luttrell?"

"Effectively, except that we shall be able to deduct certain expenses before allocating the profit."

"It's a very high mark-up," remarked James Constant cautiously. "Why on earth was your German friend's client prepared to let it go so low?"

"Apparently he wanted to get rid of it," said Charles. "The condition was payment in seven days."

"One moment," interrupted Wild. "Can we please clarify the position on both pictures? Jointly you are also paying eighty thousand dollars for the Memling and expect to sell for two hundred and twenty thousand?"

Charles nodded.

"Would you mind if we talk in pounds?" asked James. "I realize Hanson prefers dollars, but among ourselves surely . . ."

Charles could hear the echo of Lucy's voice in her cousin's words. She would want to talk in a currency she was at home with. Probably would be doing so, dammit. If he knew James the two of them would be having a long telephone conversation later.

Wild was penciling in his additions. "We are looking for a further seventy thousand dollars on the Memling, making a total profit of six hundred and ninety-five thousand." He caught James's eye. "Sorry, Mr. Constant, in pounds, allowing for fluctuations in the

exchange rate"—he fiddled with an adding calculator—"that's around three hundred and fifty-five thousand pounds for a total outlay of"—his fingers flicked over the calculator—"just over eighty-four thousand pounds. Which of course we recover." His voice trembled slightly as he finished. It was impossible. They could never raise that amount. The bank manager would simply laugh.

Charles noticed Wild's cheerless expression. "It's a lot of money," he agreed. "It's also the kind of deal we need to pull us out of the doldrums. Tomorrow we start raising our share of the purchase. That's what we have to discuss."

"Our reserve fund for purchases is only thirty thousand," said Constant. "Did you consider taking the Botticelli on commission?"

Charles glanced at him, immediately guessing where that idea came from.

"Have you discussed this with Lucy already?" he demanded.

Constant colored slightly. "As she was unable to be here I thought we should have her opinion. She realizes that this could prove to be a major coup, but the commitment worries her."

"She knows damn well you can't make money without taking risks!" Charles was prepared to be more forthright with his co-director than he would be to his wife's face. "For God's sake, what's the matter with you all? Last Friday you were demanding salvation and now I've found it you're balking at the price." He felt like losing his temper, partly because he well knew the size of the problem facing them. Sooner or later Lucy would have to face the reality that the old magnificence of Luttrell's could no longer be preserved. Meanwhile, having James pussyfooting around urging prudence was going to help no one.

"I'm not exactly balking," said James cautiously. "Cousin Lucy and I are saying that we don't see how to raise the ante. It might be wiser to accept the much

lower profit on a commission sale rather than over-stretch ourselves at such a critical moment."

Charles shook his head angrily. "We need a major sale to bounce our trading back into profit. Then we can begin to cope with the crisis. Somehow or other we have to raise the funds for the Botticelli. In any case, I wasn't offered it on commission. The whole point is that the seller wants a quick disposal."

Wild had been listening intently. He was fairly new to the art business, but as the accountant this was the sort of situation he was supposed to tackle.

"Could we approach one of the art-dealing consorti-ums?" he suggested. "Artemis or Modarco?"

"And cut them in on the profit, too?" roared Charles. "No, we bloody well cannot!" More quietly he added, "That would be an absolute last resort. I've nothing against them and they certainly have the funds. I just don't want to split this deal any further."

"And we have seven days?" James Constant spelled out the question so as to underline it.

Charles ran his fingers through his thick hair and shrugged his shoulders. "We should have sold a share in the business to a bank long ago. How else can we compete? Artemis has the Bank of Brussels behind it, Colnaghi's are tied up with Rothschilds." He looked straight at Constant. "Lucy will have to give way in the end. Meanwhile, as you say, we have until next Saturday. If we had a firm purchaser, Wild, could we talk a merchant bank into a three- or six-month loan, a once-only arrangement?"

James Constant stared at him in amazement. "You mean asking for a loan against the sale of the Botticelli? Why, it's our principle never to buy with a particular client in mind; the risks of failure are too great. We only buy what we believe in."

"Listen, James." Charles's voice was even, though tense. "We are trying to survive. We may need to change our principles, adopt less traditional ones. Shipowners raise money to build tankers on the security of long-term charters to oil companies. Why

can't we raise short-term money on a sale to Hanson, assuming Webster confirms the museum's interest when he sees the painting? Damn it, we may only own a half share, but we are in physical possession of the thing."

He could see that Constant was shocked and decided to attack harder. "Don't tell me it's unethical, James. We're not in church. We're in business, and from what little I saw of our German colleague, he's the sort who'd sell his grandmother."

"What are you going to tell Lucy?"

"Nothing. For the moment. Simply that we are arranging finance, by which I mean that you and Wild have tomorrow to find a suitable bank. Then I'll do the talking. I want the groundwork laid by Wednesday night when Webster comes."

To Charles's surprise, Wild accepted the idea enthusiastically.

"I don't see why not," he said. "But they'll charge a cracking rate of interest."

James Constant was unconvinced. He had begun voicing further doubts when the telephone cut him short. He reached for it, then beckoned Charles across. "It's Samantha. She's in Belgium."

Charles went to the corner table and took the receiver. After listening for several minutes he said delightedly, "You're a good girl, my dear. A very good girl. You just find yourself a bed for the night, drive out to the airport in the morning, hand the car back to Hertz and go to the British Airways desk. They'll have two seats on the first available flight. One for you and one for the pictures. Don't let them out of your sight. When you get to London ask the customs for the Merchandise in Baggage Office. The MIB they call it. Kind of glass cubicle with two or three customs men. The agent will meet you there. Have that letter from Herbstein ready in case they want it. But the agent will have one from us and he'll do the VAT forms. . . . You're what? . . . Short of money." Charles laughed. "Never mind. Go to the Hotel Amigo, just off the Grand Place. I'll ring and tell them to send the bill to

us." He put the phone down and faced the others, beaming.

"This calls for a drink," he said and went over to the sidetable, where some bottles stood on a silver tray. "Come and help yourselves."

He poured himself a whisky, took a gulp and explained. "We have a lot to thank Samantha for. Our kraut friend failed to produce the export permit. Never showed up this morning at all. She couldn't get any sense out of his secretary, so she put the paintings in a rented car and drove them to Belgium."

"You mean she smuggled them out?" asked James. "I fail to see what's so clever about breaking the law. The next thing will be a string of official complaints, or worse." His disapproval of Samantha was plain in his face. He was aware of Charles's relationship with her, though he usually stopped short of criticizing it openly. "You put far too much faith in that girl, if I may say so."

Charles was standing, whiskey glass in hand, beneath the big portrait of Sir James Luttrell. He flushed slightly, then jabbed his thumb up at it. "Do you think he'd have hung around waiting for permits? Like hell he would. We could do with more of the old man's buccaneering spirit! Anyway the complaints will land on Herbstein, not us. He handed over the pictures to Samantha without the permits." He stared angrily at Constant. "Which would you rather have, James, a minor infringement of someone else's laws, or no Botticelli to show Webster?"

"It smells of undercover dealing to me," said James doggedly. "I don't like it. We're risking our reputation."

The accusation stung Charles. Undercover dealing could mean anything from selling fakes to tax evasion or exporting pictures illegally, and word that a gallery was up to it would soon spread in the small circle of the international art world.

"Nonsense," said Charles ebulliently. "Herbstein assured us the permits were a pure formality. Get your-

self a drink and thank God we've laid our hands on something first-rate to sell." He would like to have toasted Samantha, he was so pleased with her initiative. She had provided just the indication he needed that things were going right at last. He drained his glass, thumped it down on the table and glanced contemptuously at Constant and Wild. "Well, gentlemen," he said, "if you will forgive me, I shall go and find myself some dinner. The food on the aircraft may have been free, but beyond that it left a lot to be desired."

In spite of Charles's brisk and confident instructions, Samantha was apprehensive at Brussels airport. The ticket for the two seats was at the British Airways desk, but she needed help carrying the paintings, and although no one else seemed to be questioned by the customs, she was immediately pounced on. The officer examined minutely both Herbstein's letter and the bills of sale from previous owners and then said unpleasantly in French, "Where are the declarations you made on arrival? You state that you brought them in a car. You should have one copy of the forms given you at the frontier."

"I wasn't stopped at the frontier. They just waved me through."

"You should have stopped." The officer was unyielding. "You cannot take these goods out of the country until you produce the form declaring them on arrival."

"But how can I?" Samantha looked at him pleadingly. Was he simply being a bureaucrat *par excellence*, or did he think they were stolen or in some way illegal? His face was expressionless.

"You will have to return to Eupen. Only the customs post at which you entered Belgium can issue the forms."

"Go back? I can't. I haven't even got the car any more! I must catch the plane."

"I'm sorry. It is your obligation to obey the law.

How do I know where you obtained these pictures? Why did you not fly direct from Germany?"

Samantha began to feel desperate. This was absurd. If the Germans had questioned her like this it would have been understandable. But these people? She decided to use her original cover story.

"I wanted to see a friend in Brussels. Please, you can check it all. I stayed last night at the Hotel Amigo. I came in a German car which I turned in to Hertz this morning." She tried to sound angry instead of frightened. "Telephone and ask if you don't believe me. No one told me I had to stop at the frontier, and God knows it was long enough before the Germans let me through. Nearly an hour while they searched everyone. On your side they didn't even stop me."

Whether it was because she sounded genuine or just that he was impressed with her fluency, Samantha did not know. But he relented, albeit with bad humor.

"Very well," he said, holding up his forefinger at her like a schoolmaster admonishing a pupil. "This time I will allow it." He handed her a long form. "Complete this, and next time follow the correct procedure."

Even so she had to ask for his help, which he gave only grudgingly. She missed the plane, and by the time the next flight landed her at London Airport she was in a state of nerves about facing the British customs.

The MIB did indeed prove to be a glass cubicle, but because she'd missed the flight the agent was not there. However, one of the customs men summoned him, and after a short delay he arrived, clutching a folder.

"Here you are, Miss. All you have to do is sign." He gave her a white form headed "Imported Secondhand Works of Art, etc. Claim to Relief from VAT" and said, "Sign at the bottom."

"You can prove that this is a work of art disposed of by the creator or as part of his estate before April 1, 1973?" asked one of the customs men with conscientious formality.

"Too right," agreed the agent sunnily. "Botticelli and Memling! Haven't seen the light of day a good

long while, those two haven't." He handed over two letters on Luttrell's writing paper. The customs officer scanned them briefly. The first read:

Purchased from Herbstein Kunsthandlung, Frankfurt. One painting by Sandro Botticelli 1445–1510. Value £950,000. We hereby declare that the above painting is an original work of art by the artist named and of the period stated.

Charles Luttrell's flamboyant signature followed above the single word "Director." The second letter was similar, affirming the Memling's value as £100,-000.

The customs officer whistled, suddenly becoming human. "You've a couple of good ones there. Let's have a look, then."

Samantha was about to protest, but the agent silenced her.

"Taking in a good bit of art never did no one no harm," he said and swiftly revealed the Botticelli.

"So that's what a million quid looks like!" sighed the customs man. "You must be glad to have it back safely!"

"I am," replied Samantha fervently, surprised in spite of her experience by the eightfold increase in the painting's value which had taken place since she set out with it. "I most certainly am." Presumably Charles was building up evidence of the value he put on it. This would make it appear he had paid highly for it himself before fully authenticating it. Once that was done the price would rocket again.

"Well, just sign the green General Import Entry form and you're away," he said genially. "Myself, I wouldn't pay that sort of money even if I had it. Not for a prissy-looking bird like that."

"Not to worry," said the agent. "It's all in the eye of the beholder, beauty is. Come on, Miss, we can go now."

Monday seemed to last interminably for Karin, one disappointment relentlessly following another. In the end the police captain had accompanied them to Herbstein's house and had interviewed the sick dealer for a few minutes, but the formidable wife refused to allow either Gerhard or Karin in. When the policeman emerged he was convinced the Botticelli was not there.

"Herr Herbstein points out," he said as they drove away, "that he merely allowed the Englishman's assistant to examine the picture at her leisure. She was asked to call on him today. Unfortunately, as we know, he was indisposed. If she has broken the law subsequently, that is her affair." He glanced briefly at Gerhard. "Maybe they will have news of her movements at headquarters. But frankly if she has taken paintings out of the country it would be more or less a technical offense, since the export permit would certainly be granted if Herbstein made the application."

"But what about the Kunsthistorisches claim?" protested Karin. "Doesn't that count?"

"If a court had ordered the return of the picture, yes, it would, Fräulein. Otherwise it's a matter for civil lawyers, not us."

When they reached the headquarters the only news was that the English girl had definitely not left by air and that the registration number of a car she had hired was known.

Eventually Gerhard took Karin back to his apartment and brewed coffee for them both.

"What annoys me," said Karin, "is the way the policeman's enthusiasm vanished after he actually spoke to Herbstein."

"You saw Herbstein's wife! She'd frighten the devil himself. And they're not a poor family. They have friends. She probably warned the captain that if he went one millimeter beyond the exact authority of the law, it would be him in court, not her husband." Gerhard laughed cynically. "Those two will bluff their way out of anything short of an actual criminal charge. The

person who puzzles me is the man from Berlin. We don't even know who he is."

Karin lit a cigarette, settled deep in the sofa, kicking her shoes off, and then said, "Does that matter? We want to know where the pictures have gone, not where they came from." She sank back into the cushions and ran over the sequence of events again in her mind. Herbstein had told them the Memling was away with a client. Yet the secretary specifically stated he had wrapped up both it and the Botticelli and taken them to his car. Obviously he had been lying, but why? Perhaps he was frightened of claimants. If so he would be every bit as secretive as the secretary insisted he was.

"Gerhard," she said at length, "if he knew someone was coming to claim the Botticelli he might have decided to send it out of Germany. It must have gone to London."

Gerhard watched her. God, how attractive she was. He would be happy to have her stay longer. He debated briefly with his conscience and then gave way to it.

"I wish you would stay here. But you should go there before the pictures have time to be moved again. That girl wouldn't make the mistake of failing to declare them to the English authorities—at least not if there was any possibility of wanting to export them later. They'll be traceable."

"I agree." Karin swung her legs around and sat up so she could reach the telephone on the sidetable. "May I telephone my boss? I'll keep as brief as I can."

"Of course."

Herr Kameier was about to go home from the Kunsthistorisches and reacted petulantly to Karin's request.

"My dear colleague, we were wondering what had become of you. Two of the staff are down with colds. I need you here."

"But I've found the Botticelli!" She related her story. "It would be madness not to follow it now."

"Are you sure?" She could hear warmth creeping into his query. He was interested.

"Completely."

"What will it cost?"

She could imagine Kameier's bureaucratic brain analyzing her request in terms of time off and expense.

"Very little, I promise you!"

"I'll still have to ask the Hofrat. Our budget is low as it is. If it was the new fiscal year . . ." Patiently she let him finish.

"It's nothing compared to the value of the Madonna, Herr Director," I'm sure the Hofrat will think of it that way. And isn't it fantastic how the Memling did lead us to it?" She was careful to speak as though they were a team, knowing how strongly ambition motivated him. It was vital to keep him on her side.

There was a pause. She could imagine his hesitations.

"Very well," he said at last. "On this one occasion I'll square the Hofrat. Get in touch with Bostock at the National Gallery. He speaks German and we gave him some help recently."

"Thank you a thousand times, Herr Director," she said as she rang off. The gratitude was not forced.

"I'll give you some friends' addresses," offered Gerhard. "London hotels are expensive."

"Oh, thank you, that is kind." Karin smiled up at him. "I wish you were coming too."

"Maybe if you come and flirt with my director he'll let me." Gerhard grinned, then became serious. "Unless you object, I'll keep inquiries going at this end, especially about the man from Berlin. I don't like the sound of him.

"Suppose this man had a claim that went back to before the war, before the picture was on loan to the Kunsthistorisches."

"That's impossible. Quite impossible." The suggestion annoyed her.

"You're very certain."

"Yes, Gerhard, I am. Its history is too well docu-

mented, at least since the Waldhofens bought it in 1822." Her eyes clouded as she remembered the troubled saga of the family. The First World War had taken their wealth, the Second took them, all except her godfather, and he had died with no known heir in 1964. "It's a funny thing," she remarked abstractedly, her mind full of images from the past. "Pictures somehow survive longer than families. Think what the Madonna must have been through since Botticelli first painted her in Florence. There are three and a half centuries unaccounted for between then and the eighteen-twenties. Someone preserved her all that time. She hung in a villa, or a palazzo or a castle, always treasured, handed down many generations."

"Or was stolen from a church!" observed Gerhard wryly.

"Don't be so cynical!" She came out of her reveries with a start. "I admit I think she did originally come from a church. From San Salvatore al Monte in Florence to be exact. But you're still a cynic."

"And you're too romantic," argued Gerhard unrepentantly. "Botticelli was forgotten, not treasured. The critics rediscovered him only in the nineteenth century." For a moment he thought he had offended her. She was sitting up on the edge of the sofa, her eyes fixed on him angrily.

"Well, the Waldhofens *did* know who he was and they *did* cherish this Madonna, long before Berenson and the rest of them made him fashionable again. What's more, they bought her quite legitimately. They were a great family and great collectors." She tossed her head defiantly. "I'd rather have one Waldhofen alive today than ten Botticellis."

"If you had, you'd stand a better chance of claiming the Madonna successfully." It was the truth, but he immediately regretted expressing it so badly. He could see she was flaring up. "I know how you feel about the Waldhofens and what the Nazis did to your family," he said quickly, looking at her with genuine affection. "That's why I'm trying to help."

Suddenly Karin was close to tears. "I can't even remember my mother," she said, only just controlling her voice. "My godfather did everything for me after she was killed."

Gerhard crossed to the sofa and held her hand. "I understand," he said softly.

There was a silence.

"If only the Waldhofens could have the Madonna back," he said. "Are there no relations alive at all?"

"He sent his daughter to America in 1938. After the war he tried to trace her. An American diplomat helped. The trouble was he couldn't afford to go and search himself. Anyway, after forty years she might not even be alive herself. She was eighteen when she left." Karin shook her head. "No, as there aren't any Waldhofens, I want the Botticelli back where he loaned it, back in our museum."

She sat up on the sofa, relinquished his hand, gave him a little kiss and said more cheerfully, "So, you see, I'm a one-woman crusade. And I'm forcing the great Herr Kameier to come along with me because he'd like to have a Botticelli in the Kunsthistorisches and so would the Hofrat." She smiled. "The Hofrat's my secret ally. You'd like him."

Gerhard grinned. "Don't forget he's not your only one. As that American bank advertisement says, 'You have a friend here at the Stadel.'"

Karin laughed, as he had hoped she would. "You're a darling, Gerhard. Thank you."

"Now," he said, delighted to have restored her spirits, "all you have to do is relax. There's no point in going to London tonight unless you want an extra hotel bill. You can catch an early flight tomorrow. Doesn't that make sense?"

She nodded. "Yes it does. I'm exhausted. And very, very grateful."

He took her hands and gently pulled her to her feet.

"Go and have a bath, then, while I make a reservation for dinner. We may not have earned a celebration, but at least we deserve an evening out."

For Hans Herbstein, Monday was a time of excruci-
ating indecision. The interview with Raeder in the
misty cold of the Vita Parcours had not in fact induced
a heart attack; it had merely put him into a sweat of
fear so intense that he was shaking when he reached
home. This, his pale expression and the way he de-
manded cognac and collapsed into a chair without
changing convinced his wife that he had suffered some
kind of seizure. Because he so desperately wanted to
be quiet and think, he allowed her to pack him into
bed and tell the rest of the world he was ill. When the
doctor found his heartbeats fractionally irregular and
asked if he had been overstraining himself at work, it
was only a short step to diagnosing the threat of a cor-
onary. Herbstein accepted the bad news gratefully. The
last thing he wanted to reveal was the truth; and he
doubted if even the SS man Raeder would get past the
formidable barrier of his wife.

However, the arrival of the police in the afternoon
upset things. After his wife had successfully brow-
beaten the captain into retreating, she turned on him
for explanations.

"Small wonder you're at death's door," she snapped.
"Never have my family suffered such a disgrace as
being questioned by the police. What's it all about, I
want to know!"

He told her the minimum—how he had made a deal
with Luttrell's after legally purchasing two paintings
from a dead businessman's executors.

"Then we'd better find out where this English
Fräulein is!" she declared forthrightly and telephoned
the Intercontinental. Her next conclusion was equally
inescapable. "If the little bitch has smuggled them out,
we could be charged with complicity in the offense.
Your heart will just have to stand a morning in the of-
fice arranging those export permits. Tomorrow morn-
ing! I'll not have our name dragged in the mud, thank
you."

So Herbstein spent a miserable night working out
schemes to deal with the SS demands. Assuming they

were after the money the Botticelli represented, not the picture itself, everything would hinge on their knowledge of current art prices. Bitterly he reflected on Luttrell's low valuation. Had it been mere bluff to force his price down? Almost certainly, though the woman from Vienna had not been enthusiastic either. But his instinct told him that she had also been putting on a performance. He deliberated some more, finally deciding the best solution was to quote Luttrell at the SS man, pretend he had made an outright sale and offer what he would receive from Luttrell. At least he would still have a half interest in the profit. Having examined this from all angles, he was satisfied and at last fell asleep exhausted.

In the morning he took a taxi to town and immediately began completing the necessary forms. After checking again by telephone with the Kulturministerium that the Botticelli was not on the index of works of art forbidden to be exported, he sent his secretary around with the papers to another well-known Frankfurt dealer who was a member of the five-man commission that made decisions on the matter, the resoundingly named Sachverständigenansschuss des Hessischen Kulturminister. Its members were entitled to sign export permits individually and met only collectively if a work was of potential national importance. To make quite certain of an easy passage, Herbstein described the Madonna as "School of Botticelli" rather than "Studio." He set the value at $125,000 and attached a black-and-white photograph, together with a note saying "Would be grateful for your signature. As you know, the master's own version is in the Dahlem Museum. This is an almost exact copy."

It was a neat utilization of Charles Luttrell's assessment. For the first time in twenty-four hours Herbstein smiled to himself. He was still feeling pleased when Raeder walked into the gallery.

The timing was no accident. Raeder had been sitting in the restaurant across the Romerberg, dilly-dallying over a number of cups of coffee since before the gal-

lery opened. The dealer and the secretary had arrived so nearly together that he had not gone straight across. He wanted Herbstein alone, and he was prepared to wait, if necessary, until the man left for lunch. The waiting gave him time to think, and he thought particularly about Horst, whose heirs this bastard had defrauded. Basically, it was because the two of them had sworn an oath that he was here now. They had sworn it, unforgettably, when they were both just eighteen, paraded along with other SS recruits in the snow outside a barracks.

"I will see in every member without thought of class, occupation, wealth, or poverty only my true comrade, with whom I feel myself bound in joy and sorrow."

Little more than a year later the significance of those words had been hugely increased when he bayonetted the American officer to save his comrade, and the same personal bond had prompted him to help Horst out of East Berlin. In turn that loyalty was repaid by the inheritance of the Botticelli. As he watched the shopfront on the far side of the square Raeder reflected on the illogicality of a Fascist oath helping restore a treasure to a Communist government. So what? Those were just political labels. The things that counted were comrades and the Fatherland. If Herbstein tried a second double cross he would kill him as surely as he had the American. The only difference was that this time it would be more subtle.

After an hour the secretary emerged again, wearing an overcoat and clutching a large brown envelope in addition to an umbrella. No visitors were inside either. Raeder knew his wait was over. As he entered the gallery he closed the door and clicked the lock on. Then he walked briskly through to the office.

Herbstein was already on his feet behind the desk, alerted by the soft buzzer which the door activated.

"Where is the picture?" demanded Raeder menacingly.

"Unfortunately . . . I . . . There is a good aspect . . ." The words were not flowing as he had rehearsed them

lying in bed last night. He tried again. "For you it is good news. You will have the money."

"What do you mean?" Raeder stood a full six inches taller than the pudgy dealer, broad-shouldered, solid, implacable. "Explain!"

Herbstein waved his hands distraughtly. "Please sit down. It's really quite simple. I swear it's the best thing for you." With one big hand Raeder hefted a chair across and sat down, facing the dealer, the desk between them. He made the concession into a gesture so forceful as to be intimidating. Herbstein subsided into his own upright leather armchair.

"I told you the picture was with a client over the weekend. Yesterday when I was ill he telephoned. He offered one hundred and twenty-five thousand dollars." He lingered sensually on the figures.

"Dollars? You never told me it was a foreign client."

"They pay better." Herbstein misinterpreted the taut concern as greed and endeavored to pander to it. As he talked Raeder drew a pack of cigarettes from his pocket and began to open it.

"So you see," the dealer went on, thankful that his speech was back on course, "all that money is yours, less normal commission, naturally. It's a high price." He spread his hands eloquently. "We were lucky."

Long training had made Raeder self-controlled. He could switch from iciness to anger in seconds and after that be genial, while throughout his mind worked fast and calmly. Now, as he played with the pack, gently tapping the end to see if one cigarette would slide out freely, he was harsh.

"You forget two things. First, the Botticelli's value is ten times that. Second, you signed a release yesterday. You had no right to sell."

"I do assure you, it is not so valuable. Far from it." Herbstein slipped comfortably into his spiel. "Any expert would confirm this. The picture is only in the School of Botticelli, by followers of the master. None of it is what we call autograph."

"You're lying." Raeder recalled the Bode Museum

director's enthusiasm. The Bode had the documentation. They knew it was genuine, though he could hardly quote them since that would reveal his East German origin. "What I want is the painting. Never mind the money."

Herbstein stared at him, genuinely amazed. "Surely your organization would want to sell. They should accept such an exceptional price."

"Are you telling me it is no longer in the Fatherland?"

"This particular client is in London."

"Who is he?"

Herbstein wavered. He emphatically did not want trouble there. It might affect the sale, though one day he would enjoy paying Luttrell back for beating him down so unmercifully.

Even as he hesitated Raeder reached out casually across the desk, clasped his left wrist and twisted his arm hard. The dealer yelped as the pain forced him to lean over sideways. When he was almost horizontal and thought his forearm would break he capitulated.

"Luttrell's. The famous dealers. They have paid an excellent price."

"You mean you cannot recover it? You've sold it?"

"Please. Consider the money. Privately you would never get half so much. My commission is negligible."

Disgustedly Raeder released his arm, watching him straighten up and start rubbing his wrist. So the Botticelli had gone. For a moment he considered the cash but as quickly dismissed the idea. He had no desire to defect and set up as an exile in the West. In any case there would probably be further double-dealing over the money. The bastard deserved what was coming to him.

"So. It's one hundred and twenty-five thousand dollars, less 'normal commission,'" said Raeder, totally changing his tone and leaning his elbows on the edge of the desk.

"In business everything is negotiable," muttered

Herbstein, resentfully massaging his arm. He was badly frightened, yet thankful that the SS man was beginning to see reason. "We can discuss the exact percentage of commission. Fifteen percent is normal."

Raeder grunted as though considering this, then said casually, "Here. You look as though you could use one of these."

He picked up the cigarette pack, tapped it gently so one eased out and thrust it toward the dealer. "They say it helps the nerves." Repeating the exact remark he made in the Stadtwald was deliberate. It offered a familiar landmark in an uncertain situation. Last time it had given Herbstein a smoke that had sustained him greatly. This time, as Raeder expected, he did not even hesitate. He leaned forward to take the one loose cigarette. As he did so Raeder squeezed the sides of the pack hard. There was a "pop" like a cork being drawn and a whistle of escaping gas. The effect was instant. Herbstein's face turned white, he began to choke, his hands flew up to his face and he collapsed over the desk before he even had time to cry out.

Raeder rose and stepped back. There was a faint smell. He skirted Herbstein's body and opened the only window, then walked calmly out through the gallery, unlocked the door and, after glancing around in case the secretary was coming, became lost among the other visitors to the square. He regretted having to kill the dealer indoors, because it meant there was a risk of the gas being detected. But it was only slight. When the KGB had used a gas gun disguised as a cigarette pack in Munich in 1959 they had successfully assassinated three Ukrainian exiles whose deaths were put down to heart failure. The truth came out only after the KGB colonel concerned defected to the West. Who would suspect poison gas here in Frankfurt, nearly twenty years later? No one. Especially not when the doctors knew of Herbstein's earlier collapse. He walked briskly out of the Romerberg, found a taxi and had himself driven to the airport.

Returning to Berlin by the way he had come, Raeder left the Friedrichstrasse S Bahn station and made his way down a street alongside the elevated railway toward the Museum Island. There was no escaping the need to explain events as soon as possible. In the distance the slender television tower thrust up over the city, its top a silver gray globe surmounted by a red-and-white-striped needle like a monstrous lance pointed at the pale sky. The air was noticeably chillier here than in Frankfurt, reminding him that winter was not far off. The river ran oily and dark beside the museum walls, somehow deepening his qualms about having failed to retrieve the Botticelli.

The Bode director was initially polite, but an icy undercurrent soon crept into his reception of Raeder's news, from which only the actual cause of Herbstein's death was omitted.

"It is most regrettable, Colonel." The director's eyes seemed swollen through his heavy spectacles. "So you never actually saw the painting."

"No."

"It would have been simpler if we could have recovered it quietly from the Bundesrepublik with no fuss."

"I realize that," replied Raeder, irritated by the implied reprimand. "But we had not expected it to be in the hands of a dealer."

"Whose death came at a most unfortunate moment." As the words sank in, Raeder watched the trees outside bowing in the wind on the other side of the river. Everything was gray—the buildings, the water, the sky. It seemed appropriate that the director should be suspicious.

"Did you know that there was also another painting removed from the gallery on Saturday? You did not? It was a small painting by Memling, presumably also looted by your dead friend Horst many years ago."

The threat was tangible, as real as if the director held a gun in his hand. The past was being used against him. In a police state one can never escape the past. But Raeder had not risen from the ranks for

nothing. He sat rocklike and unshakable, calmly gazing back at the little man in his steel framed glasses, methodically counting over the possibilities before answering. Obviously the museum had checked back with the Stasi. Possibly that odious clerk had squealed and told them about Horst's letter. Hell, he could have a clear conscience there. Far from concealing it, he'd revealed its existence to Marklin at the start, and Marklin was a friend. Maybe the way to deal with this museum official was to do what he always did with opponents— namely, outface him.

"Come to the point, Herr Director," he demanded. "Of what are you accusing me?"

"You have said that you first visited Herbstein's gallery on Saturday?"

"Correct."

"It is a curious coincidence that the Memling also disappeared."

Abruptly Raeder realized that the director did not know the contents of the letter. This was a suspicion of a different origin. The Stasi had agents in the Hessen police. He must have been watched in Frankfurt and the disappearance of the Memling misconstrued.

"If I had taken either painting for my benefit I should not be so stupid as to be here now," he said, coldly confident that he could now put the director in his place. "May I suggest you leave the interpretation of Stasi reports to us, and we will leave questions of artistic interpretation to you." He rose to his feet, hoisted his briefcase up onto the director's desk and pulled out the release signed by Herbstein.

"You are welcome to this. I don't give a damn what happens to the picture. If you want it, then you have my full authority to act in my name. I had no knowledge of its existence until Schneider left it to me, and I am completely happy for the Bode to claim it."

He closed the briefcase, gave the minimum of salutation that the director's rank required and walked out.

Half an hour later he was seated in Marklin's office at the Stasi headquarters, relating what had happened.

"I like that," chuckled Marklin. "When I was attached to an embassy the Russian ambassador was always staging walkouts from conferences. *"Niet,"* he would say, and all the rest of us from the bloc would troop out behind him. We had some fun, I can tell you."

"Fun apart," said Raeder, who was too well aware of the risks he was taking to feel humorous, "how much did you tell the museum?"

Marklin leaned across the desk, his expression serious now, and spoke in a low voice. "Enough as was necessary for your own good, Comrade. When the Culture Minister heard about the Botticelli he was extremely excited. It is one of his ambitions to recover more of the great works of art which belong here but are held in the West. A complete investigation has been ordered into how your late friend obtained it, in fact into its whole history. Any further attempt at retrieval will have full official backing. If the museum director is in a sour temper it may be because some of the blame for your failure falls on him. I stressed your total ignorance of the art business. He should have sent an expert with you."

"He had a nerve accusing me of stealing the Memling. I never even saw that either." Raeder glanced at his colleague and decided to chance the one question he was almost afraid to ask. "How much did you tell the museum about that letter I received, the one I showed you?"

"Merely that it informed you of a bequest." Marklin saw the relief in Raeder's face and smiled. "I may be a bastard, but not to my friends." He reached down to a deep drawer in his desk and produced a bottle and two small glasses. "A good officer is never without schnapps. *Prosit!*"

They both drank at one gulp. Marklin refilled the glasses. He sat down again and looked directly at Raeder.

"The ministerial investigators are going to want to see that letter."

"Unfortunately Herbstein made its destruction a condition of signing the release. He was afraid of its being used as evidence that he had dealt in stolen goods."

Whether Marklin knew this was a lie or genuinely believed the explanation, Raeder never discovered. All said. "*Prosit*."

"What happens next do you suppose? Will they want me to go after the picture again?"

"That will depend on whether the Botticelli belonged legally to the Bode. And where it ends up. The minister will decide. If I were you I'd take the rest of the afternoon off and go home."

Raeder thanked him for being a true friend and took his advice. When he got to his apartment his first action was to burn Horst's letter. Then he spent an hour considering his position and came to two conclusions. The first was that sooner or later the ministerial inquiry would probe the exact circumstances of Horst's departure from the city. If the clerk had read the letter, or if Marklin was pressured by his superiors, then he was going to be in trouble. The phrases in it about helping Horst and taking another painting could only be construed to mean that he had assisted Horst take out both the Memling and the Botticelli. That Horst had deceived him would be no defense. The other conclusion was that if he were sent to bring back the painting a second time, he would have to be damn certain that other officials were involved too. He could not afford a further single-handed failure or risk being tricked by a dealer again.

The arrival of the Botticelli caused considerable excitement at Luttrell's. Despite Charles's efforts to keep his acquisition secret, by Wednesday all the staff knew there was a masterpiece in the building. Returning after calling on a merchant banker that morning, his mind preoccupied by the ferocious terms demanded for a loan, he was called to the third floor, where Samantha was researching in the reference library.

On the way up the oak-banistered stairs, Charles was confronted by old George, the restorer, coming down. "Why, Mr. Charles!" he exclaimed, running the palms of his hands down his paint-stained overalls, as if he needed to clean them before addressing his boss. "You have a beauty here, sir, a real beauty. That's the kind that speaks to you, truly."

Charles made an effort to be polite, in deference to the restorer's being one of Luttrell's longest-serving and most devoted employees.

"George," he said with a bonhomie he was far from feeling, "keep it under your hat for God's sake, old chap. I already have a client interested, and if he does buy, he's going to publish it. I'm promising him all the glory. Too much talk around Bond Street could easily wreck the deal."

"Oh, I quite understand, sir. Mum's the word." George contrived to look conspiratorial. "Don't want it getting *brulée*, do we, sir?" Charles nodded. The French word was sophisticated art jargon for "overexposed," and it sounded all wrong coming from a man so archetypically English. It was as if he had started ordering *turbot à la reine* for lunch instead of fish and chips. Nonetheless he was right.

"I'm not even showing to anyone else," said Charles.

"Indeed you shouldn't need to, sir. It would be a fool who turned that down. In surprising condition too, sir. Someone's been looking after it all right. Whoever did the cradling was a real craftsman, and it hasn't been overrestored either. All I'll need to do is give it a very, very gentle bit of a clean and a fresh varnishing. In fact, there are some museums would like it better just as it is."

That's your precise problem, my friend, thought Charles. As he was always telling Lucy, there wasn't enough work here for a full-time restorer, and when something superb came along, as likely as not they would send it out to a specialist in the particular artist's work. Freelance restorers charged a lot, but in the long

run they were cheaper. If you added up George's salary, the rental value of his room, the heat and light and all the other overheads, then he was a luxury Luttrell's could no longer afford, like Lucy's butler at the country house. Charles wondered if he realized it.

"The Memling, though, sir," George went on, his voice troubled, "that's another kettle of fish. It's in poor condition. Frankly, Mr. Charles, it needs six months' work, and in the end I'm not sure as it would be worth it."

Charles shook his head dubiously, though he was thinking more about the thrusting way the restorer blurted out an opinion so destructive of his own interests than about the Memling.

"Well, I mustn't keep you, sir," said George, at last sensing something was wrong and standing back to let him pass.

Upstairs, Samantha was poring over a large volume in the library. It was a fair-sized room, the walls filled to the windows with slightly dusty bookshelves, plus a range of filing cabinets holding photographs. A small pile of books stood on the table where she sat. She looked up as Charles entered.

"I'm so sorry to drag you here. I'm trying to substantiate those bills of sale and I have a nasty feeling that I can't."

Charles sighed, drew up a chair beside the table and sat down. "Everybody has problems today." He glanced at the book, then at her, noticing the way her long blond hair was held back by a velvet-covered band so that it framed her face and fell softly on her shoulders. No, he did not want to lose her. Furthermore, he could rely on her for a sympathetic hearing, which was more than Wild or James Constant were likely to provide.

"You remember we have to pay Herbstein by Friday afternoon?"

"How could I forget!" She managed a rueful smile. "It cost us our weekend, didn't it?"

"Well," Charles continued, ignoring this lack of immediate compassion, "I've raised the money and been crucified in the process. Anything we did to the kraut was tea at the Ritz compared to this morning's little session."

"Sweetheart, why?" She was genuinely concerned, though it was hard to believe that anyone could negotiate him into a corner.

He slipped a thin gold case out of his pocket, offered her a cigarette, lit it for her and then took one himself. She reflected that he was as well dressed as ever, although the carnation in his buttonhole was starting to wilt.

"What went wrong?"

"I went to a merchant bank and asked for a six-month loan against the security of the painting and its likely sale. They want interest at seven percent over the base rate. What's worse, the loan is conditional on our having a letter of intent to purchase from the West-hampton College Museum. That means from Webster when he arrives. Furthermore, if the deal falls through later on, the bank reserves the right to take the painting off us for what we paid, or rather take our half share in it."

"That is pretty tough." Samantha drew in her breath sharply. "So everything depends on Webster."

"Of course he can't make a final commitment to buy for the museum while Hanson is in Australia. He can only sign to the effect that the museum intends to buy subject to Hanson's consent. Which is why the bastards insist on the right to take our share in the picture in satisfaction of the loan if it all falls through."

"What would they do with it, for goodness' sake? They don't know how to sell pictures."

"Exactly." Charles laughed harshly. "But all they'll want is some kind of profit. They'd post us a bill for the interest incurred and send the Botticelli to Sotheby's or Christie's for auction. It wouldn't fetch as much as I could get for it, but the bank would still come out very nicely in pocket. At the very worst they'd double

their money, and just to make sure they're placing one last obligation on us."

"I think I can guess what that is," said Samantha slowly. "They want it fully authenticated."

"Exactly." He stubbed out his cigarette with unnecessary force. "So will Webster, of course. Thank God old George is as excited about it as I am."

Without thinking Samantha reached out and touched Charles's hand. "Charles, I don't want to worry you unnecessarily, but I can't find a single reference to this Madonna anywhere. You know the Munich bill of sale states it was in the Waldhofen collection. If Waldhofen did compile a catalogue, there doesn't seem to be a copy in London. It's the exact opposite of the problem I'm having with the Memling, which was well documented until it disappeared during the war. I have a nasty feeling that picture was looted or stolen at some point."

"Let's forget the Memling for the moment, my dear. George doesn't think much of it anyway, but he has gone overboard about the Botticelli." Charles checked himself, realizing how uncomfortably easy it was to fall back on the opinion of a supposedly redundant employee. He pulled across the sheaf of notes Samantha had been making and perused them, idly running his fingers through his thick hair, a habit he would never have indulged when with a client.

"We need two things. First the attribution from the Waldhofen catalogue. Webster's bound to demand that. If you telephone the Dorotheum in Vienna they might look it up for you. Secondly, we have to prove there was a lost Botticelli similar to the Berlin one." He shook his head agitatedly. "It's at the back of my mind somewhere. What did you find in Vasari?"

Samantha handed him an old volume, entitled in faded lettering *Vasari's Lives of the Painters.*

"I've inserted slips of paper where there are references to Madonna paintings," she said, thinking she had seldom seen him so worried before.

Charles flipped through the pages and suddenly snapped his fingers.

"Got it!" he exclaimed. "This is the one. 'In San Francesco, outside the gate of San Miniato, Botticelli painted a Madonna the size of life, surrounded by angels, which was considered a very beautiful picture.' There's the modern annotation in the footnote 'This work is lost.' By God, we've got it!"

"But he painted dozens of Madonnas with angels," protested Samantha.

"Did you read about the copy?"

"Well," said Samantha disparagingly, "I read that extraordinary story about his pupil Biaggio doing an exact copy to sell to a merchant and how Botticelli secretly stuck paper hats on top of the angels before the merchant came to take delivery."

"You didn't read it carefully enough, my girl. Listen. 'Sandro and Jacopo, who was another of his disciples, prepared eight caps of pasteboard, such as those worn by Florentine citizens, and these they fixed' et cetera, et cetera. Eight, my dear, eight. One for each angel. Oh, it's a famous story, and many experts have tried to identify Biaggio's version."

"Yet Berenson thought the Berlin one was a studio work," said Samantha, her voice trailing away as she realized the drift of Charles's thoughts.

"Exactly. You just go through every known work on Botticelli and assemble the evidence against the Berlin one. We want a real dossier. Check them all. Herbert Horn, Yashiro, Ullman, the lot. Come back to me if you're stuck."

"I do know where to look, you know," said Samantha, wounded. "I do have a degree in art history."

"The first step to misunderstanding painters," roared Charles triumphantly, his good humor restored. "Means you can't see what they've done because you've read too many theories. Just like this bloody man Webster. Couldn't paint a baboon's arse, yet he's a museum director. Old George and I know that picture's right because we can damn well see it. Never

mind, with your help we'll produce an academic provenance for the Botticelli which will make Webster swoon."

"Do you think it will work?" asked Samantha anxiously.

"It's bloody well got to, or we're in trouble."

Among the affectations Mervyn Webster had acquired at Oxford was a liking for the ritual English teatime, with its tiny sandwiches, scones and cake. Even he realized the futility of trying to introduce this at Westhampton College—hence his sherry parties. But in London it was different. At the discreet Brown's Hotel, conveniently close to Bond Street, you could take tea in a comfortable wood-paneled lounge, with deep sofas, like a country house. In consequence when in London he always held court at Brown's. He was well aware of the importance Hanson's money gave him.

However, the painting was at Luttrell's, not Brown's Hotel. Arriving on Thursday morning, Webster catnapped for an hour, ineffectually trying to overcome the jet lag of the overnight flight, and then visited the National Gallery to refresh his memory of the several famous Botticellis there. It was afternoon before he finally reached Bond Street. Charles Luttrell came down at once to meet him in the main hall, flanked by James Constant, and welcomed him with the ambassadorial dignity the occasion demanded.

"Too bad you didn't feel like lunching," Charles said with a convincing show of courteous regret. "I'd booked a table at White's. Thought you might enjoy visiting the club again. But never mind, the real feast is here."

He ushered the American into a private viewing room, with James Constant trailing behind. The Botticelli hung by itself in an ornate round gilded frame, the fitting of which had cost Sid many hours of labor in the workshop. It was illuminated by carefully positioned spotlights fitted with bulbs that gave a near perfect reproduction of daylight, free of glare.

For a minute or so they all stood in respectful silence while Webster gazed at the painting. He had done very little research before leaving Westhampton, which had been one reason for calling on his acquaintance Bostock at the National Gallery. Now as he surveyed this tondo, magnificent against the red velvet hangings, and searched for signs of what Berenson called the painting's morphology—tiny details characteristic of the master's hand—he realized that his knowledge of the Florentine School might not be deep enough. He was going to need an authentication by a greater expert than himself. At the same time Luttrell had been right in suggesting it would look good at Westhampton.

"I won't deny it's impressive," he admitted finally. "And you do have a point, Mr. Luttrell. It would shine like a guiding light in our collection. If it's genuine."

"We believe it's the original of the one in the Staatliche," remarked Constant, whose role in this negotiation was to feed in the facts Samantha had researched, tactfully implying that Webster knew most of them already.

"Well," said Webster, "what convinces you that this is anything more than a very fine copy? Have you established a provenance?"

"James," said Charles smoothly, "just dash up and see if Samantha's finished it, would you?" As Constant slipped out he turned back to Webster.

"Happily we know all about the family with whom this picture spent virtually the whole of the nineteenth century."

"Waldhofen, you mean?"

"Exactly." Charles shrugged his shoulders eloquently. "Of course it's nice to feel, as I do, that the picture is right simply because of its initial impact on one. It's even nicer to know where it's been hidden away. As you know, in those days the nobility often refused point-blank to open their gates to visitors." He laughed convivially. "A little different from the Duke of Bedford advertising Woburn on television now.

Can't say I blame him handing the place over to his son. Must be hell."

"Quite true," agreed Webster, only marginally flattered by being thought familiar with the aristocracy. "So at least we can rule out its being a modern fake."

"My dear fellow"—there was more than a hint of acidity in Charles's voice—"you can rule out its being a fake of any period. I don't deal in them."

The door opened softly, and Constant returned with Samantha, who had a book and two sheets of paper in her hand. Charles thought she seemed unusually nervous.

"Ah-ha," said Webster. "Is this the much vaunted provenance?" He eyed Samantha, instantly recognizing her Gucci shoes and wondering just exactly what her angle was. "May I see?"

"I'd rather Mr. Luttrell read it through first."

She backed away and handed the two sheets of paper to Charles. The top sheet had scrawled on it in Samantha's bold handwriting, "Just heard Waldhofen catalogued it as 'School of Botticelli.' What do we do?"

Unmoved, he methodically took out his gold fountain pen, wrote across the note "Tell him to f--- off" and handed it back to Samantha, saying out loud, "Please don't bother me with staff problems now." Then he perused the provenance briefly. She had not altered it.

"Brilliant," he said. "Very succinctly put. I trust our American guest will agree." He passed the sheet of paper to Webster, who glanced at it briefly.

"Oh my. You have been to town!" he said to Samantha. "Do you do this for all the men?"

She flushed angrily but kept her self-control.

"As I told Tom Hanson," cut in Charles evenly, "you're the only client to whom we're showing the Botticelli. She prepared the provenance for you."

Recognizing that he had allowed an instant distaste for Samantha to go too far, Webster scanned it properly, pursing his lips as he read.

Sir James Luttrell and Sons
FINE ART DEALERS
Established 1813

SANDRO BOTTICELLI
1445–1510

Oil Painting (Tempera on poplar panel)

"Madonna and Child with Eight Angels"

The Madonna enthroned, holding the infant Christ
in her right arm; four figures of angels to the right,
one reading from a Bible, the others holding white
lilies; four angels to the left, also holding lilies; be-
hind, a pale blue sky with a golden radiance de-
scending on the Virgin.

Painted circa 1476

Tondo diameter of 56⅖ inches (143 centimeters)

From the Collection of Count Waldhofen 1822
From the Collection of Herr G. Schmidt Munich
1923
From the Collection of Herr H. Schneider Frankfurt
1948

Recorded: Waldhofen Collection catalogue, Vienna
1898

This painting has been effectively lost for many gen-
erations, having been in private collections that were
not open for inspection by critics or scholars. It
bears a close resemblance to the "Madonna with
Child and Singing Angels" (also known as the
Raczinsky Tondo) No 102a in the Staatliche Museen
Gemaldegalerie, Berlin. Vasari records in his *Lives
of the Painters*: "In San Francisco, outside the gate
of San Miniato, Botticelli painted a Madonna [in un
tondo*] the size of life, which was considered a very
beautiful picture."

*Omitted from the translation.

He goes on to relate that "One of his scholars, named Biaggio, had copied the above mentioned picture very exactly, for the purpose of selling it."

Hitherto any attempts to identify this copy have failed. Ullman's suggestion that the much larger "Madonna of the Candles" (destroyed in Berlin 1945) was Biaggio's version is generally discounted, because it included only seven angels and could not be dated before 1490, when Biaggio was in his forties. Nonetheless many experts, including Berenson, have considered that the Raczynski tondo is a studio work. Salvini summarizes the position: "Since this is the only tondo we can ascribe to Botticelli with eight angels, it was thought the tondo must be the one in San Francesco. But the evidence is tenuous. Many scholars think it is a workshop product. Others think it is only partly autograph."

By contrast the "Waldhofen" Tondo reveals many characteristics of the master's hand. It is unquestionably autograph and provides the strongest grounds for concluding that in fact the Raczynski version is the copy mentioned by Vasari and that one of Botticelli's finest lost works has at last been traced.

"Very convincing," said Webster. "And which characteristics of the master's hand do you see in it?"

The moment had come for Charles to be his most persuasive. He guided the American closer to the picture.

"Far be it from me to tell you what to look for. I can only explain what we see. Overall, of course, it is some eight centimeters larger than the Raczynski tondo, which would be consistent with its being the original."

"Especially remembering Vasari's phrase about 'the size of life,' " chipped in James.

"And then," Charles went on, "there is a quality about the face which the Berlin one somehow lacks.

You know the 'Madonna of the Eucharist' in the Isabella Gardner Museum in Boston, of course?"

Webster nodded appreciatively. "A beautiful picture. I went to see it again yesterday."

"As far as I remember it's accepted as 1472, isn't it, James?"

"By then Botticelli had escaped from a rather monotonous series of Madonnas he had been doing." James took his cue neatly. "He was using the tondo shape to achieve a closer and more self-contained rhythm. And by the middle of the decade, the time of this one and of the 'Madonna of the Sea,' he was relaxing the linear tension he had learned from Pollaiuolo."

Charles smiled deprecatingly. "James knows all the jargon."

"I'd go along with him, though," conceded Webster. He felt more at home with such critics' phrases than with Charles's own uncomplicated judgments. "The question is, do we see such developments here?"

"I think definitely," said James. "Look at those angels! They represent a real maturity in dealing with the relationships between form and space." He stepped up to the painting. "There are *pentimenti* just visible to the naked eye which shows he wasn't happy with the juxtapositioning of the angels' heads." With his forefinger he indicated a part of the sky where a shadowy line underneath the translucent blue seemed to echo the shape of one head. "He made an adjustment to give greater depth to the composition."

"Now that," said Charles emphatically, "would not appear in a copy."

Webster followed James's finger. There was no question about it. The *pentimenti*—signs of a first drafting painted over—were visible. "It could be part autograph and part studio work," he conceded.

"Only if it is the original," said James. "Vasari makes it abundantly clear that Botticelli had no part in Biaggio's copy."

"Look here," Charles interrupted, worried at Webster being outmaneuvered. "This is hardly fair.

You need several hours alone with this tondo, not minutes. I think we've stated our case. Can we offer you some coffee or a drink while you make your own examination?"

An hour later Webster had come to only one firm conclusion—namely, that he was unable to decide without other expert counsel. Indicating his intention to return in the morning, he repaired to Brown's for a meeting with Bostock over tea. One thing troubling him was that the renowned Botticellis in the National Gallery, which included two "Adoration of the Magi" and the superb "Venus and Mars," had less in common stylistically with the Waldhofen tondo than a Madonna hung in a subsidiary gallery and attributed merely to the master's school.

The advice he received from Bostock was to fly to Berlin and see the Madonna there for himself if he was in doubt.

"Incidentally," Bostock added casually, "you're not the only museum interested in Luttrell's find. There's an assistant curator from the Kunsthistorisches over here too. She came to see me this afternoon."

The information startled Webster, until he realized suddenly that he could cover his own indecision by attacking Charles Luttrell's sincerity.

The next morning he woke with his mind at last made up and kept the appointment punctually.

"Well," said Charles amiably, once they were settled in the boardroom, "what's your verdict now you've slept on it?"

Webster blew his nose elegantly with a silk handkerchief, fluttered it away and looked squarely across the table.

"Frankly, Mr. Luttrell, I have mixed feelings. You could be right about this tondo, but to commit two million dollars—if we were to agree to such a price—is a trifle risky without more security. I'd like to see two things. First, a full technical evaluation of the paint structure, X rays to reveal any further *pentimenti*, all the normal confirmations."

Charles interrupted gently. "Forgive my saying so, but while the X ray might be useful, analysis of the material will simply confirm that it is not a fake. It will do little to distinguish between the work of Botticelli and his pupil, who used the same panels, the same gesso, the same egg tempera and pigments." Inwardly he was furious. This was exactly the sort of verification a critic without vision would want.

"I am afraid the trustees will demand it," said Webster, thinking that they would if he told them to. "Our second requirement is previous authentication. I do find it hard to understand how Berenson missed seeing this tondo in his travels."

Charles struggled to control himself. The bloody fool was missing the whole point. "To ask for a voice from the past is, if I may say so, to deny yourself one of the greatest pleasures open to a museum director: the joy of publishing a major discovery. In the end publication will bring far more credit to you and Westhampton than mere purchase. A famous reputation is something not even two million dollars can buy. For this reason I do urge you to make some interim commitment now, otherwise we shall be obliged to offer it elsewhere."

Charles had played his trump. He sat back waiting for ambition to overwhelm Webster's caution and so was caught totally off guard by the American's reaction.

"That's a curious statement, Mr. Luttrell, if *I* may say so, when you have a representative of the Kunsthistorisches over here on the very same day as me."

The accusation jerked Charles upright. "What the hell do you mean?" he demanded, forgetting his normal manners. "Yours is the only museum we've approached. I don't tell lies."

"Nor, I am sure, does the National Gallery." Webster was making the most of his ammunition. "They warned me last night."

"I have no contact whatever with the Kunsthistorisches." Charles was becoming visibly angry.

"Naturally I accept your assurance." Webster in-

clined his head in a mock bow. "At the same time whom do I believe? No, Mr. Luttrell, I came here on a strict understanding that we were first. I don't say we're not interested. Indeed Mr. Hanson defintely is. But my trustees decline to take part in any Dutch auction. When you've fulfilled our requirements and we're fully satisfied with the authentication, then I'm sure we shall be back." He rose to his feet.

Icily Charles ushered him downstairs again and out into Bond Street. Then in a fury he summoned all the directors and salesmen to his office.

"Has anyone been talking about the Botticelli to other clients, in particular to the National Gallery or the Kunsthistorisches?" he demanded.

There was absolute silence, broken only when James nervously made a collective denial.

"Get out, all of you," he barked, "and send Samantha in."

By the time she arrived he had calmed down a little. "Get that damned kraut on the telephone, will you, my dear? We've got some fast talking to do, and I may need your recollections of what he said."

Samantha dialed the number, struggled briefly with questions, then said, *"Moment, bitte,"* put her hand over the mouthpiece and turned back to Charles.

"Herbstein died on Tuesday. *Dienstag.* Yes. Tuesday. I think the man is saying it was a heart attack. He sounds like the accountant."

"Let me speak to him." Charles took the phone. His German was fluent.

"Has Herr Schneider been paid for the paintings yet?" he demanded.

"Ja, ja," came the answer. "Herr Schneider was paid a month ago. Everything is in order."

"That's not possible!"

"I assure you, there is no mistake."

"How much was paid?" asked Charles impatiently.

"One thousand marks." The accountant was beginning to sound aggrieved at being doubted. "It was a

shrewd buy. The purchase also included the frames for the five paintings."

"He bought five paintings from Herr Schneider?" Charles was beginning to see daylight in this story, but he wanted confirmation.

"Not exactly from Herr Schneider, of course." The accountant's dry chuckle was audible to Samantha. "In the circumstances that was not possible. It was paid to his executor, his nephew, Herr Dietrich."

Charles asked a few more questions, including Dietrich's address, then put the phone down and looked at Samantha with triumph in his eyes.

"Do you hear that, my love? Herbstein already owned the Botticelli. And the Memling. He bought those and three other pictures for two hundred pounds. Two hundred pounds!"

"You mean he was cheating us?"

"He cheated Schneider's executor and he duped us. He completely fooled us." Charles burst out laughing. "Why, it's the most glorious thing that's happened for years. We're off the hook. We have no need to raise the money this afternoon. It could be weeks before they realize we owe them the hundred and twenty-five thousand dollars." He was exultant. Things were going his way with a vengeance. "My God, we needed a stroke of luck and it's come up in the nick of time."

chapter 6

The light shone on Bostock's bald head, and his rubicund face glowed. Karin thought he looked like a character out of Dickens, very English and avuncular. They were sitting in a small office in the modern administrative block behind the National Gallery, a building often not noticed by visitors who entered through the famous porticoed façade on Trafalgar Square.

"To be honest, Miss Schumann," he was saying, "there are limits to the influence we can exert on Lut-

trell's. It's pretty well unthinkable that they would buy without making sure the seller had legal title to the picture. Some dealers, yes. Not Luttrell's."

"But I must visit them!" she insisted. "I've wasted two precious days trying to track the Botticelli's entry through customs. This American Webster turning up is a colossal stroke of luck. I must follow it up. Surely your government can put on some kind of pressure."

"We are government-supported but not owned, and we keep out of politics." Bostock made a wry face. "Our independence is very precious to us. If you want political backing you'll have to work through your embassy. Frankly, you're going to be up against the fact that this Botticelli was only on loan to the Kunsthistorisches."

"What if I tell him the truth?"

Bostock hesitated, rattling his fingernails on the desk top as he pondered. "The truth can be a double-edged weapon, Miss Schumann."

"You mean I'll frighten him into disposing of it quickly?"

"Oh, no. Charles Luttrell is a poker player. If he has good title, you won't scare him."

"But what about the ethics of the trade, the art dealers' associations, all those high-sounding principles they have?"

"You mean the British Art Dealers' Association? Of course they cooperate with us." Bostock conceded the point gracefully. "They are in a position to exert pressure within the trade. But that would only be necessary with the small fry. If any reputable dealer has an item known to belong to a museum he usually will return it anyway. Did you hear about the icons? No? A little while ago the Temple Gallery in Knightsbridge were sold one which they eventually recognized as belonging to a Greek museum. The seller had promised a second, more valuable one. They hung on several months until he reappeared, talked him into allowing them to keep it for twenty-four hours, identified it as having been stolen from a museum in Rhodes and

went straight with the information to the Greek ambassador. Subsequently there was a nice little bit of Anglo-Greek cordiality when the two icons were officially handed back. Such things do happen."

"You don't see a small Anglo-Austrian ceremony taking place?" Karin pretended a lightheartedness she did not feel.

Bostock shook his head. "As I said, the Botticelli doesn't belong to you, does it?"

"The Waldhofens meant it to be with us." Karin was becoming defiant again. While he was talking she had conceived a plan. "I am going to try. Will you telephone Luttrell for me, please?"

Politely Bostock did as she asked.

"On your head be it," he remarked as he put the phone down. "He'll see us at three o'clock."

"For God's sake let's have a few minutes undisturbed! Tell the switchboard not to put any more calls through, would you?"

Samantha willingly did so. She wanted to have Charles alone. She had an inspiration which, if he acted on it, was bound to increase her importance to him. They had been in the office most of the morning, trying to sum up the implications of Herbstein's death. But Charles's secretary, normally a barrier between him and outsiders, was off sick, and they had been plagued with interruptions, culminating in Bostock's call. Now it was after midday.

However, Charles had hardly begun rereading the note Herbstein had sent Samantha at the hotel in Frankfurt when the internal telephone buzzed. Old George's homespun voice came over the tiny loudspeaker attachment.

"Could you spare a moment to come upstairs, sir? It's something important."

Charles swore, then reluctantly agreed. When he reached the restorer's room he found George noticeably agitated.

"That Memling, sir," he said. "It's been in another collection besides Renders'."

"Well, I know that." Charles was impatient. "A German named Schneider owned it."

"Can't be him, sir." George was whispering as if worried at being overheard. "When I removed the Herbstein label I found a kind of a monogram stamped on the back—an eagle with the initials HG in a Gothic script. Like traditional German writing. I think you ought to have a look if you don't mind."

The Memling lay on a protective cloth on the workbench. Picking up a magnifying glass, Charles bent over and examined the monogram.

"It's a Nazi eagle, isn't it, sir?" said George, standing at his shoulder. "Clutching a bloody swastika and all."

Charles straightened up. "You're right, George," he said. "But not the eagle I remember from the war. There's something different about it." He peered through the glass again. "Idiotic. I ought to know. I saw enough dead Germans in Normandy after the invasion. It's not army. What the devil . . ." He snapped his fingers abruptly. "Of course, it's the Luftwaffe eagle." The two men looked at each other, the same thought occurring to them both.

"In that case, sir," said George slowly, "we know who the collector was. Hermann Göring. The Reichsmarshal himself. Ten trainloads of loot he took out of Paris, didn't he, sir?"

"Was it as much as that? He certainly ransacked Europe. You have very eclectic interests, George."

"Oh, the war's a kind of hobby of mine, sir. I've read a lot about it. Being only a lance corporal, I was a bit ignorant at the time. Hitler assembled just about the finest art collection the world has ever known. Dead methodical they were, too, sir. Made an inventory of everything. Five thousand-odd paintings they had by 1943."

"So this should be listed somewhere, if it was Göring's," said Charles, seeing what the restorer was

driving at. "Get hold of some books about Nazi collections. Meanwhile, stick the label back, fix up a decent frame with Sid and then put the Memling in the storeroom safe. We won't show it until we know more. And for heaven's sake, old chap, keep your mouth shut."

"Mum's the word, sir," replied George loyally, though he could not help reflecting that this was the second time he had been asked to keep quiet about an acquisition in three days.

Samantha realized Charles was upset the moment he re-entered his office.

"What on earth's happened?" she asked. "Have you seen a ghost?"

"Of a sort." He passed one hand across his forehead, then sat down heavily in the elegant chair behind the desk. "We have a new problem." He underlined his concern by speaking very quietly, as though afraid of being overheard. "There's more than a possibility the Memling was looted during the war. George has found marks indicating it was in Göring's collection."

"You mean the Nazis stole it?"

"Not necessarily. Göring began buying long before 1939 and continued to pay for works of art after they'd conquered Europe. He confiscated for Hitler and for himself, but he also still bought on occasions. No, I mean looted at the end of the war."

"Darling, please explain. You're talking in riddles."

"When the Third Reich collapsed in 1945 Göring never had time to sell any of his pictures. He had them stored in castles in Austria and Bavaria. The ones the Allies found weren't sold either. The confiscated ones were given back to the original owners, the rest went to the German state. So you see old George's discovery begs a fairly colossal question. How did this picture come into Schneider's hands?"

"Well, darling, the receipt was dated 1946. He could have bought it, couldn't he?"

Charles shook his head. "Bloody unlikely. I discovered from the man we spoke to in Frankfurt that he

was only fifty when he died. So he was still in his teens in 1946. And Germany was in chaos. Even in normal times damn few teenagers buy Old Masters."

"Well, does it matter?" Samantha was puzzled. "Didn't Herbstein say there is a thirty-year statute of limitations covering stolen property in Germany? As it happened more than thirty years ago, aren't we all right?"

"Not if it was war loot. There are special German laws covering that situation and international agreements." He leaned across and touched her hand. "My love, in one way you're right. It might not matter. But we absolutely must research the Memling's recent history."

Suddenly she realized what he was driving at and reacted furiously. "You mean you want me to go back to Frankfurt! Thank you, darling, but no. Do you want to get me arrested? In their eyes I must have broken the law. Damn you, Charles. Don't you care what happens to me at all?"

"Calm down, my dear, please." Charles raised his hands in protest. "I never said anything about Germany. All I'm suggesting is you visit Belgium to discover how Renders disposed of the Memling. If Göring did buy it legitimately there may be no problems. His relations are hardly going to come out of the woodwork claiming pictures. They wouldn't dare, even now. It could be that how Schneider got it is irrelevant. It's a bridge we know is there but not one we need to start crossing yet."

Relieved, Samantha went and poured herself a drink, giving Charles a gin and tonic.

"I reckon we both need reviving," she said sympathetically. But there was a further question hovering in her thoughts, and when she had sat down again she felt compelled to raise it.

"If you're wondering how Schneider obtained the Memling, aren't you also worried about the Botticelli?" she asked. "His family are still around. Why didn't the

executors know its value? Could he have looted all the five which Herbstein bought?"

"I've thought a great deal about that," Charles admitted, instinctively lowering his voice again. "At rock bottom I've only two facts, and they're pretty subjective. Firstly, the Waldhofen collection was sold off in the early Twenties, and the 1923 Munich bill of sale looks genuine to me. Secondly, Schneider's executor might never have looked at the pictures' backs and so never found the receipts attached to them, which of course Herbstein spotted. All the indications are that Schneider's executor didn't begin to realize the value of what he was handling."

This was the opportunity to put forward her idea. She sipped her drink quickly and took the plunge.

"Darling, isn't it possible that Herbstein's accountant won't know what he's missing either? There's no written record of our transaction. The secretary is completely ignorant of the details. She told me as much. Any version of the deal we put forward will have to be accepted. You can do much more than merely delay payment."

"Are you sure?" Charles's interest was mounting.

"Yes. Her exact words were 'He took away the paintings on Saturday and I don't even know where they are.' What's to stop you claiming to have bought them outright."

Samantha leaned forward, betraying her excitement. "Charles, darling, you've seen the letter he left me. Anyone reading it would assume that was what had happened. All you have to do is write back confirming the arrangement. Plus of course a bit about payment in three months! No one will be able to disprove it."

"How do you know he never told his wife?"

"Because she would have informed the accountant and he would have mentioned it."

"When she's grief-stricken and busy burying her husband?"

"Darling, the chance is worth taking. Why, you don't even have to stick to the hundred and twenty-five

thousand dollars. If you said a quarter of that the executor would probably be thrilled to bits. It would look like a huge profit. All he knows is that Herbstein bought five pictures for a thousand marks—for peanuts. He'll be delighted. And he'll never question the credit terms."

Charles looked at her slightly sideways, as though she was Eve, hand extended, offering him the apple. She teased him with a half smile.

"Are you afraid?" she asked.

"We have always accepted that an oral agreement is binding. If the position was reversed I'd insist on the gallery honoring what Herbstein committed himself to." Even as he spoke Charles knew that playing the angel's advocate was hypocrisy.

"And would they? I bet they wouldn't! Come on, darling, if they do challenge our version you can always blame me for a misunderstanding."

She looked him straight in the eye, challenging him.

"Of course Lucy would be horrified, I know," she added cruelly. "She'd insist on giving Herbstein's gallery half the profit, even though he did tell us a pack of lies about his client."

There was a long silence. Samantha sipped her drink, feeling she had said enough, wondering if such professional ethics as Charles did abide by would prevail. Eventually he chuckled and raised his own glass.

"Bless you," he said. "Let's drink to the survival of Luttrell's. In fact, we'd better stick to the one hundred and twenty-five thousand dollars. But as to the terms, I only mentioned those to James Constant and Wild." His voice hardened. "And if they want to keep their jobs they can damned well keep their mouths shut."

"They will. They're weak-minded enough."

"Well," said Charles equably, "that leaves only the question of a little present for you. Had you anything in mind?"

For a moment Samantha was completely taken aback, uncertain whether to be offended or pleased by his directness.

"No, darling," she said at last. "I didn't have. I smuggled those pictures out of Germany because I didn't want to let you down." She stretched out her hand and held his fingertips. "Can you believe that?"

Charles smiled, reflecting on how to answer. He was a strong believer in paying people for services rendered; otherwise one left oneself open to blackmail, either financial or emotional.

"Even so you took a lot of risks, you deserve something."

"Perhaps when the sale is complete we could go on a safari to East Africa. I've always wanted to go there."

Charles blanched. Why couldn't she ask for a mink coat or a flat like any conventional mistress? A safari would land him straight in the divorce court.

"Samantha darling, be sensible. A safari is hardly a lasting asset. If we're going to make over a million I'd like you to have something more tangible. We could buy the lease on your flat. You're a statutory tenant, aren't you?"

She nodded. He was right. Britain's housing laws were heavily weighed in favor of tenants. Because she could never be thrown out, she could obtain a long lease relatively cheaply. But what she wanted was Charles himself, not a flat or diamonds or a car.

"Of course, that would be lovely," she said dully. "I'd be a fool to refuse. It would just be more fun if we could celebrate together."

"Then we will," he declared, realizing that an immediate gesture was worth a thousand promises. "This very lunchtime. We will go at once to the Ritz and order the meal of a lifetime, and while they're pondering what to do specially for us, we'll broach a bottle of Krug and have a little caviar. How about that for an idea?"

Samantha melted. "It's a lovely one." She squeezed his hand. "Just let me go and powder my nose." She slipped out of the room.

Charles watched her, thinking that afterward they

might well end up at the flat in Mount Street rather than back here in the office. She was an attractive girl and even the tiniest things about her aroused him, but if she imagined he was going to leave Lucy for her, she was totally mistaken. The unquestioned social background his wife gave him and the ancestral permanence of the Wiltshire manor house were too much to give up. However, he had to admit to himself that Samantha was proving surprisingly shrewd. This scheme for making the most of Herbstein's death was brilliant, and, as he ran over it in his mind again, he appreciated that although it would be sailing close to the wind, it would not be in any way illegal or actionable. As Samantha had pointed out, if they were challenged they could always back down and blame misunderstandings on the dead Herbstein. True, Lucy wouldn't like it. Although she no longer played a part in the firm's day-to-day affairs, having been persuaded to abandon such activity many years ago by the pain from her arthritis, she was thoroughly involved in the progress of this all-important deal, both directly and through James Constant. Yes, Lucy would need careful handling.

When Samantha returned, he pulled on an overcoat and they set out to walk the short distance to the Ritz.

"Just proves I don't need a chauffeur," he remarked cheerfully as they reached the end of Bond Street.

"You may not. I'm sure Lucy does, though. Who else would bring her up from the country?"

"Why this sudden concern for her interests?" he asked, surprised that Samantha's thoughts seemed to be running parallel to his own.

She glanced sideways at him, noticing with renewed approval how well his velvet-collared coat fitted his broad shoulders. She couldn't stand sloppily dressed men.

"She's not going to like the way we're handling this deal."

"So?" Charles affected a bravado he did not feel.

"So you ought to give way to her over something soon. And it might as well be something small, like

keeping the chauffeur. Try to please her a little, darling. We're on the verge of pulling off a colossal coup. We don't want her getting in the way of it."

They were outside the Ritz, and the uniformed doorman was saluting Charles.

"You may have a point, my love," he said softly as they were ushered in. "You may indeed. Now let's find some champagne."

Within seconds of greeting Karin and Bostock that afternoon Charles sensed there was a battle in prospect, so he delivered his opening remarks carefully, like ranging shots.

"How are you, Alan?" he said warmly after Bostock had made the introductions, then turned to take Karin's outstretched hand. "An unexpected pleasure, Miss Schumann. It is many years since we last corresponded with the Kunsthistorisches."

Karin smiled faintly, disliking him despite his good manners. Her English was not perfect, but she appreciated that he was in fact rebuking her for giving so little warning of her arrival.

"It was unexpected to hear of this Botticelli surfacing in London," she said, throwing the adjective back at him.

"Surfacing?" Charles's surprise was nicely orchestrated. "The tondo has hardly been lost. Merely owned by a little-known collector. In any case we shall be pleased to show it to you."

"I have already seen it," said Karin, "unless the journey from Frankfurt has altered its appearance."

"I can reassure you on that point quickly enough," he replied tartly, straightaway ushering her to the private viewing room. He was angered at the suggestion that he might have tampered with it, in the way pictures being moved around the world in undercover deals have their appearance disguised by temporary overpainting. Evidently this woman had a low opinion of Herbstein, but what the devil had the German been up to showing her the Botticelli anyway?

As they entered the private viewing room he switched on the spotlights, illuminating the great tondo, the Madonna composed and beautiful at its center, with the singing angels jostling around her, so full of movement as to seem alive, the tall white lilies waving above their heads.

"What Berenson called a 'linear symphony,'" said Charles, one eye on his visitors. "No one in his right mind would touch it."

As he spoke he saw a tremor of deep emotion pass over Karin's face, as if she had been confronted with a long-lost relative. Nervously she raised both hands to smooth back her hair, then moved forward to examine the picture, fearful that it might have been damaged, despite his assurances.

She's hooked, Charles thought; she'll do anything to get it. He turned to Bostock.

"I believe Webster discussed this picture with you. Tom Hanson is keenly interested in having it for Westhampton."

"Yes," replied Bostock noncommitally. He had no wish to help Luttrell's play off one museum against another. Nor would he understand Webster's indecision. This was magnificent.

"It certainly is extremely similar to the Raczynski tondo," he observed cautiously.

"Which Berenson classed as a studio work. We believe this to be the original version." Charles stepped across to a small table on which he had left copies of the provenance.

"You may not agree," he said, handing them one each, "but we are pretty certain we're right."

Karin read the page of typescript slowly. It tallied so closely to her own conclusions that she felt a reluctant admiration for Luttrell's research.

"Who compiled this?" she asked in a flat voice.

"It was my instinctive idea, and our art historian assembled the evidence."

"Ah. The fast-driving blonde!" Karin was guessing, but a flicker of aggravation in Charles's expression con-

firmed it and she decided to press the advantage. "Unfortunately there are some factual errors here." She tapped the crisp sheet of paper with her finger. "Waldhofen did not sell this Botticelli in 1923, and by 1939 it was in my museum, the Kunsthistorisches."

This time, apart from a slight narrowing of the eyes, Charles did not react. So, he thought, the shooting has started. "The documentation is upstairs," he said calmly. "You are welcome to inspect it. Excuse me a moment."

His absence gave Bostock the chance to hiss a warning at Karin. "For goodness' sake don't make any claim you can't substantiate. He'll trample all over you."

"Please! I shall not be so stupid. But I must persuade Luttrell to keep the painting here."

"Only an offer will do that, you know."

"I do know." As she spoke the door opened again. Charles entered and introduced Samantha, who was carrying a manila folder.

"Forgive my question," said Karin, "but wasn't it rather risky taking this painting out with no permit?"

Samantha glanced at her, unable to tell whether this was calculated bitchiness or a legitimate query. Not that it made any difference. They all had a surprise in store. She opened the folder and pulled out a long form.

"Technically, perhaps so," she said. "But we knew it was all right, even though we didn't actually receive the export permit until this afternoon." She turned to Charles with a secret smile. "It has just arrived. I knew Herbstein wouldn't let us down!"

Karin bit her lip. She had made a fool of herself very neatly. But how could they have obtained the permit with Herbstein dead?

"May I see?"

Samantha handed it over in quiet triumph before Charles could intervene.

"I don't think it's necessary," he began. But it was too late. Karin had already spotted what he feared.

"Really!" she exclaimed in genuine amazement. "You bought at only one hundred twenty-five thousand dollars. That is nothing for such a treasure."

Charles sighed dramatically, trying to recoup his position. "I fear our friend Herbstein—our late friend, I should say—was slightly less scrupulous than we would be. Evidently he understated the value on the form. Or possibly he was lucky enough to have purchased at that figure. Alas, we paid him far more. Far, far more. This is a million-pound painting."

"We can talk about prices later," said Karin, annoyed at this display of unctuous virtue. "I accept the export from Germany as legal. Now may I see the Waldhofen receipt?"

"The bill of sale, you mean." Charles took the folder from Samantha, anxious to control the situation himself, and extracted the 1923 bill.

"Gregorian was of course one of the most reputable dealers in Munich. It appears to have been a perfectly straightforward transaction at a reasonable price for those days."

Karin examined the thick, slightly creased sheet of handmade paper, holding it up to the light to see the watermark, then scrutinizing the old-fashioned Gothic script of the German writing.

"The top men still didn't like typewriters," commented Charles. "They wrote important documents by hand."

"It is dated September 24, 1923," said Karin tautly. "And it is not a receipt given to the Waldhofen family. It relates to a later sale. So if Waldhofen had sold it"— she laid a heavy and ironic emphasis on the "if" and paused momentarily—"*if* Waldhofen had sold it, he must have done so even earlier. I think, Mr. Luttrell, you ought to read a document which is in our possession."

Charles and Samantha glanced quickly at each other, both equally mystified.

Exploiting the tension, Karin unhurriedly opened a

slim leather document case she had brought and extracted an old and yellowing envelope.

"The postmark confirms the date," she said. "Please check it if you don't trust me."

Charles took the envelope, saw an Italian postmark and carefully removed the letter inside. As he saw the address it came from and the familiar sloping handwriting beneath, his stomach turned over at the realization of what he was holding. If only he had been able to show this to Webster! It was a Berenson authentication, written from the critic's famous villa in Florence. The old man had done hundreds for the Duveen Brothers, who had been his patrons and paid him highly for such seals of approval. Indeed the shrewd Duveen, whose massive profits as a dealer later enabled him to found the Tate Gallery in London and so earn a peerage, had schooled American collectors not to buy Italian paintings without a Berenson authentication. This one read:

"I Tatti," Settingnano. October 15, 1923

Dear Count Waldhofen,

The "Madonna" you showed me is a painting by Sandro Botticelli. Although similar to the tondo "Madonna with Singing Angels" in Berlin, its handling is a revelation and has that vivid appeal to the tactile sense, which distinguished the artist's greatest creative purpose. What differences there are, are rather in favor of your painting. The life-communicating quality is always there.

In his best years Botticelli abandoned himself to the presentation of those qualities which in a picture are directly life-communicating and life-enhancing. His rendering of line, being the quintessence of movement, as may be seen in the tossing hair and fluttering draperies of the "Birth of Venus," and in the figures of angels in your "Madonna," has a power of stimulating our imagination and of directly communicating life.

Of course during the period no great work was likely to be carried through without assistance. It was seldom that a painter as much in demand as Botticelli could indulge himself in executing with his own hand the minor parts of a picture. Nevertheless I have no hesitation in describing your tondo as autograph.

I trust you will be able to retain this most precious painting in your family. Too few Florentine masterpieces escape the hands of dealers in these difficult days. It has been a pleasure to me to be of assistance to a man from whose father my great friend Mrs. Isabella Gardner received such memorable hospitality during her European tour, long ago as that was.

Truly yours,
Bernard Berenson

Charles looked up at Karin, the letter in his hand. Somehow he had got to obtain a copy of this. Once he had one, the Hanson deal would be as good as signed.

"Remarkable," he said condescendingly. "I suppose Berenson would have done this for nothing because of Mrs. Gardner or because Waldhofen was a count. But it does beg an awful lot of questions."

"Excuse me"—Karin's English was not idiomatic—"I do not understand." There was a self-confidence in Luttrell's tone that dismayed her.

"Well," he went on, skillfully deploying his own knowledge, "I can just accept Berenson not mentioning the tondo in revisions of his *Florentine Painters*. As far as I remember, he seldom kept copies of letters."

"It's very possible," Bostock interjected defensively, "that he relied absolutely on his notebooks."

"But this authentication does not say when he saw the tondo—a crucial point, Miss Schumann. The date could have been many weeks earlier than the Munich sale. Nor have you told me how it became separated from the picture. This will all have to be investigated."

He turned to Samantha and gave her the letter. "Just run up and make a photocopy, please. We'll need to follow this one through."

Suddenly Karin understood what was happening.

"Stop!" she almost shouted. "Give me that back." She stepped over to confront Samantha, her hand held out. "Give me it back, please."

For a second Samantha wavered. Then Bostock's fruity voice sounded in her ear. "Permit me." Gently he removed the letter and transferred it to Karin's hand, as though any direct contact between the two women might have caused a spontaneous explosion.

"You think I am very stupid!" said Karin, now angrily facing Luttrell. "You think you can be cleverer than me. I know exactly how valuable Berenson's letter is, and it will stay locked up at the Kunsthistorisches. As for that bill of sale—you might as well throw it away."

Charles had been humiliated in front of Bostock, and he flushed with embarrassment.

"I assure you, Miss Schumann," he said pompously, "you quite misunderstood my intentions. Nonetheless there are questions to answer. Would you care to sit down?" He indicated a chair by the little catalogue table.

"No, thank you." She wasn't going to put herself at a further psychological disadvantage. "Mr. Luttrell," she said, tossing her head, "I will be plain with you. That picture over there belongs in the Kunsthistorisches. The authentication is with us because we used to have the picture. It was not sold in 1923 in Munich. We know its history. The Nazis removed it in 1939." She took a deep breath. Now for the critical part of her bluff. "Because Germany and Austria were united at the time, and the German authorities apparently sold it later, we would have great legal problems making a claim. Instead we have had to wait until it came on the market. We are prepared to buy it back!"

There was complete silence in the room. Bostock

was dumfounded, aware that she had no such authorization from Vienna.

Luttrell recovered himself first. "The tondo *is* a two-million-dollar painting," he murmured apologetically. "Of course in these unusual circumstances we would naturally wish to help the Kunsthistorisches." He eyed Karin blandly. "It would be a privilege to assist in the recovery of such a treasure."

Karin listened, almost holding her breath in case her luck broke. Intensely as she distrusted this man's ultra-diplomatic manner, he did seem prepared to cooperate, which meant the Botticelli would not abruptly vanish again.

"On our side," she replied gravely, "we would expect you to make a reasonable profit on your deal with Herbstein."

She had not meant this remark to be taken at anything except its face value and was surprised to notice Charles wince momentarily. In fact he was cursing Samantha for ever having shown off the export permit and so revealing the price he had actually paid. Damn! The Kunsthistorisches could jeopardize any sale he negotiated with a reputable museum, certainly until such time as they had or had not found the purchase money. True, less scrupulous collectors wouldn't give a damn about such a tricky claim, but they would want the price lowered to offset the risk. Either way he would not get anything approaching one and a half million. Double damn this woman with her Berenson letter and "reasonable profit"! Somehow, he must bid her up.

"If I may say so, Miss Schumann," he said, "we should not try to decide this in a hurry. You have been honest with me. I must be frank with you. There was nothing undercover about our deal with Herbstein. Even if you have doubts about the Munich bill, as you say yourself the picture was sold off later. Our title to it is good, of that I am certain. I must now consider the expenses involved and suggest a price for the Botticelli which we can both afford." He did not want

to promise it to her, not with Bostock listening. "May I be in touch with you next week?"

Once again Karin felt she was being outwitted. Dealers normally made up their minds on the spot. However, she could hardly object. Her plan had succeeded miraculously well.

"You can write to me at the Kunsthistorisches," she said. "The Department of Fine Art. I will discuss it with my director as soon as I am back. I know he will be extremely excited." It was an understatement. If Herr Kameier ever learned exactly what she had said he would have apoplexy.

At Westhampton in Massachusetts the museum trustees were meeting to consider Webster's report on his trip to London. He had already voiced his concern about the Botticelli, explaining to them that in his view, stylistically, the work had more in common with works by the School of Botticelli than ones by the master himself and suggesting that more verification was needed. Inevitably this had led to discussion of the money involved.

"It's too bad Tom Hanson is in Australia," commented his particular friend Jess Tyler. "If he's going to donate this picture we have to be very careful of his interests. What do you think, Dick?"

One of the seven men around the table in the museum's ultramodern committee room was a thirty-six-year-old lawyer named Dick Greenfield, whose heavy black-framed spectacles matched a confidently authoritative manner. He took off his glasses and held them momentarily in his fingers as he spoke.

"We are in an entirely different situation here from some previous occasions. In the old days when Mellon was building his collection, and Mrs. Baring was being so generous to us, a donor could set off the entire value of a gift against tax in one year. In fact they came out of it pretty well sometimes." Greenfield smiled. "I guess it's an open secret that the Barbizon School landscape Mrs. Baring gave us six years ago was valued at

sixty thousand dollars, and she got the whole against tax. But when she bought the picture a few years earlier she had paid only ten thousand. So she had a tax rebate on fifty thousand dollars which she had never spent."

"What kind of tax relief can Tom expect?" asked Tyler.

"The value group of the Internal Revenue Service have got to being very hawk-eyed, especially over increased values. You know in their code on capital gains there's one sentence which runs for two and a half pages! Even their own officers don't know how to interpret it. But, in any case, I don't see there being much capital appreciation involved this time. The Botticelli will be selling at close to its market value, which is what the IRS are interested in."

"Hence my anxiety to make sure the painting is completely 'right,' " chipped in Webster quickly, sounding as concerned as he could. "Whether Mr. Hanson pays a million and a half or a million and three quarters, either sum is still a great deal of money."

"Can Tom afford it?" asked someone else. "If that's not too indelicate a question."

"Please!" expostulated Tyler. "Let's hear what kind of tax rebate he can get before we go any further."

"Donating to a 'qualified organization'—which of course we are, being nonprofit-making—he can deduct a sum equal to thirty percent of his adjusted gross income for six successive years starting with the year of the gift." Greenfield looked at his colleagues. "In plain terms, if Tom hypothetically earns two hundred and fifty thousand dollars a year, one third of that over six years will give him a tax deduction of three hundred thousand dollars."

"Hell," said Tyler. "That's not so much of a set-off against a million and a half."

"He'd get a higher tax deduction if he gave the museum the money rather than the painting."

Tyler grunted and stayed silent for a moment. "Well," he said at last, "I guess Tom must know about

that, and he certainly is determined to give us at least one really great picture. They're harder to come by every year. Look at the von Hirsch sale in London last summer. A Dürer watercolor fetched one point two million. A crazy price for a watercolor! And not a very inspiring one at that, judging from the photographs. The reason was that it was the last known Dürer in private hands. Most of the great Botticellis are already in museums. Tom told me that if we were happy with it, he was ready to go ahead on a million and a half."

"Maybe we could have this Botticelli flown across so we could all see it," suggested another trustee, who favored the purchase.

"That's obviously possible, sir," said Webster disparagingly. "Although personally I doubt if viewing the picture would make a decision so much easier unless we also had the verifications I propose to demand from Luttrell." He sat back, pleased with the neat way in which using the word *demand* laid a slur on the dealer's character.

"Well, gentlemen," said Tyler, "what are our feelings?"

After some subdued conversation it was agreed to accept Webster's advice, though with reluctance on Tyler's part.

"We don't want to lose a masterpiece," he said. "Not with art prices rising as they are."

"I think I can reassure you on that score, sir," answered the curator unctuously. "The von Hirsch sale was exceptional. Luttrell won't find a buyer so quickly. The stock market is low in Britain and it's only just recovering in New York. No one buys when the market's down, and any other museum will take quite as long to decide as we shall."

When the meeting adjourned Webster departed with the self-satisfied inner glow of an underling who has successfully carried his superiors with him.

The summons from the Bode Museum director was peremptory. Colonel Raeder read the message and

cursed. His few days' absence had created a pile-up of
office paper which he had not yet cleared, and he did
not want to work on Saturday. His wife was planning a
day in the country and was already piqued by his ab-
sence last weekend. Reluctantly he rang for his driver.

This time the director was not alone. Entering the
circular office, Raeder recognized the Minister for Cul-
ture, flanked by two senior civil servants. He saluted,
and the minister made a perfunctory acknowledgment
without rising.

"Be seated, Comrade Colonel." The minister was the
embodiment of a powerful Party leader. Stocky, self-
confident, dressed in the same kind of unobtrusive dark
suit they all wore, from Brezhnev and Ulbricht down-
ward. The non-uniform of the Politburo, thought
Raeder. An ignoramus might take any one of them for
a typical Western bourgeois if he disregarded the short
hair and a kind of rough-hewn element in their whole
appearance. Until they spoke, that was. Then even an
idiot would know the difference.

"Comrade Colonel," the minister went on in a hard,
staccato voice, "we have decided to recover this Bot-
ticelli for the DDR. If we succeed we are prepared to
overlook your indiscretions in 1952. We were all young
once."

"Thank you, Comrade Minister." There was not
much else to say.

"It is in your favor that you at least obtained this
document." The minister picked up Herbstein's release
from the desk. "We have learned the picture is now in
London with a dealer named Luttrell. You will demand
restitution."

"Shall I maintain West German nationality for this
operation?"

The minister shook his head. "No, Colonel. But you
were wise to employ your own name from the start.
This time we shall back you up officially."

Raeder considered the implications of this for a few
moments. "With respect, Comrade Minister, how
strong is our case legally?"

"You studied law, did you not?" The minister smiled thinly. "Take all the documentation and read it over the weekend."

"Arguably the Bode could be asked to return the Botticelli to Vienna," observed the director cautiously. "You will see why from the papers."

"Nonetheless," interrupted the minister with finality, "we do not need to rely exclusively on such old claims. Thanks to you, Colonel, we have a newer one. Our embassy in Britain will advise on how best to utilize it." He stared at Raeder. "The hope of reclaiming property has been an important factor in our pursuing diplomatic relationships with the West. The Soviet Union, after all, returned our treasures in 1950. In 1950, Comrade Colonel. A long time ago. The Western countries have restored almost nothing."

"Our board for the Security of Property has been investigating for many years," put in one of the civil servants. "We know precisely where many of our greatest works of art are. Yet the West refuses to return them."

"Our lawsuit over the Dürers in New York failed," commented the director.

Raeder listened apprehensively. There could be only one reason for this carefully orchestrated barrage of facts from such senior officials. They were giving him his last chance. A moment later the minister summed up.

"For a change we want to succeed. You understand me, Comrade Colonel? To succeed. We want the Botticelli back in Berlin. Report to our London embassy on Monday." He waved his hand in dismissal and then added casually, "One final piece of advice. Leave your cigarettes behind. As the British say, they can damage one's health."

The next day Raeder went with his wife to the countryside and studied the papers during the afternoon, secure in the study of their friends' house. By the time they drove back he understood the Bode director's reservation about the Botticelli. The documents included a

copy of the receipt given by the Kunsthistorisches Museum to a Prince Waldhofen in 1939, when he loaned them the picture. There were also two Nazi orders. The first instructed the Kunsthistorisches to send the Botticelli to the Staatliche Museen in Berlin. It was signed by Martin Bormann on behalf of the Führer. The second consigned the picture from the museum to Bormann's own house in 1943. One hardly needed legal training to realize that Waldhofen was still the rightful owner.

Back at the apartment, he telephoned Colonel Marklin and explained his fears.

"Nonetheless, my friend," said his colleague, "I wouldn't fail if I were you." He sounded terse, yet somehow apologetic, as if he was a judge. "Comrade, if I don't tell you, someone else will. There are ugly rumors going around about your past activities. The Party expects you to recover this work of art. If you don't you may face considerable problems."

There was an uncomfortable pause.

"I understand," said Raeder finally. "Let them know that I intend to succeed."

To Karin's relief Gerhard was waiting at the airport when she flew back to Frankfurt on Friday evening. As she emerged from the customs area he stepped forward to greet her, and without thinking she fell into his arms.

"I'm so glad to see you," she said, embracing him fondly. "I'm exhausted. These wretched airports. This one must have the longest passages in the world."

"It's our typical German efficiency," he commented wryly as he took her suitcase. "Everything under one roof, including Dr. Müller's sex shop."

"I could do with a German meal. Oh, London!" She shuddered. "On Herr Kameier's expense allowance I could hardly afford a decent meal. Anyway Bostock was helpful and I've a tremendous amount to tell you."

"There's plenty of time. I've kept the weekend free. Do please stay."

"You're a darling," she said, taking his hand. "Of course I shall stay. Just let me have a bath and a good dinner and I'll be myself again."

Back at his apartment, after she had changed, Karin recounted her experiences in London and her confrontation with Luttrell.

"Did you try the police?" Gerhard asked.

"I was taken to meet a police superintendent at Scotland Yard."

She recalled the gray partitioned room in a modern concrete building near St. James's Park and the cautious welcome she had received from a plainclothesman who had displayed considerable knowledge of the art business.

"He was really very impressive. Their Serious Crimes Squad has details of nearly seven thousand stolen paintings catalogued in a computer. It identifies them by their size, the artists, the subject, the materials and what's in the right- and left-hand corners."

"Sounds like your miracle machine," commented Gerhard, grinning.

Karin laughed. "Oh, theirs is a lot more sophisticated. Unfortunately it didn't turn up the Botticelli, though, and as we have no proof of a theft he couldn't suggest much. If we had the receipt the Kunsthistorisches must have given Count Waldhofen in 1939, then maybe he could do something."

Gerhard shifted in his chair and stretched his long legs restlessly. "I think you ought to go to Munich," he said at last. "After all, it's on your way home."

Karin sighed. "How can I? I'll have to be back on Monday. Herr Kameier will be mad enough at what I've been doing without my being late. Anyway, what can I do in Munich? The dealer went out of business after the war, didn't he?"

Gerhard uncoiled himself from his armchair, refilled her glass, then paced up and down his small living room a couple of times before sitting down next to her on the sofa and taking her hands gently in his.

"I have a hunch," he said. "Did I show you the

Rembrandt portrait of Hendrik Stoffels in our gallery? No. Never mind. The point is that officially it's on loan from the Bundesrepublik Deutschland. Well, in one way that statement is correct and in another it's a cover-up."

"I am sorry, I don't understand."

"It belonged to the Hitler–Göring collection. At the end of the war there were so many pictures which those two had either genuinely bought, or whose rightful owners couldn't be found, that the State took them over. All the records of Hitler's and Göring's purchases are kept in Munich, and the loans to museums, like ours, are organized from there."

"But the Botticelli wasn't . . ." Karin stopped speaking abruptly. "You mean it could have been Hitler who removed it from the Berlin Museum in 1943?"

"Or Bormann for the museum at Linz." He turned to look straight at her. "There's another thing. I've been tracing the career of the late Herr Schneider, the man from whom Herbstein bought both it and the Memling. You told me on the telephone that Schneider is supposed to have acquired the Botticelli in 1948."

"So what?" Karin shrugged her shoulders.

"In 1948," went on Gerhard dramatically, "Schneider was an East German citizen. He only came West in 1952. God knows how he could have smuggled out a picture as big as that. Anyway, I do know there was a lot of looting of the storage places in East Germany after the war. In fact, as recently as 1973 the East Germans were running a publicity campaign to persuade people to give up stolen pictures with the promise of no prosecution. Naturally we were interested. In fact I've a whole file of East German newspaper clippings. Quite a few lost pictures materialized, but it was also clear that others must still be in private hands."

"It sounds as though I ought to be going to East Berlin," said Karin uneasily. "Presumably they have the records."

"Try Munich first. The more I think about it, the more logical it seems that your Botticelli could only

have been removed from the Staatliche because it was destined for Linz."

"Are you sure your imagination isn't working overtime?"

"Quite sure."

"Well, don't rush me, Gerhard. Let me sleep on it."

"All right. I'll shut up. After all, it's your hunt."

"Don't be silly." She leaned across and kissed him on the cheek. "You gave me the first clue and you're being wonderful. It's just that I need to calm down. Too much is happening at once. Now, where are you taking me for dinner?"

Gerhard told her, but his mind was still on Schneider's curious exploits. He decided to start calling on the dead man's relatives, even if it did mean traveling all the way to Hamburg to see the nephew who had been an executor. But he decided not to mention this to Karin. She would only worry.

Autumn fog had settled on the ancient city of Bruges, drifting off the canals that make it rival Amsterdam as the "Venice of the North" and shrouding the traditional red brick Flemish houses, with their high windows and gables. Samantha shivered as she walked. Her search in Brussels for the origins of the Memling had been long and frustrating. Finally she had been advised to come to Bruges, where the collector Renders lived, if she wanted to trace one of his possessions. The only significant fact she had unearthed was that on January 5, 1943, the Belgian government in exile in London had signed a declaration annulling any purchases of paintings made under duress during the war. Oh God, she had thought to herself on hearing the news. That means Renders could claim back the Memling even if Göring had bought it from him. Now she was trying to find out if he had.

Crossing a tiny arched bridge across a narrow canal, she came to her destination, the Groeninge Museum, a low building around a courtyard garden. The secretary

whom she had spoken to on the telephone beforehand was apologetic.

"I am so sorry. The director has had to go to a meeting. But we have the Renders catalogue here and he has told me a few things he remembers." She smiled. "It was long before my time, of course."

"And mine." Nonetheless Samantha reckoned the secretary was likely to be knowledgeable in her own right. She was in her mid-thirties and had a competent, assured air about her.

"I have arranged the catalogue and some other references for you in the library," said the woman, leading the way.

On a table lay a large format volume with the name "Renders" prominent on the cover. Finding the Madonna in it was no problem. The collector had obviously been proud of his acquisition because it was reproduced as a full page in color. The provenance was printed opposite. Excitedly Samantha slipped out a notebook and began copying. This was valuable material.

" 'Came from the collection of the Duke of Arenberg, who . . .' " She looked up at the secretary. "What does *'qui le ceda'* mean exactly?"

"I think perhaps 'who gives it' or maybe even 'who sells it.' My English is not so good either, I'm afraid."

"Who gave it," Samantha scribbled, "to his librarian Monsieur de Cauwer. In 1895 it came into the collection of Paul de Decker. Catalogued Exhibition of Flemish and Belgian Art, Burlington House, 1927 number 43." She gasped with delight. For it to have been shown at the Royal Academy of Arts in London set an important seal of approval on the painting. Charles would be thrilled. Now for the crucial question. She turned to the secretary again.

"Do you know if Renders sold this picture to Göring?"

"I think he might have," admitted the secretary reluctantly. "I remember a friend of my father's telling

me quite a funny history. How he went with an art expert to interview Göring's widow one winter after the war. They had to drive through deep snow to the little house in the hills where she was living. An American officer drove them in a jeep. They were asking her about a small Memling Madonna. She knew about it. Göring had kept it with him right up to the moment of his surrender to the Americans in 1945."

"And what had happened then?"

"Over that there was a slight dispute. The American assumed one of Göring's SS guards got away with it. My father's friend thought it might have vanished into American hands. Anyway it had disappeared. But no one bothered any more because it was not of the highest quality. When you look around our museum you will understand. Although Memling lived and worked in Bruges and is our painter, we already have such fine works of his that our director would not be interested." She laughed. "For an American museum it could be different."

"And if it did turn up who would it belong to now?" asked Samantha innocently.

"To our government, I suppose. Renders was paid but not by Göring. He sent the bill to the wartime administration. They had no option. They paid." The woman paused. "It's funny you should ask about it. We had a German ringing us up a few weeks ago." She gave Samantha a sharp though not unfriendly glance. "If you are researching for a collector, advise him to be careful. I do not feel it is a very lucky picture, even if it is a religious one."

Samantha thanked her profusely, paid as brief a visit to the museum's gallery as she decently could, then hurriedly retraced her way back through the fog to the main square and telephoned Charles from the post office.

"Sweetheart," he said when he had heard her story, "we must find out more about this man Schneider and how he acquired the pictures. For all we know he could have been Göring's bodyguard himself."

"You mean you want me to go to Germany."

"Not to Frankfurt." Charles heard the protest in Samantha's voice and reacted immediately before it could be made. "To Hamburg. Didn't Herbstein's lawyer mention a nephew there?"

"I don't remember." There was a silence. "Darling, do I have to?"

"My love, you've told me yourself how serious it is. I'm depending on you. Take the train back to Brussels and ring me again. In the meantime I'll find out the Hamburg address."

The next morning she reluctantly took a Lufthansa flight to Germany and was in Hamburg by midday. The taxi ride out to the suburb was long and expensive. But at least the nephew was there. Whatever Charles had said over the telephone, it had been compelling enough for him to break another appointment and go home at lunchtime. The apartment building was like a large house, with a steeply pitched roof and color-washed stucco exterior, originally yellow, now faded and drab, its flatness broken only by small balconies with wrought-iron railings that decorated the living-room window of each flat. Samantha found the bell labeled "Dietrich," and the door clicked open with a buzz as a voice said, "Third floor, please," in German.

Stepping out of the elevator, she was greeted by a chubby, cheerful man in his late twenties, wearing a blue suit that Samantha thought rather too bright and a dazzling, multicolored tie.

"You must be Miss Walker," he said effusively. "I am pleased to meet you." He ushered her into the apartment, apologizing for its small size, and introduced his wife, who was much younger and who promptly bustled off to bring coffee.

"She does not speak much English," explained Dietrich. "So she is shy."

"But yours is excellent," remarked Samantha complimentarily as she took the seat offered her, a tubular-frame armchair with orange cushions.

"I was an apprentice in England, so I had a good

chance. I am now with Blohm und Voss, the shipbuilders." He glanced at the chair. "You like it? We were able to buy all new after the inheritance from my uncle. We did not change our apartment because it is convenient for the work. So," he went on, settling himself down. "There is one of my uncle's paintings more valuable than we expected. It is very kind of your Mr. Luttrell to offer me a small share in its value." He laughed happily. "I do not think Herr Herbstein would have done that. What do you need to know?"

Studying Dietrich while he said this, Samantha decided he must be exceptionally naïve. A competent junior engineer, perhaps, but a bit of a fool outside the factory. Herbstein must have found him easy meat. Before she could say anything, the wife came back with the coffee, and there was a pause while it was poured. Eventually the wife settled down on the sofa beside her husband, as self-conscious as a newlywed. Samantha had a sudden feeling that she was watching herself in a play; the scene had all the stilted uncertainty of amateur theatricals.

"Well," she said, "we do think the big round picture of a Madonna might be valuable, and we are interested in a very small one too." She spoke with careful simplicity and was rewarded by a vigorous nodding of Dietrich's head.

"I think I remember," he said. "Yes, I remember the ones."

"Before we can sell them we must establish what we call the 'provenance,' " Samantha went on, "where the paintings have been and who owned them. For instance, can you tell us where and when your uncle bought the little one?"

Dietrich's face clouded, and Samantha, thinking she had confused him, tried again.

"How soon after the war did he buy it? Where was he living then?"

"I cannot tell you," said Dietrich with a blankness that somehow failed to convince Samantha. "As I told the other man who asked, I didn't know my uncle so

well. He was my uncle by marriage. He and my aunt
lived in Frankfurt. It is a long way."

"The other man?"

"I had a telephone call from an old friend of my
uncle some days ago. He was interested in one of the
pictures. I could not tell him anything either."

"What was his name?" Samantha could barely
conceal her anxiety.

Dietrich turned to his wife and said in German,
"You know, that's a funny thing. He hardly told me
anything about himself." He glanced at Samantha, real-
izing that she could understand, and began to answer
her question. "He was a Herr . . ." But he stopped in
mid-sentence because his wife was tugging at his wrist.
She whispered agitatedly in his ear. When she had fin-
ished, he said simply, "I think perhaps his name does
not matter." Again the blankness was there.

"Anyway," said Samantha, not pressing the point
and shifting back to her proper mission. "What matters
is the history. Didn't your uncle have any papers,
documents, anything I could read through? Did he
keep a diary?"

Suddenly she realized that Dietrich had completely
frozen up. His wife was clasping his hand fearfully.
From their expressions they might have been face to
face with a cobra.

"No, no. There are no papers, only with the lawyer.
You must ask him if you want information." Dietrich
hoisted himself upright, still clutching his wife's hand.
"I am sorry. I cannot help you. We have nothing
here."

"But he must have had some personal papers," Sa-
mantha urged.

Dietrich recoiled. "I tell you we have nothing. Ev-
erything is with the lawyer."

There was no alternative. Samantha had to accept
his word. She shrugged her shoulders disbelievingly,
went through the pantomime of taking down the law-
yer's address and said goodbye with a nice show of an-
gry amazement. Whatever kind of a past the late Herr

Schneider had possessed, it was clearly one that frightened his relations, and she had no doubt the lawyer would be equally uncommunicative. She left Hamburg without bothering to telephone him.

◠◡◠◡ chapter 7

As the train rumbled through the Bavarian countryside, past woods and old timber-framed farmhouses, Karin pondered the theory Gerhard had been propounding during the weekend. If he was right, the Hitler–Göring collection records could hold the secret of the Madonna's wartime travels and perhaps even lead her to the missing Waldhofen receipt.

By the time Karin reached Munich she was in a state of considerable anticipation. After checking her suitcase, she asked the way to her destination in the Meiserstrasse.

"Ten minutes' walk from here," a station official told her. "You can't miss the buildings. They're a pair. Both huge and ugly."

The description was accurate. The Meiserstrasse was a wide street that stretched as far as the eye could see. A short way along on the left lay the square expanse of the Königsplatz, with its elegant, classically styled museums. Facing these were two monumental stone edifices, constructed in heavy slabs of gray stone, their severe lines unsoftened by any decoration. Their columns were square and functional and reminded Karin of the Russian war memorial in Vienna. A plaque on the first building announced the location of the Bavarian State Collection of Paintings. She walked up the steps.

Inside the floors were laid with pinkish marble slabs, and the high entrance hall led past a massive staircase with brown marble pillars. Someone had spent a lot of money on this, she thought. The attendant directed her

past this to an office in a corridor. She knocked and entered.

By contrast the office was cluttered and unpretentious. A woman in her early forties rose from behind the desk.

"Lohrey," she said crisply, introducing herself, "You are Fräu Dr. Schumann? Glad to meet you. Any friend of Gerhard's is a friend of mine. Please sit down." She gestured toward a sofa, beside which stood a table bearing a tray with a thermos flask and cups. "We have so few staff, I make my own."

Karin smiled and sat down, feeling an immediate common cause with this direct and friendly woman.

"Not luxurious," went on Dr. Lohrey in her curiously clipped language, waving one hand at shelves of reference works lining the wall. "But the records are extensive. So you're after a Botticelli?"

"A Madonna which was transferred from Vienna to Berlin in 1942," Karin explained. "Gerhard thinks it could have been acquired by Hitler." She avoided the word "stolen." Curators usually have a personal allegiance to their collections, irrespective of how they have been formed.

"Then it might have been here," said Dr. Lohrey casually as she poured the coffee. "You know this was the Führerbau?"

Suddenly Karin understood the ponderous architectural style and lavish marble. She felt a chill.

"This was Hitler's headquarters?" she asked, feeling stupid at not knowing already.

"The Nazi Party's. His was in the twin building."

"And therefore the records are still here?"

Dr. Lohrey shook her head. "More complicated than that. The Americans passed a law saying that works of art should go to the provinces where Nazi leaders last lived. Hitler and Göring both had property in Bavaria, so the residue stayed here. In 1957 it was divided between Bavaria and the federal government. We do the administration. Claims are still made against us." A flicker of annoyance crossed Dr. Lohrey's face. "Often

by people who sold to Hitler freely. Even Swiss dealers swear they were forced to sell to him—when actually they'd used the protection of Swiss neutrality to inflate their prices. The Linz project created an art boom."

"Dealers will do anything," declared Karin with feeling. "Our Botticelli is in the hands of a London dealer now, complete with a fake provenance. That's why I need to trace its actual history." She glanced at the crowded shelves. "Didn't Hitler's advisers publish books on their acquisitions?"

"True." Dr. Lohrey pointed to two tall volumes bound in oatmeal-colored cloth with *Sichergestellte Kunstwerke* prominent in gilt lettering on their spines. "Safeguarded works of art!" she commented scornfully. " 'Safeguarded!' Their favorite word for everything they took from the Poles and Jews." She sighed. "Well, it's history now. One can only try to be objective. Anyway, I'm afraid Austrian works are not in those books. I suppose because Austria was officially part of Germany."

She stood up and went back to her desk. "After Gerhard's call I began to search the individual files. It's a long job. So far I found only these." She picked up a sheaf of notes and began to read. " 'School of Botticelli, Madonna with Child, eighty-seven centimeters by fifty-eight, returned to France. Tondo, School of Botticelli, Madonna and Child with St. John, eighty centimeters round. From the Palais Lanckoronsky in Vienna.' "

Karin trembled slightly. This was nearer home. "Confiscated without payment," went on Dr. Lohrey, "because the Lanckoronsky family were Polish."

"What nonsense!" Karin was up in arms at once. "They had a palace in Vienna for centuries."

"Please, don't blame me." Dr. Lohrey looked hurt. "Anyway, it was returned in 1946."

"I'm sorry. These events are very real to me."

"Tell me," asked Dr. Lohrey suddenly, "did the Waldhofen family have Jewish blood?"

Sooner or later Karin always found herself facing

this question. Many of the paintings taken from Austria had been Jewish-owned. Although she was not Jewish, she felt Hitler's persecution of the Jews had been the most emotionally explosive aspect of the whole art-looting operation his officials had carried out. And the Jews had recovered least, even now.

"The last Count's grandmother was Jewish," she said, "but Jewish origins were not quoted as a reason for the Botticelli's removal. Let me show you the actual order." She reached for her briefcase, ferreted briefly and then handed over a slightly wrinkled sheet of official paper, carefully preserved in a transparent plastic envelope.

"This is the only document proving the Botticelli was taken from the Kunsthistorisches. As you see, it orders the picture to be sent to Berlin for expert examination."

Dr. Lohrey scrutinized the directive and smiled. "This tells us more than perhaps you know. I have spent many years with such documents." She stabbed a finger at the signature. "Illegible—but I recognize the writing. It's a Gestapo officer's. This signature means Gestapo confiscation of Jewish property. Had the Count influential friends? Would the Gestapo have felt obliged to make an excuse?"

Karin thought for a few moments before answering. This straight-talking woman was forcing her to change her ideas.

"He was much respected in Vienna society. The Waldhofens have been well known since the time of Metternich."

"The title could have saved him," decided Dr. Lohrey. "As you must know, Göring's godfather was a minor aristocrat and he was a snob. But that wouldn't have saved the picture. Too many people were toadying for favor with Hitler by finding works of art for Linz."

She stopped short, glanced at her watch and frowned. "I am sorry. I have another appointment. But

you are welcome to go through the records while I'm out. Please come next door."

She led the way to another room full of filing cabinets and row upon row of box files, some labeled in German and some in English.

"Please make yourself at home." A moment later she was gone.

During the succeeding hours Karin became so absorbed in the documents that she forgot about time. The meticulousness of the Nazi art collectors was unbelievable. The Rothschild collection alone occupied three box files. Everything was concise and professional. The size of each picture, sculpture or ceramic, its provenance, where exhibited, whom it had belonged to, when it was acquired—all recorded as though theirs had been a legitimate operation, not the looting of Europe's art treasures at gunpoint.

Long after Dr. Lohrey had returned, Karin's diligence was rewarded. She rushed back to the main office, clutching the file.

"I've found it," she cried. "Here. Acquired for Linz in August 1943 and dispatched for storage to Weesenstein. Where on earth is that?"

Dr. Lohrey scrutinized the paper briefly.

"Near Dresden in East Germany. The royal castle there was a storage place from which the Russians returned nothing. Some works are said to be exhibited in the Hermitage in Leningrad. I always mean to go on a tour and see. Not that it would help. Things only reappear in the West if the Russians want dollars. Or, of course, if the object was looted and has at last been smuggled out somehow. It does happen. We presume that's how the Boucher 'Venus' which Göring owned appeared in Sweden. The same must have happened to your Botticelli."

"It can't have been sold by the Russians. Luttrell paid so little. It must have been smuggled."

"There you are, then." Dr. Lohrey was pleased. "I'll photostat this and you'll have another nail in the coffin of the dealer's story. At least this paper states that it

came from the Waldhofen Collection. You can prove that now. And surely the dealer won't want to be seen handling wartime loot?"

Karin brightened up a little at this. Then as she was gathering her notes together another thought occurred to her.

"Out of curiosity," she said, "could you check another picture for me? A Memling."

"Certainly. No trouble. What are the details?"

Karin recited the description of the Memling Madonna. Within ten minutes Fräu Lohrey had found it in the Netherlands lists.

"Yes. Here we are. Bought by Göring from the Renders Collection on May 15, 1941. But not direct. He obtained it through Goudstikker, the Amsterdam dealer, for fifty thousand guilders. A very fair price."

"And has that been returned?"

" 'Whereabouts unknown,' " read out Fräu Lohrey. "Presumably it was either at Schloss Mauterndorf or Zell am See in the spring of 1945. I can't tell you any more."

Karin thanked her profusely and left to walk back to the station. There was no reason to stay in Munich. During the long train journey she puzzled over what she had just learned. By the time she reached Vienna she was certain Dr. Lohrey was right. The coincidence of both the Botticelli and the Memling disappearing at the end of the war was too great. They must have been looted.

"My dear colleague, I cannot allow a wild-goose chase to interfere with the proper work of the department!" Director Kameier's appearance was frigid. Karin stood in front of his desk, resentful at being made to feel like an irresponsible junior.

"If I may sit down, Herr Director," she replied calmly, "I think I can satisfy you that this is far from being a wild-goose chase. On the contrary, it's a great opportunity for our museum." She stressed the word

"our," knowing he would expect the credit if she succeeded.

Kameier waved her to a chair. "So," he remarked in a more conciliatory tone, "tell me about this opportunity. I had concluded from your telephone calls that there was no hope."

Halfway through he snorted indignantly. "You offered to buy the picture. My dear colleague, wasn't that exceeding your authority a little?"

"It was necessary." Karin stood her ground. "I had to hook him somehow."

When she had finished he blew his beaky nose on a large handkerchief and then spread his hands flat on the desk, implying that he had come to a decision.

"A pity the Memling is not from Austria. It would be more in tune with our collection. Nonetheless, the First Director might wish to bid for the Botticelli if this dealer Luttrell will part with it for a reasonable price."

"You don't think we can bluff him into giving it up? Rightfully it should be here, as there's no Waldhofen to inherit it."

Kameier temporized. "Well, let us see what the Hofrat has to say." He picked up the telephone, spoke briefly and turned back to Karin. "He can spare ten minutes. We must hurry."

The Hofrat was also Director of Roman Antiquities but of a more jovial disposition than this suggested. He had been elected to the post of First Director primarily because the other directors all liked him. He welcomed Karin with a joke and then said, "I hear you may be on to something. Tell me about it."

At intervals Kameier interrupted Karin's account with his own comments. "We had to buy Count Czernin's Vermeer in the end," he said, "even though Hitler had already paid for it."

The Hofrat grunted. "Not exactly a comparable situation. Damn it, the Fräu Doctor here has a point. We've enough proof that the Botticelli was here. Why not invite this dealer across and see if we can't bluff him into returning it? With a certain amount of cere-

mony, of course. We'll need to polish his ego a little.
You should be able to do that skillfully enough, Direc-
tor. You're the diplomat among us."

Kameier cleared his throat, uncertain about the
quality of this compliment.

"With respect, Herr Hofrat, I think we should be
prepared to make an offer."

"I don't need to remind you how limited the fund
for the state museums is." The Hofrat frowned. "I
doubt if the minister would authorize more than three
million shillings. Say, two hundred thousand dollars. At
the outside."

"Luttrell bought it for only one hundred and
twenty-five thousand," said Karin. "I'd hate to see him
make a profit."

The Hofrat smiled. "I take it we are agreed on
wanting the picture?"

Kameier nodded.

"Then I suggest we contact this dealer and try a
little gentle persuasion. If you finish a brief for me
quickly enough I can probably persuade the minister to
be available."

It was a clear enough dismissal. Ten minutes later
Karin was back in her own office, hastily converting
her notes into a draft report.

Colonel Raeder's trip to London began inauspi-
ciously. Although he had a diplomatic passport and
was given VIP treatment on the Aeroflot flight via Am-
sterdam, his suitcase was lost at Heathrow. True, he
had kept everything that mattered in his briefcase, in-
cluding a razor, in case something of the sort hap-
pened. An official complaint had been lodged
immediately. The airport authorities were apologetic.
He knew his belongings would reappear when the
British security men had been through them. Nonethe-
less, it was a nuisance.

Now he was at the embassy, an elegant white-paint-
ed house on the southern side of Belgrave Square,
hardly a stone's throw from the far larger West Ger-

man establishment, and the cultural attaché was being both snide and evasive. The moment he had met the man Raeder had foreseen problems. He had an academic appearance, with a high balding forehead and a thin mouth. Worse, he was a known favorite of the minister in Berlin, which gave him more influence than his diplomatic rank would guarantee.

"The best I can offer you is moral support, Comrade Colonel," he remarked, pressing his fingertips together as though he were a professor assessing a wayward pupil. "The main burden of recovering this important part of our national heritage must rest on you."

Raeder glanced at the neat pile of papers on the desk and then raised his eyes to the unsmiling face of the diplomat.

"I thought there were gounds for an official claim," he protested firmly. "That's what they told me before I left."

"What we have is all here." The man indicated the documents. "The Staatliche Museum's cataloguing of the painting, the order removing it to Schloss Weesenstein for safekeeping until the Linz Museum was ready, the offer of a reward during our 1973 campaign to recover lost works of art. The snag is that although the 1942 order transferring it from Vienna to Berlin was legal at the time, the British regard it as having been annulled by the retrospective provisions of the Austrian State Treaty of 1955. We are more likely to succeed with the release you obtained from Herbstein."

"But that's crazy! How can you say one moment that the picture belongs in Austria and the next that I have a right to it?"

"Because it is your friend Schneider's legal ownership which the English dealer Luttrell is depending upon." There was no mistaking the emphasis on the word *friend*.

"What's so special about that?" demanded Raeder, mystified.

The diplomat arched an eyebrow. "Surely you're aware of your friend's ingenious transaction."

For a second Raeder thought of allowing himself to flare up, then decided against it. At all costs he had to avoid rows with someone as politically well connected as this man.

"When we were both eighteen years old," he said, his voice hard, "I saved Horst's life. Thereafter we went different ways. I knew nothing whatever about this damn picture until he bequeathed it to me. I hadn't even seen him for over twenty-five years."

"Hmm. Well, he was a clever fellow, your friend. He somehow managed to obtain an official authorization for his purchase of the Botticelli." The diplomat picked up a sheet of paper and motioned Raeder to get up and come to the desk. "A photostat, of course."

Raeder took the paper and examined it. The document of sale from someone called Schmidt to Horst Schneider was attested by the municipal authority of Weesenstein in the Dresden district. Across it was the imprint of a massive rubber stamp in Russian. He knew enough of the language to understand the meaning. It was the approval of the Russian military government in the area.

"How in the devil did he get that?" said Raeder, amazed, thankful in the same moment that he himself had no connection with the area.

"The ministry is urgently investigating the question. The presumption is that this man Schmidt looted the picture from the castle in the confusion of the battle, hid it and later bribed some minor official to certify this."

"Then the Russian stamp must be a forgery."

For the first time the diplomat smiled. "We do not need to mention that aspect of the matter. The Russian military government was a legal government recognized by the other Allies. As far as both we and the British are concerned, this gives legality to Schneider's ownership and it enables you, as his heir, to claim the picture." The diplomat laughed gently. "Quite an amusing situation. One which enables you to go to the British police as a preliminary to confronting Luttrell."

"Are you serious?" Raeder rapidly weighed the pros and cons. "Are they bothered about art?"

"Very much so, Comrade. They have a special squad dealing with stolen works. I have taken the liberty of notifying the Protocol and Conference Department of the Foreign and Commonwealth Office that an East German citizen will be approaching Scotland Yard. It is all in order, Comrade Colonel. All you have to do is go and fetch the painting."

"I would still prefer you to come with me," insisted Raeder doggedly. "For one thing, we don't want to be passed off with a fake."

Eventually the cultural attaché agreed. "I suppose the Stasi can't be expert in everything," he remarked condescendingly.

Raeder bit back an angry reply. In normal circumstances such rudeness from an ordinary civil servant to a Stasi colonel would produce instant retaliation. But these were not normal circumstances, he reminded himself bitterly, far from it.

Raeder's first impression of Detective Superintendent Wates's office was of modern gray steel furniture and an exemplary tidy desk. He had been escorted up from the New Scotland Yard entrance hall by a young constable, noticing with professional approval how well the contradictory requirements of politeness and security were melded together. The superintendent, who was in an ordinary suit, introduced another, younger man.

"Sergeant Jones will interpret."

Raeder shook hands with the sergeant, guessing that the officer had wanted a witness present. He certainly would have done so himself.

"Well, Mr. Raeder," said Wates, coming to the point immediately, "what can we do for you? Your embassy has asked for our assistance. But please remember the Metropolitan Police is an independent force. We make our own judgments. Politics don't come into it." There was a slight inflection of distaste that the sergeant dropped in his translation.

"I inherited a painting from an old friend, Horst Schneider," Raeder began in English but was soon forced to revert to his native language. Then he handed over both Schneider's letter and Herbstein's release.

Wates examined them.

"I intend to donate it to the Berlin Museum," said Raeder.

Wates eyed him distrustfully. "What you do with it is none of my business. We don't deal in disputes over ownership either. All we're concerned about is, was this picture stolen? If it was, we can seize it and hold it until someone satisfies us it's theirs."

"Aren't those two documents enough? It was removed from Herbstein's premises."

"There's no proof that Luttrell stole it, is there? He may have bought in good faith. *If* he stole it"—Wates's keen eyes scrutinized Raeder's face for any sign of emotion—"or if he knew it'd been stolen by someone else, then he'd have what we term 'guilty knowledge' and we could prosecute him for dishonest handling under Section Twenty-two of the Theft Act of 1968."

Raeder listened, only half understanding but recognizing the universal monotone voice of a policeman reciting the circumstances under which an offense may have been committed. "It sounds to me, Mr. Raeder," Wates continued, "that you may have grounds for a civil action if Luttrell refuses to return this painting. After all, he can get his money back from Herbstein, can't he?"

Again Raeder was conscious of being closely watched. "I suppose so," he said impassively.

"Well, if I were you, sir, I'd go and tackle Luttrell face to face. If he can't produce proof of purchase, then come back to us."

The interview was clearly over. Raeder thanked them and left. After he had been escorted away again Wates grinned at the sergeant.

"I reckon he's a copper like us. And he knows Herbstein's dead. What d'you think?"

The sergeant agreed. "I wouldn't want him for an enemy either, that's for sure."

"So now there are two claimants to Charlie Luttrell's little find. The friend of Bostock's from Vienna and this joker. There's a villain in the story somewhere. There just has to be."

"Surely," the sergeant protested, "Luttrell's too fly to be caught on dishonest handling. It wouldn't be worth his while."

"I'm not so sure. There's a rumor about his having financial problems, and Bostock reckoned this Botticelli was worth a good million quid. That constitutes a sizable inducement. I think it's time we paid a courtesy call on Sir James Luttrell and Sons."

"The X rays confirm your theory, Mr. Charles. We've just finished fitting the photo mosaic together, and the whole thing's as right as rain!" In the fourth-floor workshop, old George proudly revealed his handiwork. Beside the great Botticelli tondo hung a full-scale X ray, made up of many separate photographs, all painstakingly joined at the edges with transparent tape and mounted on a translucent white screen. Since X rays cannot be focused through a camera lens, the X-ray plates had to be made full size, as they are in a hospital. George flicked a switch and the mosaic was illuminated from behind.

"You must have spent some time on that," commented Charles admiringly.

A layman might have wondered at his enthusiasm. Although the shapes of the Madonna and the angels were clearly discernible, the luminous coloring of the original appeared in the radiograph as blotchy gray areas, in places almost black, in others near white, and even these were obscured by various wavy vertical lines.

"The wood grain's as clear as day," said George, "and there are the joins." He pointed to two straight vertical lines. "Three poplar panels and no later additions."

"Excellent!" said Charles. He peered at the X ray, trying to prevent his eye's being distracted by the outline of the wooden grid supporting the back of the panels. "Are those worm holes?" he asked, stabbing a finger at some small white dots in the top righthand part of the sky.

"Been filled with putty, then overpainted, I should say, sir. Nothing to worry about, though. They're later, of course, but I reckon most of the overpainting was Botticelli's own. See where he'd changed the position of the angel's head, sir."

"Oh yes, the pentimenti we'd already spotted."

Charles followed the restorer's finger, tracing a ragged dark line near the outline of the angels.

"It would show up even better with an infra-red, sir. But there's no problem seeing it here. There are quite a few others, like where her hand is holding the baby's legs. He seems to have scratched out new shapes after his first paint layer was already dry. That would account for the ragged edges. And there are parts where the original paint must have flaked a little." George indicated some tiny dark shadows on the X ray. "I'd be prepared to bet those were overpainted by the master himself. The worm holes apart, there's nothing that looks like later touching up to me."

Charles moved across to the tondo itself, clicking his tongue meditatively.

"We may have to analyze a chip or two of paint to convince Webster. He's bound to claim the overpainting is oil, not egg tempera."

"I'm sure it's not, sir. Do you remember Professor Ruheman's investigation of the 'Adoration of the Magi' for the National Gallery?" It had been a classic analysis.

"Never mind." Charles cut him short. "You've done a splendid job, George. Absolutely splendid. Now, do you suppose you could cook up a smaller print of this X ray and get it down to a size we can post off to America?"

"We can take an ordinary photograph of the mosaic, sir."

"You do that, then." Charles patted his restorer's shoulder, as if rewarding a faithful dog. "I don't know what we'd do without you, old chap. Let me know as soon as it's ready."

Back in his office, Charles was about to dictate a letter to Webster when he remembered that this would be a good time of day to telephone. In London it was early afternoon. In Westhampton the museum would just be opening for the day. When his secretary obtained the connection he thought he detected a certain caution in Webster's nasal voice.

"We have our quarterly trustees' meeting Thursday. I really am extremely occupied. Can we please keep this brief?"

"Of course." Charles's mind was clicking over fast. "I only rang because I have important news your trustees may like to hear."

"About the Botticelli?"

"What else? We've had an X-ray mosaic done. It confirms our belief that this is the original version. There are various pentimenti which can only be the master's own alterations as he worked. The panels haven't been added to and there's very little over-painting."

"Hmm. Too bad the trustees won't be able to see it." Webster sounded far from regretful.

"They will," said Charles, wondering what the bastard was playing at. "Today's Tuesday. A print will be air-freighted on tomorrow's day flight. What is your nearest airport?"

"Well, I suppose we could have someone pick it up from Brattleboro near Hartford. It's more than thirty miles, though." Again the reluctance in Webster's words was audible. Charles wondered how dangerous it would be to push harder. On the other hand, he could not afford to leave the prospective deal on ice until Hanson's return from Australia.

"I assure you I respect your scholarly misgivings

about this picture. It's to allay them that I've had this radiograph made. I do hope your trustees won't miss this chance to see it and express an opinion."

"It is on the agenda."

"Frankly, Mr. Webster, we are now completely satisfied as to the tondo's authenticity. If you are not going to be in the market for it I would appreciate knowing. I prefer pictures to be either sold or not sold." He refrained from talking directly about alternative buyers: that would be too much like horse trading. But he intended the implication to be obvious.

"If you insist. Cable us the waybill number and I'll have the package collected." Webster's tone was cool. "But I must be honest with you. I don't myself feel this picture is for us."

Charles put the phone down, wondering whether Webster's antagonism was simply due to the clash of personality or whether the curator had genuine doubts about the Botticelli. For the umpteenth time he wished he could have mentioned the Berenson letter. But it would be futile to refer to an authentication which he could not produce. Then he called for his secretary and dictated a letter to the director of the Getty museum at Malibu. He was signing this when the receptionist rang to say there was a man downstairs asking for him.

"It's a foreigner, sir. His name is Raeder and he is interested in the Botticelli."

"He's what?" Charles's anger began to mount. Try as he might he seemed unable to maintain any confidentiality over the picture. Presumably Bostock had been gossiping about it. "Ask Samantha to talk to him, will you?" He rang off.

Twenty minutes later Samantha herself appeared, her eyes worried. "Charles," she said, "could I speak to you alone?"

"Of course." He did not have to ask his secretary to leave. She slipped quietly out, wondering what new situation was developing.

"Darling," said Samantha as soon as the door was shut, "there are two Germans downstairs, one of whom

says he inherited the Botticelli from Schneider but only heard about it after the executors' sale. He has a written release from Herbstein authorizing him to collect the picture."

"The devil he has. Did you see the date?"

"That's what I don't understand. Herbstein signed it on the Monday, the day before he died. The day I smuggled the pictures out."

Charles ran his fingers through his hair, scratching the back of his neck meditatively. "Which was two days after we made the deal with him."

"I don't like it, darling. I don't like it at all." Samantha faced him, shivering slightly. "We know the Memling was looted. Whatever Herbstein may have told us, there's something very wrong about the Botticelli." She reached out and held his hands. "I'm frightened."

For a moment Charles held her reassuringly in his arms. Then he kissed her on the cheek. "Ogres were made to be bearded," he said confidently. "Let's have them brought up."

Raeder had given deep consideration to the handling of his confrontation with Luttrell. The interviews he had endured in Berlin and the near insolence of the cultural attaché left him in no doubt that his future was staked on this mission. The minister was determined to recover lost treasures from the German national heritage. This was considered to be one. If he failed to recover it, then—assuming the little rat of a clerk had squealed—he would pay the price of assisting Horst all those years ago. The system was inexorable. The sins of the past were invariably revived to justify retribution in the present. He knew the game too well not to understand how humiliating his disgrace and demotion would be made. Even if he succeeded he would still be in suspense, waiting to learn the significance allowed in his achievement. The political system could create an infinite number of subtle gradations between glory and dishonor. For the moment all he knew was that he had hope, otherwise a fresh report from the Stasi's agent in Frankfurt would not have

been passed to him, nor would the cultural attaché be with him now, and he was ready to concentrate his formidable will power on defeating Luttrell.

When they came upstairs the cultural attaché was given a cautious welcome. He then introduced Raeder.

"Although the colonel's claim is a private one, it has the full support of our government."

"Claim?" asked Charles coolly, speaking in German.

"As we explained to your secretary"—Raeder nodded brusquely at Samantha—"there has been a misunderstanding. The Botticelli picture you acquired in Frankfurt belongs to me."

"Well, gentlemen, I find that a most surprising statement." Charles remained as urbane as ever. Indeed the tighter the situation, the more courtly he usually became. He affected the ghost of a bow as he asked for proof.

"The proof is simple," said Raeder uncompromisingly. "The late Herr Schneider made a bequest to me. Herbstein has honored the bequest and released the picture to me." He handed the paper across without saying more.

"The embassy lawyers have examined the document," commented the attaché. "It is in order."

Charles scanned the release briefly, noted the apparent genuineness of Herbstein's signature and then indicated a leather armchair.

"Would you care to sit down?" he said. It was obvious from Raeder's demeanor that there was substance to the claim. The colonel didn't fidget or look around. He simply stood there with a rocklike self-confidence, as though he had commandeered the office.

"My friend would like to see the picture," said Raeder, not moving. "He is the expert."

Charles flushed slightly. "Are you suggesting there is anything wrong with it?" he asked defensively.

"We wish to know it is here," snapped Raeder. "Not in yet another country."

For a moment Charles wanted to tell him to go to hell but thought better of it with the attaché present.

"Samantha," he said, "would you take this gentleman down to the safe?"

As she led the attaché out, he turned back to Raeder. "If you wish to go on standing, please do so. Forgive me if I sit."

Raeder glanced at the deep armchair he had been offered, rejected it and chose an upright one, which he positioned so that his back was to the window and his face in shadow. On alien territory he bid for every psychological advantage possible. In the first chair he would have been lower than Luttrell and have had the light in his eyes.

"I presume you can understand Herbstein's words," he said after a pause.

"Perfectly, thank you."

Nonetheless Charles spent longer over the perusal than was necessary, giving himself a chance to sum up his visitor. This colonel, despite his short hair and strong features, was certainly no simple soldier.

"And why didn't Schneider's solicitors hold onto the bequest?" he commented at last.

"It was only discovered some time after his death. The picture had already been disposed of. Herbstein recognized the injustice by signing the document you have there."

"Two days after selling the painting to us?"

The gloves were off now. Charles leaned forward questioningly, wondering how far he had spiked Raeder's guns. He soon discovered he had not.

"The validity of the release is unaffected. In any case you have never paid for the painting."

"How the hell do you know?"

"Because it's my business." Raeder decided to utilize his new information. He jerked a thumb at the door. "Your pretty little secretary there broke West German law and you are delaying payment. You can save yourself a lot of problems by handing back the Botticelli."

"Leave her out of it," snapped Charles angrily. "Herbstein applied for and obtained an export permit. The law was only broken in a technical sense."

"Send her back to Frankfurt and see."

As Raeder spoke Samantha returned and it was immediately obvious that she understood she was being talked about. She hesitated in the doorway.

"What is he saying?" she asked.

"I am saying," said Raeder, switching briefly into his laborious English, "that if either of you is so stupid to return to Germany the police will be interested."

There was complete silence. Raeder waited. He had planned this tactic. The Stasi's agent had provided him with one trump. He intended to win with it. He also reckoned Luttrell's composure would break if the girl was shown as being at risk. He was right.

"Leave her out of it, damn you. If you think you have a claim, get in touch with my lawyers. Meanwhile, I have nothing further to say." Luttrell thrust back his chair and stood up. "Except that if you make any more threats I will put this in the hands of our own police. Where's the attaché?"

"James is with him," said Samantha. "They'll be up in a moment."

Again there was silence. Raeder did not budge. For a moment Charles wondered if he would need assistance to remove him.

When the German spoke, it was unhurriedly and with complete assurance. "Why not call the police now? The detective Wates already has the details."

"What exactly do you mean?" Charles asked, demoralization creeping into his voice. "We bought in good faith."

"You removed the picture illegally from West Germany after Herbstein had agreed to restore it to me." Raeder knew when an opponent was going down and he moved in on Charles ruthlessly. "The Frankfurt police are putting out a request for assistance through Interpol. It will reach Wates tomorrow." This information had formed the crucial paragraph of the Stasi agent's report, who did not, however, know that the expected police action was the result of Gerhard's

activity. Nor would Raeder have cared. He was after a quick kill.

Charles sank slowly back into his chair. Obviously this man was an intelligence officer. Would the Metropolitan Police collaborate with an East German? For once his brain was not responding fast enough to give him a useful answer. All he could think of was Samantha's conclusion that both pictures had probably been looted and that some of Herbstein's bills of sale must be fakes. Could Luttrell's survive a police inquiry, with all the publicity it would entail? In despair he saw the coup which would save the firm vanishing, as Raeder's shadowed face confronted him, the eyes expressionless, the mouth set and hard. He knew it was a duel of wits and he knew he was losing.

"Better to hand over the painting now," said Raeder quietly, reading Charles's thoughts as accurately as a hypnotist and aware that his resistance had collapsed.

"No!" Samantha had seen enough from Charles's expression to understand what was happening. She leaped forward between the two men. "No, Charles! Don't give way to this man. Don't do anything without a lawyer. Tell him to come back another time."

Raeder was just rising to his feet to plant the release on Charles's desk and defeat this interference when the attaché came back accompanied by James Constant. For once Samantha put her faith in him.

"James," she cried, "stop Charles from giving the Botticelli away. Telephone a solicitor!"

As James fumbled to comprehend what was going on and the attaché stood prudently silent, Charles began to recover himself. He felt exhausted, as though he had been physically beaten up. He glanced at Raeder, then looked away again, still frightened by those compelling eyes.

"We shall have to take legal advice," he said unsteadily. "Miss Walker is right. Please leave the documents with us."

Raeder stepped forward and faced him, forcing him to look up. "I will give you twenty-four hours," he said

brutally. "Until tomorrow midday." He turned to the attaché. "I presume the picture itself is in order?" The attaché nodded. He swung back on Charles. "Have it packed ready for shipment. We shall be taking it with us."

So strong was Raeder's personality that Charles almost acquiesced. But he always had resented orders, whoever they came from. With an effort he stood up.

"Show these two gentlemen out, would you, James?" he said. "Then phone our solicitors."

"I'm damned if I'm saying goodbye to a million pounds! There must be a way to fix that bloody kraut."

Charles was weary, recovering from an ordeal that had been as unexpected as it was unprecedented. He had taken Samantha out to dinner, and now they were in the drawing room of the Mount Street flat. A tape was playing classical music softly. The only light came from a huge jade lamp with an appropriately large green silk shade on a table by the sofa. Samantha lay with her feet up and her head in his lap, while he sipped a drink.

"He was a sinister man," she said. "Was the lawyer sure he would win?"

"Ninety-nine percent. The proceedings would take time, of course. Years possibly." He gazed down at her with real gratitude. "You certainly saved me from making a fool of myself this afternoon. He was making me feel I had no alternative."

"He frightened the life out of all of us." Samantha frowned. "There was one curious thing, though. Did you talk to James afterwards?" Charles shook his head. "Well, I did. Apparently the diplomat made a remark about the Botticelli going to the Staatliche Museum. I thought Raeder wanted it for himself."

Charles was puzzled. His instinct told him this had an important bearing on the business, but he could not immediately see why.

"Perhaps he intends to donate it," he said. "That would explain the cultural attaché hovering around!"

Then he remembered. "Wait, though. Didn't the Austrian woman say the Nazis seized it during the war? They could have transferred it to the Staatliche in Berlin."

Samantha could follow this line of reasoning only so far. "Darling, there couldn't be two museums with a claim, could there? Anyway, Raeder's is a purely private one."

Charles suddenly felt drained. If it were morning and he was fresh, he felt sure he could spot the link.

"This is maddening. Nothing adds up."

"Anyway, I don't understand why that woman from the Kunsthistorisches said their claim wasn't strong enough. Or why the letter asks you to fly over and discuss a price. D'you suppose the Germans are trying to beat them to it?"

Charles considered this. "It would make sense if Raeder's claim wasn't based on a postwar transaction, the very same one that underpins both Herbstein's purchase and ours. No, it won't wash. If the Staatliche had any sort of right to it, they wouldn't be playing things this way."

"Unless they're afraid we might return it to Vienna. Darling, oughtn't you to go there and see what they have to say? Take me with you. I might dig something up. Lucy can hardly object. Will you, darling?" She rolled over slightly, reached up and pulled his head down to kiss him. For a few moments he yielded, then released himself, put one arm around her shoulders and lifted her into a sitting position. Automatically she snuggled against his shoulder.

"I want to be with you. Even if you do taste of whiskey."

"Let's go to bed," he said almost roughly. It was the only answer he could think of. His mind was completely absorbed with how to handle the German in the morning.

Samantha roused herself, went through to the bedroom and undressed. But when he joined her, he merely murmured something inaudible, kissed her hair

as she lay in his arms and fell asleep. Disappointed, she tried to do the same and found she could not. He was restless, perhaps possessed by a dream, and her own thoughts were whirling. Eventually she rose, pulled on a dressing gown of his and made herself a drink. Then she climbed back into bed and lay propped on the pillows, with the light dimmed, pondering. When he stirred and reached out a hand to find her, she could not stop herself from speaking.

"Darling," she said softly, "why don't you buy off the Germans with the Memling?"

He grunted, turned over and then opened his eyes.

"What did you say?"

"Didn't Wildenstein once give a Monet to the Louvre when he wanted their consent to export a Rembrandt?"

Reluctantly Charles pulled himself up. "I don't see the connection." Then he saw her glass. "If you must chatter, for God's sake get me a whiskey too."

She slipped out again and came back with one.

This time she perched on the end of the bed. She had an idea and she wasn't going to let him drop off again until he'd heard what it was.

"Why not follow Wildenstein's example. Give the Germans a Memling in exchange for their dropping the claim to the Botticelli. Say that as it was Göring's it ought to be theirs. Pretend the Botticelli is being returned to Vienna anyway."

Sleepy as he was, the ingenuity of the scheme startled him. He gulped some whiskey.

"You think the Germans would fall for that?"

"I think that man Raeder is being driven. He's so determined."

"You mean he'd rather avoid a long lawsuit?"

"It's only a hunch. You couldn't watch the conversation you had as I could. I think the German had to succeed. He was so aggressive. Maybe if he's actually giving it to a museum, not making money himself, he'd settle for second best rather than go home empty-handed."

Charles swallowed the rest of the whiskey.

"What's more," insisted Samantha, "if the Belgians do come panting after the Memling you could simply refer them to the Germans." She giggled. "And it would be proving to Lucy what an honest, upright, straight-dealing sort of man you still are."

Suddenly Charles began to laugh. "I believe it could work. By God, it's a bluff, but a beautiful one." He stretched out his arms. "Now will you come to bed!"

When she did he kissed her affectionately. "Will you come to Vienna, my sweet?" he said.

Five minutes later they were both asleep.

The message from Westhampton was terse, even for a cable: TRUSTEES REQUIRE SPECIMEN ANALYSIS GROUND, MEDIUM AND PIGMENT. WEBSTER.

Charles found it waiting for him when he reached his office on Thursday morning. He called old George down and tossed it across to him.

"Can you arrange something with the Courtauld?"

"They're a bit reluctant to accept commercial work nowadays, sir." The famous Courtauld Institute in Portman Square was increasingly devoting its research effort to aiding poorly funded provincial museums. Only the National Gallery's Scientific Department could rival its equipment.

"Well, chat them up, George. We need to be able to show Hanson the results when he passes through on the way back from Australia. If he does." He sighed. "It's not often a client puts one through the hoop like this. The trouble is, Webster is visually blind. That's the only word for it. He has eyes but he can't see. And he's a persnickety bastard to boot."

"Not a very gracious gentleman, sir."

"You're damned right. Well, let me know how you get on."

But George did not go. He remained in front of the desk, fingering the cable.

"Is something the matter?"

"Excuse me, sir. Since I'm here I wanted to ask."

The restorer's embarrassment was manifold. "There's a bit of a rumor going around about your cutting the staff. Redundancies. Is that true, sir? I mean, if it is I'd like to know. So would Sid. If we're affected, that is."

Charles shot him a keen glance and realized that behind the awkwardness George was determined to have an answer.

"We are having cash-flow problems," he admitted, "but if there's one person Miss Lucy and I don't want to lose it's you."

"That's very kind of you, sir." George still did not move, however.

"It's common sense," growled Charles, embarrassed himself for once because he had completely changed his mind about sacking George. The framer, Sid, was another matter. But the last two weeks had shown how indispensable George was. "If the Botticelli fetches a decent price, we'll pull through. If not . . ." He shrugged his shoulders. "We're all of us on the firing line. That's strictly between ourselves, you understand."

"Of course, sir. Thank you very much. One other thing, sir." George hesitated as he made for the door. "That Memling. It's so badly abraded, the more I see it, the less I think it's worth spending any time on. I'd sell it off quick, sir, if I were you."

This advice rammed home the desirability of Samantha's solution. Raeder wouldn't notice the abrading, the erosion of the surface paint by time and careless handling. All he would see was a Madonna with angels, nothing like as grandiose as the Botticelli admittedly, but a comparable subject. He checked the time. Ten-forty. He could expect the German punctually at three. This time the solicitor would be present. Before then there was one even less enjoyable interview to face. Whatever the outcome, he must speak to Detective Superintendent Wates and preferably in person. Not that Wates was an unpleasant man. Charles had assisted him in the past. But he was methodical and unyielding. In so far as Bond Street dealers prayed for

anything, it was to avoid being the subject of a Fraud Squad inquiry. Charles gathered his courage together and telephoned Scotland Yard.

When Wates arrived an hour later he was shown the Botticelli, made notes, asked for and was given a black-and-white photograph and was then ushered up to Charles's office. The acid test of a police officer's attitude was often whether he would accept a drink. As it was now past midday Charles offered refreshment. To his relief Wates accepted a dry sherry.

"Shouldn't when I'm on duty," he remarked. "But a small one won't do any harm. Regulations are made to be bent occasionally, aren't they?"

Charles agreed heartily and decided to waste no more time over what was worrying him.

"We've had two would-be claimants for that Madonna," he said. "One of them suggested Interpol was involved. May I ask you a straight question? Has it been stolen?"

Wates was standing by the fireplace. Like Raeder, he instinctively positioned himself carefully. He raised his glass, took a sip and savored the sherry with slow deliberation. Then he held it to the light.

"Very nice. Very nice indeed. An amontillado, isn't it?" Then without waiting for an answer he admitted, "The wires have been humming a bit."

"It's no secret that we bought it," said Charles defensively. "However, there is a man who says he inherited it."

Wates's eyes narrowed fractionally. That could only be Raeder. "And was it him going on about Interpol?" he asked, annoyed at the use of confidential information which could only have come from either East or West German police sources. London was the Metropolitan Police's patch and no one else's.

"In case you don't know, Mr. Luttrell, Interpol merely circulates information. It does not make arrests." Wates drained his sherry. "Well," he said, "for what it's worth, I would advise you to deal with that

particular gentleman through solicitors. Thank you for showing me the picture."

He moved toward the door. "If you are thinking of exporting it, would you mind informing us? Just for the record. Don't come down. I know the way out."

The only possible conclusions to be drawn from Wates's careful remarks were that someone other than Raeder was pursuing the Botticelli, which could only mean the Kunsthistorisches, and that Raeder himself was bluffing as far as any criminal charge went. When the East German arrived, Luttrell and the solicitor were well prepared. They received him in the boardroom, where the Memling was propped up on an easel with a cloth over it.

This time Raeder could not choose his seat, and as the attaché had declined to accompany him, he was outnumbered. Once they were settled, Charles opened the proceedings with something less than his accustomed courtesy.

"Well, Colonel," he said with an intentional show of dislike, "we are forced to agree that you have a case. In civil law. If you sue us for the return of the Botticelli you are likely to win."

Raeder's expression did not change, even though he had anticipated a fight rather than abject surrender.

"Good," he said shortly. "Then there is nothing to discuss. I presume the painting is packed?"

"No. Nor will it be."

"What do you mean?" Raeder shifted a fraction in his chair. "You have just told me . . ."

"That you have a case. But we shall fight you every inch of the way. If you win in one court, we shall appeal to a higher. If you win there, we shall appeal again. If necessary we shall take it to the House of Lords."

"The House of Lords?" Charles had used the English words and Raeder did not understand them.

The solicitor consulted his notes and read out a laborious explanation in poor German.

"You cannot take such a case to the Parliament," protested Raeder disbelievingly.

"In England we can. And we damned well will!" He turned to the solicitor and spoke in English. "How many years would the action occupy?"

"I have known cases run five years."

Luttrell translated, adding, "You will probably win, but it will cost you a fortune and you will have nothing to give your museum for a very long time." From Raeder's face he could see he had drawn blood. Yesterday's debacle was being avenged.

"Then I shall go to the police."

"Too late. They came this morning. Wates has seen the picture. He is not interested."

Charles waited for a reaction, but Raeder merely flexed his shoulders, like a boxer limbering up.

"So," he said, "we fight. You are a foolish man, Mr. Luttrell, to struggle when you cannot win." He glanced witheringly at the solicitor. "We too can afford lawyers and our embassy has a press officer. We are keen to publicize the Democratic Republic's losses."

It was a shrewd thrust and one for which Charles was unprepared. Indeed things had gone so well up to this point that he was having second thoughts about the Memling. Now, disturbed by Raeder's resilience, he concluded he would have to offer it.

"Listen," he said more cordially. "Why fight if we can compromise? You want to donate a picture to the Staatliche, correct? I have one here which we have recently discovered belonged to Göring and was hung at Karinhall. We were not aware of this, of course, when we purchased it. If the Botticelli belongs anywhere, it belongs in Vienna, not to you, or me, but to the Kunsthistorisches. This other one could be said to belong to East Germany. It is by an equally famous artist. Would you like to see it?"

Raeder deliberated briefly. The argument was an attractive one. The ruins of Göring's home were indeed in the East. The prospect of long litigation was daunting, though from what the Bode director had told him

the government had not hesitated to undertake similar actions in the past. The snag was that he himself would be on tenterhooks for years to come.

"Yes, show it to me," he said.

Charles had planned to reveal the Memling in a mildly dramatic way, but when he switched on a spotlight and flung back the cloth from the easel the effect amazed him. Raeder started and had to suppress an exclamation.

"By Hans Memling. An extremely valuable work," said Charles. "I see you're impressed."

But Raeder was back thirty years, reliving the murder of two Americans and the finding of this picture. He would never forget it as long as he lived. For the purpose of clearing his name, this was indeed a substitute for the Botticelli. Better indeed. That accursed letter from Horst made it clear that there was a first painting about which he, Raeder, knew.

"I suppose this came from Herbstein also?" he remarked, keeping his voice as unexcited as he could. He had been a fool not to have guessed that the dealer might have acquired both.

"As a matter of fact, yes." Charles could see no harm in the admission.

"Did you buy much else?" Again a casual tone, though this was the crucial question, because Horst might well have left documentary evidence of how he acquired his assets.

"Only the two." Charles paused, slightly disliking this interrogation. "Well, will you accept it in lieu of the Botticelli or not?"

"Yes," said Raeder firmly. "Yes, I agree. You will of course provide the documents."

Charles had the Schneider and Herbstein receipts and a typed provenance ready and handed them over.

"Are these all?" One look at the supposed 1946 bill of sale was enough to tell Raeder it was a forgery. Done by that crook Herbstein presumably. It was too clean and careful to have emerged from the turbulent poverty of 1946. In those days if one got a receipt for

anything at all, it was not on expensive white paper. As for Horst, he didn't possess a suit then, let alone the six hundred marks quoted here.

"Precisely how it came into the previous owner's possession is not clear, I admit," said Charles, affecting unconcern. "If it's important to you, why not approach Schneider's executor? I believe he has all the letters. Frankly I doubt if it will worry the Staatliche. They will be delighted to have back another item of Göring's property, particularly such a fine one."

Raeder assented, convinced at least that the Bode director would be content. Ten minutes later he left Luttrell's with the Memling in a neat parcel and a letter confirming that the work had been in Britain less than fifty years and so did not require an export permit.

That afternoon he debated taking a flight straight to Hamburg to interrogate Schneider's nephew. However, after a brief and unfriendly conversation with the cultural attaché, he thought it prudent to return to Berlin as he had come, make his presentation to the Bode on Friday and then slip out of Berlin again at the weekend. The search would take time and the nephew would not be at work on a Saturday.

Schneider's nephew, Hans Dietrich, was a coward. In spite of a healthy, almost farmboyish appearance, he had always been afraid of being hurt. When he had read his dead uncle's papers he had been appalled. So his aunt's husband, the successful Frankfurt businessman, had been a scoundrel all his life, with a career founded on looting and fraud! He had deceived his closest friend, Wolfgang Raeder. Worse, he had retained links with SS comrades in South America through the Kameradenwerke. Yet by some curious inverted sense of pride he had kept all the documents and diaries which would have been so damaging to himself if they had been discovered before his death. Dietrich's first thought was to burn the lot, but the solicitor insisted that they be preserved in case there were

claims against the estate. However, he wasn't going to invite trouble. Hence his refusal to help Samantha. The small amount of money Luttrell had offered was emphatically not worth the risk of scandal and lawsuits.

Gerhard Balck's proposition, made by telephone from Frankfurt, was less easy to reject. The mere name of the Stadel impressed Dietrich, although he had never been there, and the curator appeared to know all about his uncle. When Gerhard suggested that to cooperate was a duty and that a firm as famous as Blohm und Voss would surely approve of their employee helping to right a wrong done in the war—which meant by implication that they would disapprove if he didn't—Dietrich wavered. Finally he acquiesced. Gerhard could come on Sunday.

When Raeder also rang demanding an interview on the same day the little nerve Dietrich did possess collapsed. He hastily arranged to take his wife on a visit to relatives and was in a sweat of fear from breakfast time on Sunday. He had to stay at home until Gerhard came, and he had to be out when Raeder did.

To his relief Gerhard arrived before eleven, accompanied by a woman who was introduced as "Fräulein Schumann, a colleague." Dietrich had arranged the papers on a teak veneered dining table which stood by the French windows giving onto the living-room balcony.

"Please make yourself at home," he said within seconds of their entering. "Unfortunately we have to go out now."

"There is coffee on the stove if you want it," echoed the wife.

"We ought to have a phone number," put in Gerhard, "if only to say when we're leaving."

"Oh, yes." Dietrich scribbled hastily on a scratch pad. "My mother's place," he explained. "She likes us to visit on Sunday's." With that they were gone.

"Odd," commented Gerhard. "Scuttling out like a pair of rabbits." He and Karin left the hallway and surveyed the small living room.

"It's probably better to be alone," she remarked. "We can talk more freely. Suppose we divide the files, half each?"

For nearly two hours they sifted. Mostly the documents related to the business the late Herr Schneider had built up, to loans and mortgages. Then Gerhard whistled and called Karin over. He had come across the correspondence with the Kameradenwerke, which had references to the events at the end of the war. This gave Karin an idea.

"You know," she said thoughtfully, "there don't seem to be any papers relating to his time in East Germany. Perhaps he didn't dare take them through the frontier post. But he might have had a diary."

Gerhard surveyed the mass of correspondence. "There are no normal diaries here, except those business engagement books."

"Let's quickly go through anything that might be," she urged.

They began again, and Karin picked up a bundle of tattered school exercise books which she had put aside earlier as irrelevant. She untied the string. The outside cover of the top one was marked "History." She flipped it open casually. Inside was a closely written narrative, with dates in the margin. As she read she realized with a shock that the text had nothing to do with kings or empires. It was a personal account.

"Gerhard, come here. I believe I've found it!"

The book was almost square, with ruled lines, and the handwriting was ill formed and schoolboyish, though energetic. She turned to the first page and burst out laughing. It bore the bold heading "My Incredible Life." "It's not true," she said, giggling in spite of herself. "How absurd!" Five minutes later she was completely absorbed. The volume contained an account of murdering an American and stealing a picture which could only be the Memling.

"One of these is bound to explain how he got the Botticelli!" she exclaimed.

They were interrupted by the buzzer in the hall.

"Damn. I suppose we'd better answer it." Gerhard crossed the room, leaving Karin at the table by the window. He pulled back the catch and opened the front door. Framed in it was a bulky figure in a trenchcoat.

"Herr Dietrich?" inquired the man, thrusting out his hand with vigorous warmth. "Wolfgang Raeder. Delighted to meet you!"

For a few seconds they stood poised there, Raeder set to launch into the genial role of the trusted family friend, Gerhard temporarily startled into silence.

"I'm afraid Herr Dietrich is out," he said finally, keeping his hand on the doorknob. "We are just acquaintances. Can you come back later?"

Past him, through the half-open living-room door, Raeder saw the piles of paper and Karin starting to rise as she realized that the stranger must be the mysterious man from Berlin.

"Stop him," she shouted. "Don't let him in!"

With a thrust of his left shoulder, Raeder pushed the front door back and tried to force his way past Gerhard, who leaped for the living-room door and pulled that shut, standing in front of it protectively.

"Get out of my way," said Raeder grimly. "Out!" Gerhard gritted his teeth and did not budge.

"I give you ten seconds. After that you get hurt."

In the living room Karin heard the threat and knew she had to raise an alarm and save the diaries. Behind her was the French window onto the balcony. Outside she saw a woman walking across the grass with a dachshund waddling behind on a leash. Frantically Karin unfastened the window and stepped onto the balcony, clutching the exercise books.

"Help!" she yelled. "Call the police!"

The woman with the dog turned. Karin shouted again. Behind her she could hear a pounding against the door. She felt sick at the thought of what was happening to Gerhard. The woman was standing on the grass, looking stupidly in her direction but doing nothing. Perhaps she was shortsighted. Karin shouted again.

The noise in the hallway increased. She leaned over the balcony, craning her head around to see if there was anyone else around, and suddenly realized that she could at least put the books out of Raeder's reach. The flat below had an identical balcony. Leaning over perilously, she tossed the books down. They scattered as they fell, but her aim was good; none missed. Out on the grass the woman had at last realized something was seriously wrong. She was dragging the dog back toward the building.

"Call the police!" shouted Karin again and then was forced to turn around by Raeder's voice. He was in the room. She could see Gerhard lying on the hall floor, inert.

"I'm taking the papers," said Raeder. His knuckles were bleeding slightly, but he was completely calm. He advanced toward the table.

"If you've hurt him I'll kill you," she spat at him. Then, as Raeder crossed the room, she felt for the side of the table and heaved it up with all her strength. The piles of paper shot forward, landing in a heap at Raeder's feet, the table falling on top, a barrier between the two of them.

"Take the papers then if you want them so much!" She darted around one end of the table and ran to Gerhard, who was groaning slightly, with blood trickling from the side of his mouth. Raeder paid no attention to her. He was kneeling on the floor trying to scoop up the papers.

Outside voices suddenly sounded. Then there was a hammering on the front door.

"What's going on?" a man called out.

Raeder straightened himself up, realizing the hopelessness of attempting to remove any of the documents, and moved in short steps through to the hall. Unconcernedly he stepped over Gerhard's body and opened the door, confronting the inquirer outside.

"I tried to stop them," he said. "They've had a terrible fight. I must fetch a first-aid kit from my car."

He thrust aside the man and made for the stairs. The woman with the dog was in the hall.

"I'm going for assistance," he said. He walked quickly across the grass toward the side road where he had parked his rented car, a defeated man.

⌒⌒ chapter 8

Gerhard lay propped up on the pillows, with Karin perched on a chair beside the bed. He was in a private room at a Hamburg hospital, and she had been staying in a hotel until he was well enough to receive a visit. It had been two days since his fight with Raeder and initially the doctors had feared internal injuries. He had suffered a bad concussion. Now they had decided he was mending and could be discharged soon, though with two broken ribs it would be a couple of months before he was himself again.

"Darling, you've got to be well in time for the Opera Ball," Karin was saying. "It was going to be a special surprise, but I might as well tell you now. It may encourage you to get better more quickly. Some friends have asked us to join their table."

Gerhard squeezed her hand. The Vienna balls were unique events in Europe now, with diplomats in their resplendent, rarely seen uniforms and the women bejeweled in long gowns. But the invitation mattered less to him than the discovery that he was in love with Karin and she with him.

"I promise I'll be there," he said and tried to smile, but the wires in his jaw hurt so much that he winced instead.

"Oh, darling," said Karin. "Is it terribly painful?"

"Not with you here." Then speaking very slowly, he steered the subject on to the diaries. "Have you read them all yet?" he asked.

She made a tiny grimace. "I've had plenty of time!"

He had been in shock when the hospital admitted him and no visits had been allowed.

"Were they worth it?"

"Apart from the lurid details of his sex life—Schneider could have sold those to the *Hamburger Nachtrichten* any day—it's not the stuff publishers would bid for. It's conceited and tedious and he only seems to have put it all down because at heart he was enormously proud of his few achievements."

"Isn't there anything, then?" asked Gerhard despondently.

She leaned across the bed and kissed him on the cheek. "Yes, there is. In the years after the war he lived off black-market deals, buying farm produce out in the country and then hawking it around Berlin. On one of these trips a farmer in the Dresden area offered him the Botticelli, which had evidently been looted in the turmoil of the Russian advance. He made sure he had a valid receipt for it, though, and bribed an official to countersign and stamp it."

"A very fly young man," commented Gerhard.

"He didn't care about risks. The way he escaped to the West with his valuables must have been hair-raising. He couldn't have managed without the help of a former comrade."

"Read it to me."

Karin reached down into a shopping bag and pulled out the exercise book. She settled herself as best she could on the hard upright chair and began, emphasizing the overdramatized style of the diary.

" 'My problem was to escape the search at the checkpoint. Only one friend could help me. We had saved each other's lives. We had killed together. But that was seven years ago. Would the blood bond hold, or would Wolfgang betray me?' "

"I've decided to leave," said Horst in a low voice. They were sitting out of doors at the solitary café open on the Unter den Linden, drinking foul-tasting ersatz coffee. It was late on a hot July afternoon. Wolfgang

had only just come off duty and was in his gray-green police uniform.

"If you're making the *Bundesflucht,* why the hell tell me? It's my duty to stop you from going West."

Horst surveyed his friend's impassive face. He's growing old fast, he thought. We're both only twenty-six, yet he looks like a cop already.

"Let's take a stroll," Horst said abruptly. "Which way are you going?"

"To law classes."

"You're certainly taking things seriously!"

"I'm making my life here," said Wolfgang shortly.

They walked down the broad avenue, past groups of Russian soldiers, rifles slung on their backs, staring curiously at both the buildings and the passers-by.

"That's why I'm going," said Horst. "I've had enough of them."

"You'll only find Americans and British on the other side. What's the difference?"

"I want to try my luck."

They walked on in silence for a few minutes before Wolfgang replied gruffly, "Go and visit relatives in West Berlin one morning. But don't try taking a suitcase. Then you will be in trouble."

"That's the problem, old friend," said Horst in as light a tone as he could manage. "I want to take a van."

"You're crazy!" Wolfgang stopped, surprised in spite of himself.

"No. I'm an exporter." Horst took a step forward. "Let's keep moving. I don't like eavesdroppers. Listen. I've a new line. Sells like hotcakes. The paperwork is in order. The goods have been paid for—in British sterling. All I have to do is deliver to West Berlin. I've done it before, but this time I'd rather go out through your checkpoint."

"Is this some kind of black-market deal?" Wolfgang was immediately suspicious. There was illicit traffic in virtually every desirable commodity: farm eggs, shirts, cigarettes and, above all things, nylons.

"I swear not. It's completely aboveboard. Except that I'd like to take a few personal possessions with me, things I'll need. They'll be under the freight."

"It's a hell of a risk. We could both get fifteen years."

"We've taken risks together before. This is the final run. I won't ask again. All you have to do is check the load carelessly. My own stuff will be well hidden."

"What are the goods?"

"Bit of a joke, really. If I tell you now you might not react naturally when you see them."

It was a valid point. Raeder was silent for a minute. They had reached the Karl Marx Platz. There were more people around.

"Friday," he said. "Make it mid-morning, when we're busy." He stopped and shook hands. "Keep your head, old friend. There are a lot of Vopos around that checkpoint. Send me a postcard one day, but not too soon."

Early on Friday morning Horst loaded the old black van in the shed where he kept it in the suburbs. The Botticelli, wrapped in a sheet, went flat on the floor. He packed it around with straw. On top went two small cases, one of personal clothing, plus the Memling, the other crammed with banknotes. If he was going to take a chance, Horst reckoned he might as well take a big one. Wolfgang's mistrust was well justified. The money came from a variety of minor deals. In fact the acquisition of the Botticelli had been an unexpected addition to a transaction with a farmer.

When Horst had positioned the cases he surrounded them with his proper freight, four hundred statuettes, all individually wrapped in straw. They were packed too close together for an investigator to poke a stick through and find the suitcases, and unloading the whole lot at the checkpoint would be time-wasting and messy. At least that was how he reasoned.

By midday the sun had made the inside of the vehicle like a furnace. In spite of winding down both windows and driving in his shirt sleeves, Horst was

streaming sweat by the time he reached the checkpoint. He was worried in case the guards thought it was from fear. Barbed wire and concrete blocks stretched away on both sides, marking the division of the city. Immediately ahead a wooden barrier closed the road. Beyond, across fifty meters of wasteland, he could see a sign in German, English and Russian: YOU ARE NOW ENTERING THE BRITISH SECTOR OF BERLIN. He took a deep breath. The guards would shoot until you were past the British barriers. They had often done so, sometimes even after permitting a car to pass.

"Papers!" demanded a harsh voice. A frontier policeman was peering into the van. Beyond him stood three Vopos, their submachine guns held loosely ready.

Gingerly Horst eased the van door open and emerged to show his documents. Out of the corner of his eye he could see Wolfgang seated inside the low concrete building, watching impassively.

"What kind of statuettes?" demanded the guard. "Show me."

Obediently Horst went around and opened the rusty back doors. He pulled out one of the statuettes. It was a gaudily painted garden gnome, with a pointed hat and white beard.

"Made of clay," said Horst. "The British army families buy them through their forces shop. The NAAFI, it's called. They're already paid for."

The guard gazed at the inside of the van, filled with layer upon layer of these straw-wrapped figurines, then shook his head and went to the control post. A moment later Wolfgang emerged.

"Is this serious?" he demanded, genuinely amazed. "You sell these to the British?"

Horst did not dare look him in the face. Instead he removed another statuette, held it out and said simply, "Believe it or not, Sergeant, the British go mad over these things. Making them gives us work and earns hard currency."

Wolfgang examined the gnome, wondering if Horst

was somehow sneaking out more than he had said.
Two of the Vopos had wandered over in curiosity. No
one was paying attention to the line of cars building up
behind. Suddenly it occurred to him that these things
must be hollow. There could be contraband inside
them. With a sharp swing of his right arm he cracked
the gnome against the side of the van, decapitating it,
then stamped on the body, grinding it to fragments,
and peered down. To his relief nothing more than clay
and scales of paint lay on the pavement.

"Here," he said to the guard. "Take another at
random."

Horst watched, not daring to speak, while a second
gnome was smashed. Again it revealed only clay and
dust.

"When are you returning?" asked Wolfgang.

"This afternoon, Sergeant." Horst's reply was
unblinking, though a surge of relief swept through him
as he realized that the question was purely for the
record.

"Stamp the papers and let him through," Wolfgang
told the guard. "I'll start on the next one." He did not
look back. Three minutes later Horst was passing
through the British control, explaining about the
garden gnomes to an equally incredulous Scots ser-
geant. An hour after that he was unloading them at a
warehouse run by the British forces shops, the NAAFI.

"Two broken, I'm afraid," said Horst. "I'll refund
you now."

"What about those?" queried the storeman, pointing
to a quantity still inside the van. "Be simpler to make
up the number."

"Sorry, my friend. They're promised to another
customer."

That evening Horst broke open the remaining
twenty gnomes and removed the gold jewelry he had
embedded in the wet clay before baking them gently in
his oven at home. He hadn't wanted to melt the gold,
after all. The next day he sold the van and took a
British European Airways flight to Hanover. As the

Dakota bucked and groaned its way at low level through the thunderclouds he was too elated to feel sick. A pity I can't send old Wolfgang a share, he thought, smiling to himself, but that would be bound to arouse suspicions.

However, a month later he did send a picture postcard from Bavaria. It showed the church in the village near which they had lived on the farm, killed the Americans and buried the ammunition box of loot. Happily the treasure was still intact. But he wrote on the postcard, "Someone got here before me. That's life, I suppose. All the best. Horst."

Karin closed the exercise book with a snap. "What a story!"

Gerhard took her hand. "There's something else I never had time to tell you. Our own Hessen police went through Herbstein's gallery and found a drawerful of prewar letterheads from the Munich dealer who supposedly sold the Botticelli in 1923. There's not much doubt that Herbstein was in the habit of forging old bills of sale. My love, you've enough ammunition to sink a battleship, let alone a London art dealer."

Gerhard let go of her hand and settled back on his pillows.

"How easily could Luttrell discover about the loan?" he asked at last.

"As far as I know, the only place it's recorded is in the June 1939 catalogue, which mentions quite a few outside works."

"And is their ownership obvious?"

"Unfortunately, yes. The name of the owner of the collection is printed in italics alongside the text, so that it stands out. Funnily enough there's only one copy of the 1939 catalogue in the library. The others must have disappeared in the war."

"If I were you," said Gerhard, "I might decide to borrow that one copy from the library on the day Luttrell comes. If he actually asks for it, well, you'll have

to produce it. But if he doesn't, why leave it where that art historian of his might browse around and find it?"

"Darling, that's not exactly ethical behavior, is it?"

"From the sound of him Luttrell is not a particularly ethical man. He's playing for high stakes." Seeing how worried Karin looked, he made a further suggestion. "Have a word with the Hofrat. If he persuades the minister to back the purchase, and Luttrell is going to make a profit, he may feel a little subterfuge is acceptable."

"All right." She gazed at Gerhard gratefully. "Listen. I have another idea too. When they release you from here, why not come and stay with me in Vienna? I can look after you."

"I'd like that," said Gerhard, "very much."

For once James Constant was living up to his name, and Charles was irritated by his arguments. "We ought to hold a board meeting," he was insisting. "All right, the East Germans have agreed to accept the Memling and drop their claim on the Botticelli. Fine. Lucy will be most relieved to hear it. But in my view the attitude we adopt toward the Kunsthistorisches Museum should be decided by all of us. You're going to Vienna next week. We must meet before then."

Charles bit back a desire to tell his wife's cousin to go to hell. The two of them had clearly been discussing the firm's affairs behind his back. "Listen, James," he said quietly, "a month ago you were all demanding a coup. I produced one. Let me handle it my way."

"We should make a collective decision. It's too important."

"Goddamnit, do you think von Karajan lets a committee decide how he's going to conduct at the Vienna Opera? Does Peter Wilson stop the bids so he can take boardroom advice in the middle of an auction at Sotheby's? Here I've laid my hands on the most valuable picture to come our way for years and you're crowding around like a flock of civil servants trying to tell me how to negotiate its sale. I'm going to play it by

ear, just as von Karajan and Wilson do in their different ways, because that's how this game works."

"Lucy and I are worried about the ethics of it all."

"Ethics?" Charles felt if this went on much longer he would burst a blood vessel. With a great effort he controlled himself. "My dear fellow, as far as I am concerned there aren't any ethics. We exist to buy and sell pictures, not souls."

"Lucy and I feel that if the Botticelli belonged to the Kunsthistorisches, we should restore it to them. We can perfectly well refuse to pay Herbstein's executors."

"And go bankrupt? Thank you, no. I admit that Herbstein's bills of sale leave a lot to be desired. So do many provenances in this business. But our transaction with him is valid and so was his with Schneider's executor. They may have been sharp, but they're legal. If the Kunsthistorisches had an unassailable claim to this picture they wouldn't be offering to buy it, even at a nominal price. They're hiding something. I hope to find out what when I reach Vienna. That is why I shall play it by ear." Charles paused and devoted a full minute to lighting a cigar. Then, after inhaling a first puff, which slightly restored his temper, he added, "I will make one concession, James. I won't commit myself finally in Vienna and I will hold a board meeting on my return." He took another long pull and blew smoke toward the ceiling. "If you care to get Lucy on the telephone, I will tell her now. Otherwise it can wait until the weekend."

If there was going to be a scene, he thought, he would rather have it at home.

"Not only is the minister honoring us with his presence at lunch," announced the Hofrat, "the director of the Bundesdenkmalamt will also be there. I need hardly say that their attendance is the measure of our concern over the Botticelli."

Four people were at the circular table in the Hofrat's office. Charles Luttrell faced him. Karin and Director Kameier flanked him on either side. Despite his

naturally cheerful disposition, the Hofrat had decided to make this a solemn occasion. In any case if he didn't, the minister soon would.

Charles acknowledged the Hofrat's opening remark with a murmured platitude and an inclination of his head which, had he been standing, would have developed into a bow. He recognized the Hofrat's formula. Presumably the ministry would have to fund a purchase, while the director of the Bundesdenkmalamt was responsible for the safeguarding of the entire Austrian national patrimony, from castles to carvings. Short of wheeling in the President of the republic, they could hardly be giving him higher-level treatment.

"I am honored." Charles hesitated a fraction. "May my art historian join us? She is doing some research at this moment."

"She will be welcome."

Even though he was talking to the Hofrat, Charles did not miss the antagonism that flashed across Karin's face.

"I believe I saw your Miss Walker in the library," she said, already half afraid of what Samantha might have unearthed.

"Quite possibly." Charles affected to shrug it off as inconsequential. "She is taking the opportunity of calling on the Dorotheum, too." This was one of the oldest auction houses in Europe, and its senior staff had an encyclopedic knowledge of who had bought what, not only in this century but in previous ones. Chat up old Dr. Molden, he had instructed Samantha. If there's a mystery, he'll know about it.

Aware of the warning concealed in Karin's remark about the library, the Hofrat put the ball in Charles's court.

"So. Where shall we start?" he said briskly. "The authenticity of the Madonna is hardly in question, is it?"

"Indeed not!" Charles always believed in praising whatever goods he had on offer. "Considering the

changes of ownership the tondo has endured since the 1920s, it is in a remarkable state of preservation."

"The Fräu Doctor here has confirmed that," put in Kameier, glancing at Karin.

The Hofrat nodded assent. Nonetheless, Charles's statement was dangerously two-edged with its reference to changes of ownership. Before the meeting began, the Hofrat had agreed that they should challenge the Luttrell version of the picture's provenance with every fact at their disposal, putting him morally in the dock for handling stolen property. They would embarrass him to the limit. But in the last resort they could not assert that the Botticelli belonged legally to the Kunsthistorisches.

"Let us consider those travels," he suggested blandly. "You mention the 1920s, Mr. Luttrell. May I ask why?"

"Because according to the records it was sold through Gregorian of Munich in 1923." Charles was polite. "I realize Dr. Schumann doubts this. Nonetheless here is the bill of sale." If they were going to dispute his provenance, he thought, let them produce proof. He passed the thick, creamy sheet of paper to the Hofrat.

Without a word Karin opened the folder in front of her, removed a sheaf of exactly similar sheets and placed them in the center of the table. She waited until Charles had realized what they were before she spoke.

"Considering that Gregorian went out of business in 1940, a remarkable amount of his writing paper has survived, hasn't it, Mr. Luttrell? The Frankfurt police found these in your late friend Herbstein's office. He apparently used them for creating prewar authentications."

Even Charles Luttrell's well-drilled imperturbability was dented by her iciness. He flushed, and as he picked up one of the sheets his hand shook slightly. He had seldom been confronted with such a damning indication of fraud, even if it wasn't proof.

"Evidently Herbstein identified the picture," said

Kameier. "Nor would he have had difficulty. Wald-hofen's 1898 catalogue was a printed one. In Austria and Germany at least the collection was well known—and so was its dispersal during the financial disasters of the early 1920s." Kameier picked up the bill of sale and waved it dramatically. "Not a bad effort," he went on in his best professional voice, "but it fails to score ten out of ten because Count Waldhofen kept several paintings of which the Botticelli was one. It came into our hands in 1938."

Karin gasped. The unbelievable had happened. Here was her punctilious director stretching the meaning of words to the limit of propriety. She was astonished.

"I fear, Mr. Luttrell," cut in the Hofrat, quickly backing up his subordinate, "you have been cruelly deceived."

There was no answer to that. Charles took a deep breath. He might as well know how much more they had ferreted out.

"Are you implying the postwar receipts are forgeries too?"

"The Fräu Doctor has the facts more at her finger-tips than I."

Again Charles found himself forced to face Karin's eyes. However, her tone was less condemning now.

"We have traced the movements of the Botticelli both during and after the war. Herr Schneider bought it, certainly. He smuggled the picture out of East Germany."

"So I gathered." Charles was quick to gain a point. "I have already had the dubious pleasure of assuring the East Germans that if anyone has a prior claim it is not they, even though they had some impressive documentation."

"Really?" Karin was taken aback. She had never expected to have the existence of the missing papers confirmed by Luttrell. She hesitated, turning over various possibilities in her mind. The East Germans would surely not have shown him the Waldhofen letters. To do so would have destroyed their own case.

Watching her, not fully understanding the reasons for her discomfiture, Charles suddenly found himself thinking that beneath Karin's determined manner there lurked a highly desirable woman. The thought did not last long. It was routed by Karin's recovering herself and starting to relate the wartime history of the Madonna.

"In plain language," she concluded, "it was first confiscated by the Nazis and then looted."

The Hofrat decided it was time to sum up. "So, given the provisions both of the Allied Declarations of 1943 and of our own State Treaty, we have some justification for feeling the picture belongs in Vienna." He smiled, as though they were now the best of friends. "Don't you agree?"

This was the kind of diplomatic understatement that underlined an argument far more effectively than shouting. Charles wished Samantha had been able to report the results of her morning's search. There was nothing for it but to fire his last broadside. "The one thing I do not understand," he said in his suavest tone, "is why I am here. Why do you talk of buying the Botticelli instead of sending your lawyers around to Bond Street and demanding it?"

"My dear Mr. Luttrell, you have provided the answer to that question yourself." The Hofrat beamed. This was going better than he had hoped. "The Nazis took the documents as well as the paintings. We presume they are now in the East. All our attempts to recover anything from there have failed." He spread his hands deprecatingly. "Of course a lot of perfunctory noises were made during our Prime Minister's last visit to the Democratic Republic. But nothing significant followed. You have hit on our problem. We have no record of our arrangements with the late Count Waldhofen. Morally our claim is undeniable. Legally it could involve a long-drawn-out and expensive battle." The Hofrat smiled again. "Expensive for both sides. In the long run it could be cheaper to buy the painting from you rather than fight for it. And, as I say, the ad-

vantage would be mutual." He consulted a heavy gold watch. "Now, shall we adjourn for lunch? We mustn't keep the minister waiting."

Charles allowed himself to be ushered out. As they escorted him down the passage he thanked his stars that Lucy wasn't with him. She would have promised them the painting back for nothing by now. And where the devil had Samantha got to?

By the time Samantha had located Dr. Molden at the Dorotheum, which sprawled through a range of buildings in a narrow street near the Hofburg, she was beginning to wonder if there was anyone of consequence in Vienna who did not sport a university doctorate. Listening patiently to his fragmented English, she learned how the Dorotheum was founded in 1707 by the Archduchess Dorothea as a loan institution to help small businesses. Later it developed into a salesroom. It still owned a bank. At long last he came to the point and began explaining how the acute inflation of 1920 to 1924 had forced many noble families to sell their pictures.

"Did you know Count Waldhofen? What happened to his pictures?" Samantha felt as though she were looking for an end in a tangle of string. There was a lead here if only she could grasp it.

"When I know him he is an old man, he doesn't talk so much, not about himself. His wife she dies in the war. His daughter, I think she is in America somewhere and not to be found. Really the war finishes him," explained Molden, who was unable to escape from the present tense.

"But his pictures?" insisted Samantha gently.

"His father sells them in the Twenties. Maybe he keeps one or two."

"A Botticelli? Did you hear of a Madonna? In 1939 it was supposed to have been in the Kunsthistorisches."

Dr. Molden shook his head in a kind of seesaw motion and clicked his tongue irritatedly. "You must know 1919 to 1938 is a very bad time for art records

in Austria." He looked up. "I tell you one thing. I think perhaps Waldhofen is a bit Jewish blood. In 1940 there is a director of the Gemaldegalerie at the Kunsthistorisches called Grimschitz. He has taken some Jewish property as loans to protect them."

"As loans?" Samantha could hardly suppress her excitement. Now she was getting somewhere. "Not as purchases? As loans?"

"To keep from the Nazis. He refuses to let the Nazis take anything. 'You cannot even have the frames of these pictures because they belong to the Austrian people.' Very few people have his courage. But he is moved from the Gemaldegalerie in 1941 and then the Nazis take things. After the war people attack him because he is a Party member. But he only joins it to save the pictures. It is, what do you say, ironic."

Samantha was no longer really listening. This would explain why the museum was negotiating instead of claiming.

"Please," she said, "how could I check these loans?"

"Only at the museum, I think."

Samantha thanked him profusely and hurried out. She was already hopelessly late for the lunch, but she didn't care. She was certain she had uncovered the vital clue—two clues, in fact, since Waldhofen's daughter's having disappeared could mean he had no known heir.

The lunch had been excellent. Charles had been urged to yield up the Madonna for the sake of the Austrian patrimony and the maintenance of good international relationships. Before leaving, the minister had promised a paean of official praise that would echo around the world. It was all very flattering and he had found himself responding, just as the Hofrat predicted. Finally, when both the top men had gone, the subject of money was reached.

"You will appreciate our funding problem," said the Hofrat. "Your own National Gallery suffers similarly. However, the minister has agreed to authorize excep-

tional expenditure from the fund for the state museums. We can offer three million schillings, approximately one hundred and ninety thousand dollars."

Charles blinked. It was a mere tenth of the Botticelli's probable open-market value. He had no doubt that the Hofrat was telling the truth and that the sum was exceptional for them. Nonetheless, but for the Kunsthistorisches' claim, it would be preposterous. Figures clicked through his brain. He had to pay Herbstein's executors one hundred and twenty-five thousand dollars. Plus the forty thousand for the Memling.

As if reading his thoughts, the Hofrat added, "From our information this would still ensure you a reasonable profit, would it not?"

That damned export license, thought Charles, glancing at Karin. "Unfortunately I was obliged to purchase certain other items at the same time . . ." he began.

"Like Göring's little Madonna?" asked Karin.

"You certainly are a mine of information, Fräu Doctor." Charles could not disguise his annoyance at being outwitted by this woman.

"Hardly our affair," remarked the Hofrat curtly. He loathed sarcasm. "One hundred and ninety thousand is our absolute limit."

"May I think it over for a few days?" Quite apart from holding the promised board meeting, Charles knew that realistically he could not reject this out of hand. The alternative could be a lawsuit which would paralyze any sale for months, possibly years, and end up forcing him to return the Botticelli not to this museum but to Herbstein's executors because he would be unable to pay them.

The Hofrat, sensing victory, had just ordered brandy when Samantha arrived.

"I'm terribly sorry, I simply couldn't find a taxi. You've finished? Never mind, I'll have some coffee." She handed Charles a note. "A message for you. I picked it up at the hotel."

Aware of Karin's watchfulness, Charles unfolded the

paper. As he expected, the handwriting that stared up at him was Samantha's bold scrawl: "Very possible Madonna *on loan* from Waldhofen along with other Jewish pictures. We must check prewar museum catalogue. What's more, Waldhofen's only child disappeared. Suspect no legal claimant exists."

Charles slipped the note into his pocket, accepted some brandy and asked if the ladies would mind him smoking. He wanted to think. The ensuing silence was broken only by Kameier insisting on ordering Samantha something to eat.

"I completely forgot to ask how you catalogued the Botticelli back in 1939," Charles said at last, looking keenly at the Hofrat through the cigar smoke.

"The catalogues of the period are in our library," replied the Hofrat noncommittally.

"As a matter of fact," said Samantha, conscious of the tension she was generating, "the 1939 one is out and the next wasn't printed until 1958."

Good for her, thought Charles. Let's show them two can play at researching awkward facts.

The Hofrat raised an eyebrow. "Perhaps you could help find it afterward, Fräu Doctor," he said to Karin, then turned back to Charles, apparently unperturbed. "We have a different system from you. We do catalogue loans, so it is presumably recorded as from the Waldhofen Collection."

Charles checked himself. He had been on the verge of making a scene and protesting at this eleventh-hour revelation, but thought better of it.

"You seem surprised," went on the Hofrat, sliding into sentences which he had rehearsed in case of disaster. "Really it is not so peculiar. Waldhofen bequeathed the picture to his daughter, but his deathbed wish was that if she was never traced, the Madonna should revert to us on permanent loan. The actual conditions are, unfortunately, in the lost correspondence."

"He never gave up hope of finding his daughter," explained Karin. "And he died very suddenly."

"How old would she be now?" asked Charles.

"She was eighteen in 1938 when he sent her to America to be out of the Nazis' way."

"Forty years and no word," said the Hofrat. "Legally it can be assumed she is dead."

A memory of Berlin came back to Charles—of a wasteland of bombed sites near the Tiergarten and someone telling him nothing could be done until the original Jewish landowners had been untraceable for forty years. Austria must have a similar law. Even so, the Kunsthistorisches' case was full of holes: lost documents, deathbed wishes. In essence this whole morning's rigmarole had been bluff. They could make his provenance look utterly fraudulent. But they could not prove the Madonna was theirs.

"Well," he said in more conciliatory tone than he felt they deserved. "These are questions for lawyers, not laymen like me. I can only thank you for your offer and your hospitality and promise to be in touch again shortly.

It needed only a glance at his watch to prompt the Hofrat into dignified farewells, though the next flight back to London was not until tomorrow morning.

That evening Samantha tried to persuade Charles into the course of action most likely to displace Lucy as a decisive influence on the fortunes of Sir James Luttrell and Sons, Fine Art Dealers. She was never likely to have him in a more receptive mood.

"Sweetheart," he said admiringly as they started on a predinner drink, "you certainly pulled the rabbit out of the hat this afternoon. I can't imagine why I never thought of checking their catalogue." He chuckled to himself. "That Hofrat is a very cool customer."

"Did he ever actually say they owned the Botticelli?"

"Not once. Whatever he may have implied, he never made an untrue statement. And from the start he laid it on about the painting morally belonging in Austria. Which it undeniably does." Charles laughed again de-

lightedly, as if he were appreciating more than one aspect of a joke.

"They really did a beautiful job on me. First that Schumann woman cutting me to ribbons, and then the minister applying the soft soap. I could easily have fallen for it."

"Don't, darling!" Samantha squeezed his hand. "Between us we've outwitted Herbstein, and the Germans, and now these people. Don't give up now."

Charles sat silent for a minute. There was no doubt about it, however much he still cursed Samantha for revealing the export license price, she had been amazingly successful at coming up with ways around the obstacles to selling this picture. Had she got the instinctive flair for making a coup which Lucy accused him of having lost? In a way it was a far from palatable thought. It confirmed that he was indeed losing his touch. On the other hand, the traditional answer was always to bring in a younger person. "Selling is a young man's game, buying is an old man's." Why not a young woman's? And if you wanted to keep the talent working for you, how better to cement the relationship than in bed?

"We're going to win, darling. I promise you we are," said Samantha softly.

"If you do tell the Kunsthistorisches to go to hell—politely, of course—they can still make things pretty difficult. A few words in the right places and our Madonna is going to be regarded as suspect. Or worse, become a newspaper story." Charles shuddered. "Some of the salesroom correspondents are more interested in scandal than anything else.

"Let's talk it through over dinner, darling. There's no rush. I think I might have an idea."

She didn't put it to him until much later. And even then he gave it a mistrustful reception:

"My love, that's the last thing a firm of our standing wants to do! It's an admission of defeat."

"Which is exactly the traditional attitude your beloved wife would take! Don't be so conventional.

Handled properly, it would both force the Kunsthistorisches to authenticate the picture and establish a market price for it."

Charles's resistance was weakening.

"But the others on the board will never agree."

"You know what you can tell them to do," she whispered, caressing him. "And the sooner you do it to me the better."

"Herbstein's executor is demanding payment by the end of next week, Mr. Luttrell." Wild, the accountant, was seriously concerned. He knew better than any of them how precarious the firm's financial situation was becoming. The others around the boardroom table turned to Charles.

"The executor will have to wait," he said bluntly. "We still need time to sell the Botticelli."

"I think we should accept the Kunsthistorisches' offer," said Lucy, trembling slightly. She felt she no longer possessed the inner strength to fight her husband. This meeting had begun with a quarrel over what she saw as an inescapable moral obligation. She steeled herself to repeat the argument. "We'll make a profit and we'll earn a lot of credit."

"With the Viennese perhaps, not with the bank. Damn it, Lucy, the Botticelli never belonged to the Kunsthistorisches. In fact, I doubt if the Waldhofen family could claim it back, even if there were any of them around to do so. The transaction by which Schneider acquired it bears an official stamp. I've had an expert examine it, and it's unquestionably the stamp of a local office of the Russian Military Government in Germany."

"Does that make so much difference when all the evidence suggests it had been looted?" Lucy knew this was her last throw. If James and Wild did not back her now, then she had lost.

"There was a lawsuit in the United States a few years ago which hinged on the legal right of the Rus-

sians to dispose of a painting their troops had confiscated. The court upheld the new owner's title as valid."

"Even so, we're not in America."

"No, my dear, but the Botticelli very soon can be." There was a rumbling determination in Charles's voice that Lucy knew all too well. "It's a simple choice. Do we want to survive, or do we sink with a halo around our heads in honor of a questionable claim? A highly questionable claim." He looked straight at Constant. "I believe Schneider had as good a title to the Madonna as anyone. What do you think?"

Constant glanced at Lucy, and she smiled thinly back. There was a lot of truth in Charles's private assertions that she saw the business as she would like it to be, not as it was or ever had been. "Unfortunately my wife lives in the manor house, not the market place," he had remarked once. It was cruel but true.

"Come on, James, get off the fence for once," demanded Charles abruptly. "We have decisions to make."

"I am afraid, Cousin Lucy, that I tend to agree with Charles. If we can find a buyer quickly enough to hold off the bank, then we should aim for a proper price."

When Lucy asked what the position was with Hanson and the Westhampton College Museum, Charles knew he had won.

"All the evidence the trustees asked for is ready. But that's only a delaying tactic of Webster's anyway. He has no real confidence in his own judgment, so he's safeguarding his position."

"Looking after Number One, you mean?" put in Wild.

"Exactly." Charles was delighted. Evidently Wild was on his side too. "He's frightened of advising Hanson to part with a million and a half dollars and then being lacerated by some New York critic. If only Hanson would show up from Australia there'd be no problem."

"And if he doesn't, will you sell to the Kunsthistorisches?" asked Lucy.

"No, my dear, I will not." Charles could afford to be adamant now. "The Getty people have replied and are interested. I wish I hadn't approached Hanson first."

Lucy thought to herself that this was just more evidence of Charles's having lost his touch, the very failing she had attacked when this all began. How long ago was it? Only a month. It seemed like six. Nonetheless she kept quiet.

Instinctively James Constant spoke for her. "Have we time for negotiations with more clients?"

Charles consulted Wild. "Can the cash flow stand much delay?"

Wild shook his head. He refrained from saying how badly Charles's preoccupation with the Botticelli had damaged business over the last few weeks. The salesmen might be on commission, but they still needed direction. Wild's private analysis of the firm's trouble was that far too much responsibility was vested in Charles himself.

"Then I'll give Webster an ultimatum. If he doesn't respond we'll auction the Botticelli."

"You'll what?" Constant was so shaken that he spoke vehemently for once. "Surely that's the last thing we ought to do. It's a public confession of failure." In the long war of attrition between dealers and the old established auction houses, like Sotheby's, Christie's, Burnaby's and Phillips, the one tenet of the galleries' faith was that a dealer worth his salt could raise a higher price than any auctioneer. His contacts were personal and discreet; his results were more often kept secret than publicized. He put a painting to auction only if there was something badly wrong, either with it or with his firm.

"Perhaps I should rephrase that," said Charles coolly. "The Botticelli will be put to auction in New York. Burnaby's are scouting around for first-class items for their big February sale."

"But we can't do that!" protested Lucy. "I absolutely refuse to allow it. We'll be the laughingstock of New York."

"I assure you we will not, my dear," said Charles. "Quite the contrary. There will be a sensation in the New York art world at the appearance of the Botticelli, fully authenticated and submitted to Burnaby's by"— he allowed the words to hang unspoken for a moment—"the executors of Herr Horst Schneider."

"What sort of a trick is this?" Lucy was now thoroughly alarmed.

"Only a well-established practice. The painting goes in as the property of Schneider's executor, and we bid it up to the reserve. If no one else pays more we shall at least have established a market value. Some museum or other is then bound to decide they want it and we can sell at a disarmingly low profit."

There was silence as Lucy wrestled with her growing anger. Her husband, whom she had once so admired, seemed oblivious to all the moral standards in which she believed. His way of working was becoming more and more underhand. She had held her tongue at the last meeting, revealing her worry but not challenging him. After that she had asked James to take a firm line on her behalf, but he had failed. Now she had no option. She was still the major shareholder and she would have to insist on Luttrell's trading honorably.

"You're taking a risk, Mr. Luttrell," interjected Wild, trying to break the tension. "We'd need to be very sure of a quick sale later if we were left with it."

Charles shrugged his shoulders. "I don't agree," he remarked dispassionately. "The picture will be out in the open. All the museums will have had a chance to think about it, especially Westhampton." He turned back to his wife. "Well, my dear, are you really so shocked?"

"This has become a hateful business, all squirming and deceit." She made a last effort to sound practical, though unable to conceal her disgust. "Anyway, who's going to play-act the executor for you?"

"Who else but the real one? Schneider's nephew. If Samantha's charms don't sway him, I'm sure ten thousand dollars will. Payable after the sale, of course."

Suddenly Lucy guessed intuitively who had devised this scheme. She could tolerate his seeking sexual relief in London. But for the mistress to influence what the firm did, what *her* firm did, was more than she could bear. She looked at her husband, ignoring the others, trying to delve beneath the self-assurance and the good looks, searching for answers in his eyes.

"She must be a very persuasive girl," she said quietly.

His gaze shifted away for a moment, and she knew she had been right. She reached for her cane.

"I want you to come back to Wiltshire with me, Charles," she said. "There's a matter of principle here that only you and I can decide." She turned to James. "Go down and ask for the car to be brought around, would you?"

Wild tactfully followed Constant out. For a few seconds Charles considered arguing, then he capitulated. "I'll just go and tell my secretary to cancel my other arrangements," he said and hurriedly left the room.

The drive to Downford was two hours. Nonetheless, Lucy immediately closed the glass partition which separated the chauffeur from the passenger and tackled her husband.

"Now we're alone I can say more of what I feel," she began. "This whole saga we've had with the Botticelli smells of undercover dealing. My father would never have allowed you to go as far as you have. I'm very unhappy about it."

"Do you want to save Luttrell's or not?" Charles had decided to stick to this theme relentlessly.

"What's the point if you destroy our good name in the process?"

"I assure you I'm doing nothing others haven't done, firms just as well known as us. My dear," he went on more gently, "I hate to say it, but you are a little out of tune with today's realities. Times have changed. Things are much tougher than they were when your father and I restarted the business after the war."

As he anticipated, this emotionally charged memory

affected her. For Lucy those had been golden days. She sighed, then touched his hand, wishing time could return.

"Charles, for my sake, accept the Kunsthistorisches offer. Please! It may be only a fraction of the painting's value, but at least it will be a clean transaction and one we shan't be ashamed of. We can find other ways of saving the firm!"

He temporized, not wanting to compromise and equally trying to avoid a row. She usually gave way in the end. They talked for most of the journey, exploring possibilities, yet always she came back to the same demand, until at last he felt he had to demolish her argument more forcibly.

"I don't think you understand how damned hard we've worked for this coup," he said. "And as for the Kunsthistorisches Museum, they are no lily-whites. They tried their best to trick us. If Samantha hadn't . . ." As he mentioned the name he knew he had made a serious mistake. Lucy's expression hardened and she glanced at the chauffeur, as if he might overhear them.

"I want to talk to you about her," she said in a low voice, bracing herself for the subject she most feared, yet which had become inescapable. "How involved in this deal is she?"

Charles was cornered. "As you know," he answered warily, "she researched the provenance of both the Memling and the Botticelli."

"So she is very deeply involved?"

"In a way."

"Will she go with you to New York?"

If Lucy had asked outright "Is she your mistress?" her meaning could scarcely have been plainer. Charles thought rapidly. By talking about New York, Lucy seemed to be accepting the inevitability of the auction. So he was winning, as he always did. Provided he could dress up Samantha's presence there with a façade of necessity, why should his wife spoil the joint triumph?

"Actually she'll be accompanying Schneider's

nephew," he said. "She'll make sure he fills in the right forms and doesn't try walking off with the proceeds."

Lucy sat up as straight as the car's deep upholstery would permit.

"If anything does go wrong there," she said, trying to keep her voice level and unemotional, though she was shaking and was afraid he sensed that she was, "and you have taken that girl with you, you needn't come back to me." She took a deep breath. "It's bad enough hearing the gossip about your affairs. If the firm is going to be wrecked as well as our marriage, then there's no point in making pretenses any more. The children are growing up. We can manage without you. As for Luttrell's, if it does have to be cut back and lose staff, I'm sure James will be able to run it quite adequately."

"James Constant?" Charles was stunned, not only by his wife's sudden turning on him but by this preposterous suggestion. "He couldn't organize a canvas latrine! You'd be bankrupt in weeks."

"I am perfectly serious."

Charles laughed, though unconvincingly. He had to treat the whole threat as a joke. There was no other way.

"Lucy, my dear," he said lightly, "none of your imaginings will come true. The Botticelli is going to be the rediscovered masterpiece of the year, and Luttrell's will be saved."

She gave him a little glance and saw he was shaken. She hated scenes. "Whatever happens that girl must go," she said. This was the price of her compliance, and Charles realized it.

"If you insist."

"Then let's consider the subject closed," she said. She would have liked him to renounce Samantha more positively but was afraid he might make some reference to her own disability, and then she would break down. Anyway, she had long discounted their marriage. Luttrell's mattered more. In consenting to the auction she

was sacrificing all her principles. Now Charles knew where he stood if this abhorrent solution did not solve their problems. She sank back into the cushions and remained silent for the rest of the journey.

chapter 9

Burnaby's auction galleries on Fifth Avenue are an established feature of the New York art business, mixing British style with American practice and always in hot competition with Sotheby Parke Bernet on Madison Avenue and Seventy-sixth Street. Whether Burnaby's is the more important might be open to question. Some observers here thought its position eroded by the recent opening up of Christie, Manson and Woods on Park Avenue. This rivalry decided Charles Luttrell to maneuver the Botticelli into Burnaby's big February sale. They would give the masterpiece tremendous publicity, and there was no point in taking the wraps off the picture unless he did so with a vengeance.

The transatlantic conversation with Burnaby's New York chairman, Alexander Tritton, in which Charles made the arrangements, was a model of Anglo-American understanding with more omitted than was ever said.

"Alex," he began ebulliently on the telephone, "there's a kraut I'm advising who believes American buyers have more confidence in auctioneers than in dealers."

There came a slow crackle of laughter over the line. "He could be right."

"Furthermore, he's in a hurry and he thinks you could sell his Botticelli faster than I could."

"How much of a hurry? And how good is the Botticelli?"

"Very good. And he wants it in your February sale."

In New York Tritton made notes on a scratch pad. "Is it secular or religious?"

Charles described the Madonna. "It's highly decorative," he concluded. "Not the sort of depressing religious subject only a museum would buy."

"We're nonetheless living in a secular age. If you'd unearthed another *Primavera* the price would have no limit. Okay, so it may be a great painting. It's still going to be of more interest to museums than private collectors. We'd prefer to build up interest. Couldn't this guy wait till June?"

"In all honesty, I had to tell him your big February sale was an important innovation and he might make more impact by being in it."

This subtle way of saying that Burnaby's could not afford to turn the offer down appealed to Tritton. He guessed that Luttrell's would be bidding too. A babe in arms would have suspected Charles's motives.

"What reserve are you advising?"

"A million and a quarter dollars. Personally I think it should make five hundred thousand more."

So Luttrell's would go up to one million three or maybe four, depending whether they were genuinely acting for a client, or were buying for resale, or simply bidding it up. The reason scarcely mattered. The February auction was to be a black-tie affair, held in the evening, what the trade called a "spectacular." It would need the drama of high prices. Nonetheless, one or two straight questions could not be avoided.

"Will you be in it?" he asked.

"Very possibly. I have a buyer who can't make up his damned mind."

"Okay." Tritton paused to allow for the fractional time lag on the transatlantic line. He wanted his next question clearly heard. "What about the commission? I suppose you'll want the dealer's rate if you're handling this picture on the German's behalf?"

Officially Burnaby's commission on sales ran downward from 25 percent on the first thousand dollars to 12½ percent on the portion of the sale price over fifteen thousand. This was much more than the 10 percent they charged at their London salesrooms, because there

they also took 10 percent off the buyer. But in either capital they would give a substantial concession to a dealer who introduced business, and they would also drop right down to secure a really important work because of the publicity value inherent in handling it.

Charles had reflected carefully on this. In London as a dealer he would expect to pay only a 6 percent commission. But on a masterpiece he could bargain Tritton into the ground.

"I thought that if we paid for a fair amount of advertising, you might handle it free."

"Jesus Christ! You're not offering us Mentmore to sell. This is only one picture!"

"It will make the evening, though."

"Tell you what," offered Tritton, thinking of the money that even only one percent would give him if the Botticelli fetched a million and a half. "I'll settle for four. I quite understand you're not advising this kraut for nothing."

"Two and a half." Charles cursed the impersonality of the telephone. He liked to watch a man's face when he was bargaining. There was a long pause—so long that he thought they had been cut off. "Three if you insist," he said.

"All right," conceded Tritton unenthusiastically. "I accept. But don't waste any time getting the picture across here. And, Charles"— he paused again—"I assume there'll be no hassles over authentication. We still give a five-year guarantee on our attributions, you know."

"I promise you, this Botticelli is as near completely autograph as any painting of his ever was. I'll send one of my staff across with it and the documentation tomorrow."

"With full authority from the owner?"

"Of course."

Charles hung up, well satisfied. The plan was working. The day after the board meeting, he had sent Samantha to Hamburg, and she had found Schneider's nephew unexpectedly amenable. True, he had wanted

cash for his cooperation, but he had readily signed the necessary documentation. Now she could take the picture to New York. In the urgency of the situation Charles was turning a blind eye to Lucy's demand, telling himself that he would somehow explain matters once the mechanics of the sale were under way. In any case English employment law legislation stipulated that you couldn't sack staff without reason—and jealousy was not a good one.

Ten days later, as Burnaby's lawyers decided Dietrich appeared to have satisfactory legal title to the Madonna through the 1948 purchase and his uncle's will, Tom Hanson passed through London, long delayed on his way back from his Australian visit. His manufacturing subsidiary there had run into tangled labor problems that forced him to stay on as his own troubleshooter. He was furious when he called at Luttrell's and heard what had been going on.

"I'm sorry," said Charles bluntly, in fact far from regretful at having a chance to revenge himself on Webster. "But we carried out all the tests your young curator demanded, the picture came through with flying colors, and we still couldn't get a straight answer. We were in fact selling on behalf of this man Dietrich. He quite suddenly decided he'd had enough of what seemed to be endless negotiations and instructed us to go to auction." Charles poured out some more whiskey and handed the glass to Hanson. "God knows I hate seeing the auction houses get such a prize, but I can understand his feelings. He's seen stories about the huge prices art fetches at auction, and he's no kind of a collector himself. He simply wants to turn something he inherited into cash."

Hanson sighed, took a large gulp of the whiskey and rubbed the back of his hand across his chin reflectively. His plane had been late, and the longest stopover he could allow himself was a night. Now even that seemed pointless.

"So I can't even see the Madonna?"

"Only in New York." Charles glanced at his watch. "It's not yet five-thirty. Old George may still be upstairs. He could at any rate explain the results of the Courtauld's tests. Having a scientific mind, you'd probably appreciate them better than Webster does."

Hanson agreed. At least he would be deriving some benefit from the visit. Upstairs he was shown the X ray, microscope slides of a paint chip and the further analyses that had been made of the pigment. He listened with growing fascination.

"I'm sure I don't need to tell you, sir," old George went on tactfully, "about the optical properties of mineral pigments. They tell us this blue is lapis lazuli, not, for instance, Prussian blue, which was only invented in the seventeenth century. And equally we can determine for certain that these lake pigments were made from the crushed bodies of scale insects. If they'd been derived from modern coal-tar dye stuffs the chemical tests would have unmasked them straightaway."

"You've sure as hell convinced me this is no fake." Hanson picked up a graph. "Tell me, what was this?"

"Well, sir, your Mr. Webster called into question some of the overpainting. We thought it must have been where the paint had flaked and been redone by the master himself at the time. But of course we had to prove it."

"And you can?"

"Pretty well, sir. We know the Florentines often used only the yolk of the egg in creating the medium to hold the pigment. It's called egg tempera. If we can show that the overpainting is also in tempera, then it's most likely original. We can do that by analysis. As I expect you know, sir, when everything else is removed, the yolk is fifty percent oil."

Hanson nodded and George pointed at the graph.

"This displays the analysis of a sample which has been broken down by gas chromatography—basically a stream of hot gas separating out the components." He pointed to three sharp high points on the graph line. "You see, sir, those are the fatty acid components of

the egg-yolk fats which survive in the tempera. A drying oil would have a large amount of azelaic acid in it."

"So you think the overpainting was done by Botticelli himself?"

"Exactly, sir. We've had pictures that are ninety percent later overpainting. If we took it all off there would be nothing left. But apart from varnishing, the Madonna has hardly been touched. That's the beauty of her, sir. The condition."

"Of course," put in Charles, "this is a great picture. Professionals like George here tend to take that for granted. So will bidders at the auction. The condition matters a lot. You've only got to look at the state of some paintings in your most famous museums to appreciate why. You know the Stubbs of a white horse being savaged by a lion that is in the Met? Take a close look at it next time you're there. It's so abraded there's scarcely any surface paint left."

Hanson waved his hand in dismissal. "Don't worry, Charles. This fellow's convinced me. Now what I want more than anything is to get those damn trustees of ours together."

As he shook hands with old George, Hanson was not only thinking of the Botticelli. It had occurred to him that Westhampton did not only want pictures. The museum badly needed a down-to-earth, practical man like this restorer to take charge of their conservation. And to talk sense on technicalities. If he had been on their side, the Botticelli would be arriving at Westhampton now, not sitting waiting for competitive bids from dozens of others at Burnaby's.

"What's your surname?" he asked.

"Thompson, sir."

Hanson turned to Charles. He wasn't the sort to steal another man's staff behind his back. "If you ever cease to need Mr. Thompson, we'd be glad to have him join us."

"Listen, my friend, as far as the minister is concerned, you've failed."

Marklin was seated on the red leatherette-covered sofa in Raeder's living room. Several weeks had passed since the abortive trip to Hamburg, about which Raeder had kept silent, not even telling his wife. She was out now.

"That's what you wanted to tell me?" he asked. Marklin had suggested they have a chat after work.

"You ought to know."

"I'm grateful." Raeder didn't waste breath on unnecessary invitations. He fetched the bottle and glasses and poured their customary schnapps.

"*Prosit,*" said Raeder, swallowed the drink in one, licked his lips and grunted. "I had a feeling the Bode director was not too pleased with the little Memling when I first brought it to him."

"They don't think much of it, apparently."

"They shouldn't look a gift horse in the mouth," remarked Raeder angrily. "Hell, it cost them nothing. The artist was supposed to be as famous as that Botticelli man."

"I'm only repeating what I've heard," said Marklin. "I'm trying to help. The minister wanted the Botticelli more. Probably only because there is a similar one in Dahlem. They're like spoiled children, some of these politicians. Nonetheless, you have to face facts. It's a dangerous thing to fail the Party. Look what's happened to Dubcek in Czechoslovakia! Employed as a gardener and thought lucky to have a job at all. From Prime Minister to laborer."

"You mean I'll be back on traffic duty?" Raeder laughed incredulously. He found it hard to believe he was really involved in such an atrocious stroke of bad luck as the Botticelli had brought.

"You could be," said Marklin. "Don't joke about it."

"It was your joke, if you remember. Traffic duty in the Karl Marx Platz."

"Well, it's gone flat, my friend." Marklin fingered his glass reflectively. "You could have one chance left, you know."

"I don't see it."

"Didn't you say the picture's original owners were an Austrian family and you have some letters between them and the Vienna Museum?"

"Yes. They were called Waldhofen. They would be the legal owners; the letters make that clear. But the last Count died in 1964. There are no longer any Waldhofens." Raeder reached for the bottle and poured them both another schnapps.

"In our position," said Marklin, "I should be very tempted to find a Waldhofen. Are you certain there is no longer a lost relative living here in Germany?"

Raeder shook his head. "The old Gestapo files show the Count's only child as having been sent to America in 1938. Presumably she's dead."

"A son would be better."

"He had a younger brother and the brother had a son," said Raeder, still not comprehending the drift of Marklin's thoughts, "which was one reason the Gestapo were interested. The brother was a staff officer in the Bendlerstrasse Headquarters. Whether he was actually involved in the July 20 plot against Hitler is hard to say."

"But they executed him all the same?"

"And the son died in infancy that winter."

Marklin made a rapid calculation. "So he would be thirty-eight or thirty-nine now." He looked at his friend. "What's the problem? There are plenty of reliable Party members around that age."

At last Raeder understood what he meant. A delighted grin spread across his broad face. He snapped his fingers, then reached for his glass. *"Prosit!"* he said happily. "Any chance is better than none. Here's to the last of the Waldhofens!"

Not long after Hanson's return home his annoyance with Webster caused news of the impending sale to leak out before Burnaby's were ready. Up at the University of Massachusetts, a public radio station called WFCR serves various Ivy League colleges. One of its

reporters, an enterprising student majoring in journalism at Westhampton, heard rumors of dissension at the museum and managed to contrive a brief interview with Webster, who, in an ill-judged attempt to save face, stated that the trustees had been divided over the purchase of the Madonna. That was enough. What was a local scoop to the radio station swiftly stirred wider attention and was printed in the New York *Times*. It reported: " 'Letting slip the finest Botticelli to hit the art market in two decades is a setback Westhampton's trustees can scarcely afford if the museum is to continue building a reputation as a New England art center,' says Burnaby president Alexander Tritton. Museums actively interested include Getty at Malibu, Los Angeles County, Kimble at Fort Worth, while both the Norton Simon collection and the European art-buying consortium, Artemis, are likely to be in the bidding."

Not surprisingly when Hanson, now thoroughly enraged, called an emergency meeting of the trustees his first request was that the others should join with him in a visit to Burnaby's to view the Botticelli and his second was for some explanation from Webster.

"The most important things we have to decide," he announced when they had seated themselves in the modern functional committee room at the museum, "will be how high we can afford to go and who is going to bid for us. But before that I would like to know just exactly who gave the information for this most embarrassing broadcast."

There was a moment's silence as Hanson scrutinized their faces, already guessing the answer in Webster's expression.

"Well, sir," said the curator, "I can't say how the radio station obtained their orginal lead. I only knew of it when a reporter asked me to comment on the rumors. Frankly, sir, I believe that to refuse information does no good. He asked me if it was true there were differences of opinion over the desirability of the purchase. I could hardly deny that."

Hanson recognized this ingenuous piece of special pleading for what it was. "You should have damn well refused to be drawn," he snapped. "You're paid to administer this collection, not criticize your employers. In any case, was there any serious disagreement?" Again he looked around the table for replies.

"Frankly, Tom," said Hanson's close friend Jess Tyler, "Webster here was worried about its being a fake, and it would be more true to say we agreed with wanting tests done than that we disagreed on anything. A million and a half dollars is a lot of money. We didn't want to be fooled."

"And did you seriously believe this Botticelli was not genuine after you'd seen the X ray?" demanded Hanson.

"I don't trust Luttrell," replied Webster doggedly.

"Listen, man." Hanson was becoming visibly angry. "Quite apart from the unlikelihood of Luttrell trying to pass off a fake, this game is about trusting pictures, not dealers. You're our eyes, you advise us. Even if you had doubts, it beats me how you could disregard the findings of an institute like the Courtauld. We're trying to build a collection here, not a vendetta with the art trade."

"Since we've all agreed to bid for the Madonna," cut in Tyler, attempting to cool the atmosphere, "maybe we should shift onto fund-raising questions and not detain our curator longer."

Webster flushed and rose to his feet. When Hanson nodded he silently left the room.

"We're going to have to sack that guy," observed one of the other trustees after the door had closed. "He's too wound up in his own ambitions and prejudices."

There was a general murmur of approval.

"Talking of staff," said Hanson, "I haven't found a potential curator, but I have discovered the right man to take over all the conservation work." He told them briefly about old George, finishing with the words "What our curator has only read in books this man

Thompson feels in his fingertips. Should we make him an offer?" Again there was general agreement. "In that case let's get down to questions of cash."

"As I told our last meeting when you were away," said Greenfield, the lawyer, twiddling his heavy framed glasses in his fingers, "my advice is for you to make an immediate donation of the money that will attract considerable tax relief. That way you may not be caught for more than four hundred and fifty thousand on a million-and-a-half-dollar purchase."

"The newspaper story suggests it may fetch two," said Tyler.

"That's why I'm so damn angry," said Hanson. "Webster has no understanding of dealers. I was confident of fighting Charles Luttrell down to one and a half million or maybe lower. He'd never sell me a doubtful painting; he has too much to lose. But the price is always negotiable and the quicker one reacts, the lower he'll come. He's in business like the rest of us. What's more, if his German client was in a hurry for cash, he'd have talked him down."

"You think the client exists?" asked Tyler. "I mean he could be a phony. We had the impression Luttrell owned the picture."

"So what?" Hanson spread his hands. "We're still going to have to bid, and we'll be out in the open against the competition." He sighed. "What I'm saying, I'm afraid, is that one and a half million is around my limit at this time. If we want more we'll have to pass the hat around."

Most European museum committees would have greeted this bald statement with a nervous hush. But American museum trustees are chosen for their ability either to dig into their own purses or—in the case of colleges like Westhampton—to persuade the alumni to do so. Tom Hanson's announcement provoked a buzz of discussion. Within five minutes as many hundred thousand dollars were metaphorically on the table or anticipated.

"We guessed this might be necessary," said Tyler la-

conically. "I and the rest of the boys had a little talk beforehand. Now, can't we hijack Luttrell into withdrawing from the auction? Won't two million persuade him?"

This idea did produce a silence, finally broken by the lawyer.

"They must have some contractual arrangement with Burnaby's."

"But surely auction galleries reserve the right to pull an item out of sale at any time. Isn't it a two-way street?"

"Maybe," conceded Greenfield.

"Well," said Hanson with finality, "after the generosity you've all this minute shown, the least we can do is try. I'll call Charles Luttrell myself. Meanwhile, if we do have to compete for the Madonna, can we agree to choose a dealer to bid for us? A top man, like Clyde Newhouse or Jack Lennox? Don't forget it's a skilled game at the best of times, and on this occasion the strategy for our bidding will need a first-class brain."

A general nodding of heads signified acceptance, and the emergency meeting ended with a date set for further discussion nearer the time of the auction.

In Vienna Karin learned of the forthcoming sale through the *International Herald Tribune*. It is always the Saturday-Sunday paper which carries the art-market pages, and she bought it eagerly this early December weekend, bringing it back to her apartment for Gerhard to read. He had all but recovered from the fight with Raeder, though his ribs were still sore. They spent every weekend together now, and there was an unspoken assumption that they would get married, but Gerhard was holding off making his formal proposal until the gala evening of the Opera Ball in February.

When Karin brought him the paper she spotted the headline at once, with the subtitle characteristically printed above: For Auction February: $2 MILLION BOTTICELLI REDISCOVERED.

"What a nerve!" Karin cried out as she showed him

the story. "Someone—it can only be Luttrell—has re-
vealed that the Madonna was on loan here before the
war, but official East German authorization was given
to the postwar sale to Schneider. It's outright fraud!"

"But it may well be legal," commented Gerhard,
taking the paper and starting to read for himself. "I'm
not surprised they expect it to be the auction event of
the season in New York."

"What can we do, darling?" Karin's exasperation
was bringing her near tears. "If I produce our Beren-
son letter all we'll achieve is raising the price Luttrell
gets." She clenched her fists angrily. "Oh, it makes me
sick! He must have bribed Schneider's nephew some-
how. Can't we tell the papers what we know? Wouldn't
that stop the sale?"

Gerhard gently took her in his arms for a moment.

"No, my love, it wouldn't. I'm sorry, but as it stands
a lawyer would say the Kunsthistorisches claim just
isn't strong enough."

Karin slipped away from him, dabbed for a moment
at her eyes with a tissue, then suddenly threw back her
head defiantly.

"There is still one thing I can do," she said. "And
come what may I'm going to America to do it."

The offer of two million dollars cash from Hanson
caught Charles Luttrell by surprise. Psychologically he
had been conditioned by Webster's prevarications to
feel that the Westhampton Museum trustees would be
reluctant bidders right to the end. He understood
rather better when Hanson hinted at the curator's dis-
missal. Even so he delayed giving an answer for
twenty-four hours. Where the Botticelli was concerned,
he now felt unable to make decisions without consult-
ing Samantha. She seemed to have had an instinct for
handling the deal from the moment she smuggled the
picture out of Germany onward, and his sense of de-
pendence on her had only been increased by the show-
down with Lucy. He immediately canceled a dinner

engagement in order to spend the evening with her at the Mount Street flat.

"Come on, darling, this time we really can do the town," she cried delightedly when she heard the news. "We've won, we've absolutely won! Let's have some champagne."

Infected by her mood, he opened a bottle of Krug.

"To us!" said Samantha and kissed him. "We've seen off the East Germans and the Belgians and the Austrians. Not to mention that odious creep Webster."

"I must say, your auction idea certainly brought Tom Hanson running. The question is, do we accept the two million or not? Burnaby's will be a trifle upset if we withdraw."

"Darling, things sometimes get withdrawn when the sale is actually in progress. This one is still two months off. Anyway, Burnaby's know how to look after themselves. The point is whether we might not make more by going on with it."

"Two million is a very good price," said Charles doubtfully, sitting down in one of the deep armchairs and twiddling the stem of the glass between his fingers. "A damn good price."

"Two and a half would be better. Even after Burnaby's commission we'd have four hundred and seventy-five thousand more." She moved across the room and sat on the arm of his chair. "Darling, what are you risking? If Hanson's willing to go to two million now in December, why should he go to less in February? He might go higher. After all, you can bid him up yourself. Or make that the reserve. So what's at stake? The three percent cut for Burnaby's if it does only reach two." She took his hand. "Incidentally, sweetheart, I don't want to sound mean, but you've allowed those people too much. They ought to be down to one percent on the second million. Think what they're getting out of it! The advertisement value of selling the Madonna will be terrific."

Charles consulted his watch. "It's still only mid-

afternoon in New York. Perhaps I should call Alex Tritton."

"Ask him who else is interested. Tell him about Hanson's offer. That'll wake him up. Then tell him you'll withdraw if he doesn't take less."

Charles looked up at her. There was a calm assurance in her face that stilled his tremblings of unease. "Let's see what he says then," he remarked, picking up the telephone on the sidetable.

Initially the conversation was as euphemistic as their earlier ones, then Tritton became more down to earth. "Yes, I can imagine this offer of Hanson's is a temptation. I'd be seriously wondering if I ought not to take the money and run myself. But listen, Charles. Since the story broke in the New York *Times* we've been inundated with requests to view. Getty, Kimble at Fort Worth, Los Angeles County, the von Thyssen Collection's man in Lugano. Damn it, I've even had a representative of the Power Bequest in Sydney on the line. Have you heard of them?"

"Only vaguely."

"Apparently they have six million Australian dollars in the kitty and feel like blowing a chunk of it on a major purchase."

"You feel you might make over two million?"

"That's become the starting price. Haven't you seen the *International Herald Tribune*? The clipping from the Paris edition just reached me. 'Two million dollar Botticelli rediscovered.' The whole world knows about the auction now."

"Since you mention that," said Charles hesitatingly, "it did occur to us to suggest a lower commission on the second million."

There was an explosion of wrath at the other end.

"We made a deal. Let's stick to it."

"If you insist."

"I certainly do."

After he had put down the receiver again Charles turned to Samantha, who had been leaning close to him in order to hear what the conversation was.

"There has to be some honor among thieves," he remarked jokingly, then became more serious. "You do definitely feel we should turn down Tom Hanson and stick to the auction plan?"

"Yes." There was a trace of harshness in Samantha's voice, as if she was tired of Charles's uncertainty. "In Tritton's words, I certainly do. Nothing can stop us pulling off a tremendous coup. Luttrell's will be saved and"—she tossed her head—"you can tell that wife of yours where she gets off."

"All right. Auctioned the Botticelli will be."

Samantha relaxed and bent down and kissed his forehead.

"You've made the right decision, darling."

ᑤ chapter 10

Jim Gerrard was the only law-enforcement officer in the United States concerned solely with stolen art. Graded as a detective, he ran the Art Antiques Investigation Department of the New York City Police, with an office in the Police Plaza, and maintained friendly relations with Scotland Yard's Serious Crimes Squad in London, plus a running link with other police forces in the world through Interpol. His other distinction was, if anything, rarer: He had started life as an art student, founded a small contemporary gallery in the SoHo district of New York and been enticed into the police after assisting in uncovering a major fraud.

Now, in his early thirties, Gerrard had the friendly, casual expression of a mature student. Put him in a business suit, trim his untidy hair and there stood before you a personable business executive. Add a mustache, rumple his hair, change the garb to jeans and a T-shirt and you had any one of ten thousand young Americans tramping round Europe, helping run a summer camp or arguing philosophy in Greenwich Village. He was the sort of pleasant guy you would

happily give a lift to and whose face had no single ob-
trusive feature you would remember afterward. This,
and a sharp mind, were his two great advantages. He
could slip into almost any role and had recovered many
hundreds of thousands of dollars' worth of artifacts by
posing as a collector, a dealer or in some other guise
connected with the trade. Whenever possible he kept
out of police blue. This was why when he agreed to
meet Raeder on the day before the Burnaby auction he
chose a bar in the mid-70s as a rendezvous and waited
there looking more like a hippie than a cop. He wanted
to keep this initial contact as informal as he could. De-
tective Superintendent Wates in London had filled him
in on Raeder's visit there. From the sound of it the
German's case was thin, though his mention on the
telephone of a Waldhofen claimant added a new di-
mension to the business.

When Raeder entered the bar, a younger, close-
cropped man at his heels, he was taken aback. There
was no one remotely like a policeman in there. He
stood just inside the door for a half a minute, surveying
the few people at the bar. As he watched, a man in
blue jeans and an old military jacket slid off a stool
and came toward him.

"Mr. Raeder?" said the man. "My name's Gerrard.
Glad to know you."

Raeder stared in amazement at the detective's coat.
It was of loose-fitting khaki. Over one breast pocket
were embroidered the words "U.S. Army" and a row
of imitation medal ribbons. A pack of cigarettes was
visible in the other.

"You are Gerrard?" he asked in disbelief.

"Right. I don't like to look like a policeman. Let's
grab a table." He led the way to one. "I take it this
gentleman is Herr Waldhofen?"

"Correct." Raeder was recovering his self-assurance.
"In the West he would be Count von Waldhofen. Of
course in the Democratic Republic we do not recognize
such trappings of the imperialist past."

"Sure." Gerrard dismissed this piece of tomfool di-

alectic, ordered three beers from a passing waiter and got straight down to business. "So you reckon you're the rightful owners of the Botticelli being auctioned at Burnaby's tomorrow."

"I am the nephew of the late Count and the only survivor of his family," said the younger man calmly. "My father, the Count's brother, was shot in 1944 for his part in a plot against Hitler. My mother died that winter, leaving me an orphan. I was brought up by my friend in what became East Berlin. You would like to see my identity papers?" He unstrapped a heavy leather briefcase. "Here. My own birth certificate. Documents on my father's execution. His photograph."

Gerrard examined them, his eyes switching briefly from the faded photograph of the officer to the claimant sitting before him. There did seem to be a resemblance. "You are Claus von Waldhofen?" he asked with momentary formality.

"I am."

"You speak pretty good English."

"I need to. I am in the import-export business."

"Tell me"—Gerrard dropped back into a casual, conversational tone—"what are you going to do with this Botticelli if you do prove it's yours? Take it back to East Germany?"

"Our intention is to loan it to the Staatliche Museum," put in Raeder.

Gerrard smiled. There was no disguising which of these two was the heavy. Presumably Waldhofen would never have been let out of the country without an escort, at least not to make this valuable snatch. But then why the hell had Raeder been after it himself before?

"I thought you had a claim on it once, Colonel," he said.

Raeder glanced at his companion, who translated quickly.

"That's true. In the course of investigating the background of the friend who bequeathed it to me, we found documents which led us to Herr Waldhofen here," explained Raeder.

Between them they launched into a history of the picture's movements during and after the war.

"These are the letters exchanged between my uncle and the Kunsthistorisches Museum in Vienna in 1939," said Waldhofen finally, handing over another thin folder. "They show the picture was on loan and could be returned to the owner at any time, provided six months' notice was given."

Gerrard stiffened as he read them. Although he knew only a smattering of German it was perfectly clear that the papers were what they purported to be. Nonetheless, Wates at Scotland Yard had heard something about the Count having a daughter.

"What about the old Count's own children?" he asked disingenuously. "Where are they?"

"His only child was sent away from Austria in 1938," replied Raeder, confident in the accuracy of the Gestapo files, though the collorary was guesswork. "She has not been seen since and is presumed dead. Under German law," he added, "we assume death after forty years."

"I guess we'll have to go back to the Police Plaza and start in on the formalities." Gerrard handed back the folder. The claim looked solid enough. "Now let me just enlighten you gentlemen on what I can and cannot do. First, under New York City law I have a right to put a stop on the sale or transfer of stolen property, whether it was taken physically or not and whether or not the possessor holds it innocently or knowingly." He paused while Waldhofen translated this to Raeder. "It's called putting the property 'in escrow,' and the police have power to keep it that way for up to ten years. Doesn't matter whether the thing was stolen in the States or not. We had a street scene by the French painter Utrillo back in 1974 which had been taken in France. Bought in good faith over here. There was quite a party when it was handed over to the French consulate here. But . . ." Gerrard looked intently at the pair facing him. "That was because the dealer involved agreed to return it. Now if this guy Die-

trich, who's put the Botticelli into Burnaby's sale, re-
fuses to do that voluntarily, I can't force him. You
have to take a civil action against him. You under-
stand? If Burnaby's part with it after I've told them
'You are not to dispose of this work,' then, sure, they're
committing a crime. The picture's frozen. The law-en-
forcement procedures protect it. But establishing that it
belongs to you is a separate civil process."

After some consultation between the two Germans,
Raeder nodded. "We understand," he said.

"So you want me to step in just as soon as I'm satis-
fied you have a claim?"

"I think not," said Waldhofen. "There is one detail
we are waiting for. It is being said the sale of the pic-
ture to Schneider in 1948 was authorized officially. We
only succeeded in seeing the document yesterday. Now
in Berlin they are checking. We do not want to act un-
til we have notification that the official stamp is the for-
gery we think it must be. It is the last link in the chain
of proof."

"I guess if that's how you feel, I have to agree." Jim
Gerrard sighed, visualizing a last-minute drama of the
sort he had so often encountered before, such as on oc-
casions when he had played the part of a collector buy-
ing from a fence and had to carry on negotiating right
to the moment when FBI agents closed in as he was
handing over the money for a stolen painting. In one
way he enjoyed the tension because there was a bit of
the actor in him; in another he liked to settle things
cleanly if he could. "O.K.," he said reluctantly. "Come
and see me at headquarters tomorrow morning. I
should have checked out your credentials by then and
we can decide what to do next." He fished into the
pocket beneath the embroidered medal ribbons, pro-
duced a visiting card and rose to his feet. "Thanks for
the beer," he said and left them. If they were homing
in on two million dollars he had no doubt the East
German government would settle the check.

Raeder remained seated, eyeing the gold-and-blue
shield of the New York City Police in one corner of

the card. "Odd people, Americans," he remarked in German. "Difficult to understand." He wished Marklin was here with him, not this humorless university-trained Stasi major. "Don't you find that, Claus?"

"What matters is that they do what we want, Comrade Colonel." There was no hesitation in the fake Waldhofen's response to his assumed name, any more than there had been earlier. He had spent day after day immersing himself in the background of the Waldhofen family and of his supposed upbringing until he was word perfect. Finally he had been closely briefed on how the Culture Ministry wished the claim to be handled, which was the exact opposite of Raeder's earlier attempts. "We are instructed to intervene during the auction itself and obtain the maximum publicity for our country's wartime losses. I agree this detective appears unorthodox. That is irrelevant if he is the correct official to act on our behalf. All we have to do is maneuver him into stopping the auction as this Botticelli is being sold."

"We shall do our best," said Raeder noncommittally. He suspected there was considerable strength of character behind Gerrard's casual façade and that the detective was the kind of man who forced others to play the game his way.

"Our government's denunciation of the 1948 transaction is ready to become available at the crucial moment. I see no problem," remarked Waldhofen coldly.

Raeder shrugged his shoulders. The major was one of those intellectually invincible men who believed that if you thought a plan out closely enough it could not go wrong. Presumably this quality had made the Stasi choose him. The two of them were opposites, as much engaged in watching each other as in planning the recovery of the picture. He had to make certain Claus did not defect with it, while he in turn knew Claus had been instructed to force his hand if the government statement about the 1948 receipt was challenged. That eventuality was the real bastard. Marklin had warned

him about it. If Luttrell challenged their prepared statement that the official authorization on Schneider's receipt was a forgery, arguing that the document must have been accepted by the border guards as genuine when the picture was taken out of East Germany in 1952, then he, Raeder, was going to have to stand up and explain precisely why the Botticelli had been allowed through.

"That letter Schneider wrote you has come to the minister's attention, I'm sorry to say," Marklin had said sympathetically. "Your clerk informed on you. If you bring the Botticelli back, the incident will be forgotten. If not . . ."

Raeder sat drinking his beer in silence, recalling the conversation with Marklin three days ago. What had the letter said? "As a blood brother you helped me in spite of the danger." Why the hell had Horst dramatized it? That mention was bad enough. But if he had to reveal the incriminating details, would the incident truly be forgotten by the Party? He doubted it. Marklin must have pulled a lot of strings for the situation to be left as it was and the Waldhofen plan accepted. If it failed, Raeder now knew he would be lucky to be given traffic duty; total disgrace and dismissal were more probable, possible even a jail sentence. If he did not return with the Botticelli this time he would rather not go back at all. There were many former SS men down in Brazil. It might be better to join them if he could give the man sitting opposite him the slip. He dwelled on this possibility for a moment, then decided his long silence might seem suspicious.

"Come on, Claus," he said abruptly. "Let's go back to the consulate. Our arrangements for tomorrow must be perfect, mustn't they? Our reputations are at stake."

He made the remark as a half-sour jest, but the reply was uncompromising.

"I agree that yours is, Colonel. However, as the documentation is perfect, I have no doubt we shall succeed."

Samantha could sense the excitement the moment she stepped out of the elevator into the lobby at Burnaby's. The lots in tomorrow's "spectacular" had been on public view a full week, and the Botticelli had attracted throngs of sightseers. Now, on the eve of the sale, with publicity reaching its peak, the gallery's normal routines were being completely eclipsed. Every seat had already been allocated, and a note pinned up near the reception desk stated that no more admission tickets were available. Although the delivery counter adjacent to the lobby had a trickle of potential sellers bringing objects for appraisal, hopeful as always that they possessed an unrecognized treasure, the talk was all of tomorrow. Already the press office was besieged with reporters writing their preview of anticipated prices, while upstairs in the principal salesroom arc lights and stands were being erected for the television cameras. As well as the nationwide coverage the event would receive, Burnaby's themselves had cameramen operating a closed-circuit system to two other rooms which would hold the overflow of guests and from which bids could be relayed to Alexander Tritton as he conducted the sale in the main gallery. He was not only in executive control of Burnaby New York; he was their star auctioneer, a transatlantic rival to the urbane Peter Wilson at Sotheby's in London.

As soon as Charles Luttrell arrived, he and Samantha were due to see Tritton. They had flown across separately, as part of a subterfuge that annoyed her. In deference to Lucy's sensibilities, Charles was maintaining the pretense that Samantha was here as escort to Dietrich, who, in fact, was safely at home in Hamburg. Samantha doubted that Lucy was deceived and in any case didn't care a damn whether she was or not. Once this was over, and Luttrell's had the money, Samantha intended to force Charles to choose between her and his wife. Meanwhile, she waited impatiently, killing time by observing the people and things around her.

The lobby was furnished with as much elegance as

the constant passage of would-be buyers and sellers permitted. Framed color photographs of both paintings and porcelain reminded clients of previous auction records. A notice announced "This business is licensed by the Department of Consumer Affairs." Another set out the standard conditions of sale. Samantha perused them. The gallery guaranteed "The Definition of Authorship," which it described as covering the identity of the creator, the period, culture, source of origin of the property, as the case may be, as set out in the bold-type heading of each catalogue entry. If this should subsequently be challenged, the "sole remedy" was the rescission of the sale and the refund of the purchase price paid. For the umpteenth time she flipped through the handsome, glossy-paged catalogue of *Important Old Master Paintings,* which had a full-color reproduction of the Madonna on its cover as well as a black-and-white one inside. The picture's entry was much briefer than the full provenance she had prepared in London, and it omitted the dubious 1923 Munich transaction.

*SANDRO BOTTICELLI
• 85 MADONNA AND CHILD WITH EIGHT ANGELS
The Virgin enthroned holding the infant Christ, surrounded by seven angels holding white lilies, one with a Bible.

On panel 56.4 inches diameter
 143 cm diameter

Provenance:

Count Waldhofen (on loan Kunsthistorisches Museum, Vienna 1939. Sold 1948)
Herr H. Schneider, Frankfurt

* AUTHORSHIP: Attributed to the named artist, subject to the qualifications set forth in the CONDITIONS OF SALE, front of this Catalogue.

Literature:

Vasari's *Lives of the Painters*

Catalogue of the Waldhofen Collection 1898, no. 54

Catalogue of the Kunsthistorisches Museum, 1939, no. 192

(See Illustration and Cover)

They had certainly done their best, she reflected. As number 85 it would come up about a third of the way through. The plums were apparently casually placed in the list, but in fact were arranged with care to generate moments of drama which would carry through the momentum of the auction and build both tension and, with luck, an irrational willingness among the bidders to pay high prices. She noticed there was a Van Dyck portrait earlier on and also a small landscape by David Teniers the younger. Those would help work up the atmosphere for the Botticelli.

A familiar voice interrupted her thoughts. Charles was standing beside her.

"We can hardly accuse them of underselling it, can we?" he said. "Let's go up and see Tritton."

Samantha swung around to face him. "Why are you so late? I've been here ages. Don't you ever think of other people?" She felt entitled to a show of petulance, having rushed to be on time herself.

"I'm sorry, darling." He kissed her cheek. "I was delayed and then I couldn't catch a taxi."

"Has something happened?"

"Nothing important." A shadow of worry crossed his face. "No, just something rather perplexing." He took her arm. "I'll tell you about it later. At this moment Burnaby's latest news is more important." He guided her to the elevator.

Apart from its air conditioning, large modern windows and a Civil War flag hanging limply from an eagle-topped pole in one corner, Alexander Tritton's office was a blood relation of Charles's own in Bond

Street. The walls sported Spanish walnut paneling, a portrait of the founder gazed down from above a marble mantelpiece, though the fireplace below was purely for show, and Tritton himself was seated behind a huge mahogany desk. He rose as they entered, a tall man of fifty-two who carried both his years and his weight well and possessed what reporters called a "commanding presence" in the salesroom. Samantha's first thought was that he ought to be a Senator. The thick gray hair, the cultivated New England accent and the ready smile all belied a mind as sharp and unorthodox as broken glass.

"Good to see you, Charles." His welcome sounded unaffected. "So this is the Miss Walker who researched the Botticelli. Delighted to meet you." He moved around the desk and shook hands warmly, his blue eyes taking in Samantha's expensive clothes and well-groomed hair. "Well, Miss Walker, this may not be the Geraldine Rockefeller Dodge sale all over again, or Mentmore, but you've certainly found us a masterpiece to remember. Do sit down. I guess five o'clock's none too early for a drink if you'd like one."

Flattered, Samantha asked for a vodka martini on the rocks and politely inquired how Tritton visualized the auction going. She quickly realized that a pretty woman provided all the prompting he needed to expound his philosophy.

"There is a continuity of objects passed along through these great sales, at least on this side of the water there is. One generation builds a collection, the next sells it. That's the way it should be. Without selling there are no yardsticks in art. Auction houses like ours are constantly reconsidering the canons of taste, rediscovering forgotten painters, awakening the public to what is significant from the past. Where would 'art nouveau' be but for us? A series of lost treasures gathering dust in attics!"

Samantha listened, fascinated, not so much by the credo of Tritton's existence, which given half a chance would transform simple selling into an art on which the

whole of civilization depended, but by the dynamism of the man himself. She also noticed Charles's restlessness at having to listen and was sufficiently irritated by it to encourage Tritton.

"So you really feel you create the market?" she asked innocently.

"Miss Walker, one or two minutes of bidding in the great gallery downstairs tomorrow evening will put a whole new gloss on the contemporary assessment of Botticelli's works." He smiled graciously. "Your respected employer may not like to admit this, but museums the world over will be surveying their Florentine paintings with fresh eyes as of Friday morning. And they will be coming to us for new valuations, because we will have made the record price for the artist."

"The only snag," observed Charles, his voice tinged with cynicism, "is that museums only buy, they never sell in the way private collectors do, and we all of us need collectors if there is to be a market at all."

"Which reminds me," said Tritton blandly, as if the idea had only this second struck him. "What kind of a guy was this Schneider? How did you find him?"

"His nephew came to me." It was Charles's turn to smile. "People do, you know. As to the man himself, as he was dead . . ." He spread his hands out expressively.

"Our lawyers weren't too happy with that 1948 transaction of his."

"Surely the Stroganoff-Scherbatoff lawsuit in 1976 set a precedent." Charles glanced inquiringly at Tritton. With his own attorney's aid he had long prepared for this query. "I'm no legal expert, but as I understand things the former Count Stroganoff's works of art were expropriated by the Russian government before they were sold, and the Judge in the U.S. District Court here turned down the claim because your Act of State Doctrine required him to refrain from querying the validity of the Russian government's action. So the Count didn't get the Van Dyck and the Houdon bust back from their American purchasers."

"Agreed. Nonetheless, we could be close to the wind with this Botticelli," said Tritton. "That judge's decision rested on the Soviet state being recognized by the U.S. at the time of the lawsuit. It's damn lucky we decided to recognize East Germany in 1974. Otherwise someone could question their authority."

"A miss is as good as a mile." Charles shrugged his shoulders. "Now, how do you see the bidding going? Does my client need to specify a reserve?"

"Depends how greedy he is. As you see from the catalogue, we've marked it as having one. The little black circle is printed there right in front of the lot number. And you've seen the catalogue estimate of one point five million to two million dollars."

"Did you know that the Botticelli portrait of Giovanni de'Medici which was on loan to our National Gallery is having to be sold by its owner's executors and they're offering it at around one million pounds? One million pounds. Over one million nine hundred thousand dollars. And it's not a patch on this tondo in importance."

"Is that so?" For once Tritton was caught unawares, but he rapidly appreciated the uses of this information. "Maybe I might mention that fact to warm things up. No. We want it in tomorrow morning's *Times*. Mentioning it at the sale is leaving it too late. All those museum trustees will have decided their limits by then and briefed their representatives. Is it public knowledge in Britain yet?"

"We heard it on the grapevine, so if it isn't now, it soon will be."

"Fine." Tritton leaned across his desk and pressed a switch on the small loudspeaker console of his telephone. "Is Mr. Spencer there? Well fetch him. Good. Now listen, Herb, the British National Gallery is about to lose a Botticelli. One million pounds' worth. The story could help us a lot. Get on to London, have them research the facts as fast as they damn well can, then give it to the press. We want it in tomorrow's editions. Right. Backing up the sale previews. O.K." He flipped

off the speaker. "There's one sure way to fix an art story and that's to give it complete to a reporter, written, documented and nicely double-spaced so he can make a few corrections. Same principle as cake mixes needing an egg—makes the housewife feel she's into creative cooking. Herb does that for journalists. He's the best press officer in the business. Now, about this reserve."

"One and a half million would suit Dietrich, I suppose." Charles deliberately sounded tentative.

"You don't have to put eggs in the cake mix for me," said Tritton brutally. "I know damn well you're going to bid it up yourself."

"The situation remains more convincing if the auctioneer is seen to be maintaining the reserve, don't you think?" Charles remained urbane, though only with an effort of will, and there was a cutting edge to his reply. The way an auctioneer brought a price up to the reserve was by inserting bids himself, which he pretended to have accepted from the floor. This was invariably done with such aplomb and speed that an unenlightened spectator would never spot the fiction, though professionals were seldom deceived. Hence Charles's insistence on Tritton's being seen to be supporting the reserve. "In your own words," he concluded, "this is to be a 'spectacular.' As I shall not be bidding for anyone else, I have no desire to make the running for my client publicly." He paused, still wondering why Tritton seemed so determined to strip away the façade of their arrangement.

"All right. I accept that," said Tritton. "What reserve does the celebrated Herr Dietrich really want?"

All pretense was gone. It was obvious that Tritton regarded Dietrich as a man of straw and Luttrell's as the principal. Samantha watched the two men, aware that in simple alley-fighting terms, Charles was outclassed. She ought to be leaping to his defense, yet somehow she found herself passionately wondering whether, at the crunch, the prospect of commercial

gain would unite them and, if not, what it was that Tritton wanted.

"I've turned down a two-million offer from Hanson," replied Charles coldly. "The minimum reserve is one million four hundred thousand." It would always be the bid just below a round figure which edged the price up because both institutions and individuals instinctively set themselves round-figure limits.

"Agreed, then," said Tritton calmly. "Let's drink to it." He got up, shook up another martini and refilled their glasses. "You know something?" he continued, noticeably more relaxed. "I had a slight fear of this spectacular turning into a charade. There are one or two people around questioning the existence of Herr Dietrich, and just as it only needs two bidders to make an auction, it also only needs two gossips to make a scandal. To be frank, I'm relieved you won't be taking part."

"If you want to see Dietrich, we'll fly him in for you."

"I promise you, he is a real person," put in Samantha, feeling uncomfortable at not having given Charles moral support earlier. "I've been to his apartment and met his wife. He genuinely did inherit the Botticelli." She gave the affirmation of faith as much emphasis as she could. Why should Tritton care what Dietrich had actually done with his inheritance? Nonetheless, it crossed her mind that, when the auction was over and the money paid, it might be amusing to spend an evening with him revealing the truth.

"Naturally," said Tritton, looking very directly at her and smiling. "I accept your word, Miss Walker. In point of fact, with the degree of interest there is I am sure Herr Dietrich's reserve will prove a purely academic figure. We might easily do a million better. I hope you'll be joining us at a little celebration afterwards. I took the precaution of reserving a table at Regine's."

"I'd adore to." She smiled back.

Charles's acceptance was a shade less enthusiastic,

and in the taxi on the way back to their hotel he attacked Samantha directly.

"I think you could have devoted rather more effort to backing me up and rather less to making eyes at Alex."

"Darling, you're being grossly unfair. We're going to clean up a fortune and live happily ever afterwards and he's making it possible. It was a business necessity to be nice to him. How often have you said yourself that the mere fact of Burnaby's handling it adds authority to the provenance?"

"So does the name of Luttrell's."

"There's no point in being bitter, darling. We needed Burnaby's."

"We could have accepted Hanson's offer."

"Well, we didn't and we're going to make much more as a result." Now Samantha was becoming annoyed. "Are you losing your nerve or something? What's come over you?"

Charles hesitated, then felt for her hand and held it despite her lack of response. "My love, I told you something odd had happened." Her fingers stiffened as if resisting him. "No. It's nothing to do with Lucy. It's the Memling. The East German embassy in London sent it back by messenger yesterday without a word of explanation. No letter, no phone call. Just a request to sign a receipt for its return. I don't understand what they're playing at."

On the morning of the auction a quorum of Westhampton Museum trustees met to finalize their bidding strategy with the New York dealer they had chosen to act for them, Jack Lennox, a short, balding man whose well-cut suit failed to disguise the pudginess of his figure. But, as Hanson had remarked, they were paying for his expertise, not his appearance. He occupied the chair that was normally Webster's, the curator having been told brusquely by Tom Hanson that his assistance was not required. The others present were Greenfield, the lawyer, and Jess Tyler.

"A few weeks back," Hanson recapitulated, "you told us there were two things we needed to know for tonight: how much the Botticelli is going to fetch and who the underbidder will be if we're making the running."

"Sounds pretty much like asking for the date and location of the Second Coming of Christ," commented Tyler. "How can we possibly tell?"

Lennox chuckled softly. "If you hire a cat to catch mice you don't query how it acquired its sense of smell, do you, gentlemen? For the past two weeks I've been mousing around a little, picking up a scent here and there. For instance, why should the man from Getty at Malibu have held a discussion with his colleagues about the picture within earshot of Burnaby's receptionist?"

The dealer raised a well-manicured hand. "Don't waste time guessing. He wanted the world to know that he thought the Botticelli was by no means of the quality it's cracked up to be."

"Hell," interjected Tyler. "Do you think we're making a mistake, then?"

"On the contrary. I think Getty will be in there bidding hot and strong."

"Come on, man," argued Hanson, unconvinced. "Aren't you jumping to conclusions?"

Lennox sighed audibly. "If you don't believe me, ask the Met what happened over the Velasquez portrait of Juan de Pareja, the one they paid five point four million for at Christie's in London. The Washington National Gallery ended up as underbidder on that occasion. Well, two of the Met's men had openly denigrated the picture after viewing it in order to put the National Gallery off the scent and maybe fool them into allocating less money than they had available. Sure enough the Met won out."

A crackle of nervous laughter ran around the table. Then Greenfield spoke. "We can afford to raise our sights a certain amount," he said firmly. "But there is

no way we can outbid Getty. It looks to me as though the underbidder is going to be us."

"Not necessarily." Lennox glanced around the room, mentally taking the temperature of the meeting. "I happen to know there is an exceptionally fine collection of early Columbian artifacts on offer. The Getty trustees want it entire, but the asking price is exceptionally fine, too. As I understand it, they are most unlikely to commit more than two and a quarter million to anything else until they know for sure how much the Columbian collection is going to cost them." Lennox leaned back in his chair, a flicker of self-satisfaction on his face at having yet again served up the crucial inside knowledge that justified his own considerable fee. "The quarter million over the upper Burnaby estimate will be their allowance for demolishing other contenders. But of course there is unlikely to be a mere fifty-thousand raise at the climax. Tritton will be keeping the bids going in hundred-thousand stages if he possibly can. So his hammer will go down at either the two or the three."

"I could strangle that idiot Webster," snapped Tyler angrily. "Now we're talking nearly a million up on the figure we could have had the picture for from Luttrell three months ago."

"Take it easy, Jess," said Hanson. "We've sacked him. That's enough. The point is, just how high will this Botticelli go. Isn't there any limit?"

"In my opinion two million four hundred thousand will fix the opposition." Lennox touched the tips of his fingers together as though praying. "Yeah, I think that will be the final bid. Several others will still be there at two million one, but they'll drop out pretty fast."

"Before we decide," insisted Tyler, "I would just appreciate your explaining what has catapulted the value of this painting up so high."

"So would I," added Greenfield. "I don't doubt we can rustle up the cash, but I'm still mystified."

"It's the quality of the painting and the fine state it's in," explained Lennox patiently. "Once it was on view

the word got around about its superb condition. Those thin translucent layers of paint the Florentines used are easily damaged by cleaning. This picture hasn't been. You know, if you'll forgive a vulgar expression, there's a lot of crap talked among critics about Botticelli being out of fashion, the heyday of his revival dying with Berenson, all the rest of it. The fact is damn few autograph Botticellis are ever going to come on the market again. Sure, a Berenson authentication would be nice. But once the condition of this one was appreciated, the price was bound to rocket. Especially now that pension funds are investing in art."

"There we have it, then," summarized Hanson, glancing at his colleagues in turn. "Are we going ahead or not?" Two quick nods confirmed that Greenfield and Tyler were. "In that case, I guess I'll attend the auction myself along with Jack." He grinned. "Don't worry. I swear I won't interfere." He gave the dealer a searching look. "You are as certain as a man can be that two million four will be enough?"

"Given the museums known to be interested, yes." Lennox raised a cautionary finger. "However, there are rumors about the West German government repeating their effort at the von Hirsch sale. You remember they backed several German museums financially and the prices went very high indeed. If so, it will be a tacit admission on their part that the similar tondo in the Berlin Museum is indeed the copy Berenson thought it was and not the original. Theoretically, this should make no difference. The money we've been discussing is based on precisely that assumption. Nonetheless . . ." He waved his finger again as if admonishing a pupil. "The fact of the Germans' bidding could affect the valuation."

"How will we know?" asked Hanson.

"Easy enough. Klein will be representing them. He'd probably be there anyway, of course, in pursuit of other lots. But if he makes a pass at Lot Eight-five, then we can expect fireworks. He'll enter the bidding late and he'll go up fast." He emitted another of those

sighs which were so well known in the trade. "We shall have to wait and see."

"Will it affect our own tactics?" asked Tyler.

"Not much. I'm quicker on the draw than he is." Lennox's confidence was reassuring. "Our aim is to make the two-million-four bid, which I believe will be conclusive. To do that we have to make the two-million bid. We have to establish our hold on the even figures because I'm convinced Getty's man will be aiming for victory on the three. Now if we bid the three, he might go to three-fifty or four, but if we can catch the four he won't be able to go to five."

Hanson nodded. "I take the point absolutely. What I don't quite see is how you make your entry at the right moment to pre-empt the two-million bid for us."

"Naturally I plan for various eventualities. I'm pretty sure the reserve is either one million four or one million five. Now Tritton may reach it in two bids which jump from one million to one million five. Or he may go up from one million in two hundred thousand stages. Or one hundred. As soon as I sense the progression I will enter. There are some tunes one can only play by ear."

"How long will it take?" asked Tyler, whose experience of auctions was confined to visiting occasional furniture sales.

"One and a half minutes. Two minutes at the outside."

"More than a million dollars a minute!"

"Approximately." The dealer's eyes glistened in happy anticipation. "That's what I like about it. And I can promise you one thing, gentlemen. Once I am in there I will make the running, Klein or no Klein, Getty or no Getty."

"Darling, do I look all right?" Samantha swiveled before the mirror in her hotel room, her long dress swirling, her breasts provocatively firm under the pale-blue silk, her hair loose on her shoulders.

"Like a million dollars." Charles watched her appreciatively.

"No, darling." She kissed him lightly on the cheek. "Two million, remember? Perhaps even three." She concentrated a moment's attention on his dinner jacket, touched at his bow tie more from instinct than necessity, then reverted to the more important question of her own appearance. There were going to be sensational events at Burnaby's this evening, and she was determined that the first would be her own arrival. If this dress didn't excite the photographers, they must be men of stone. It ought to do something for her standing with Alexander Tritton at Regine's later on, too. She intended having a night out to remember. Auctioning the Botticelli had been her idea, and this would be her evening.

"You don't think I should wear my hair up?"

"You're magnificent as you are," Charles reassured her. He didn't want to be delayed. Burnaby's tonight would be a Who's Who of the international art world, and he relished the chance to greet old friends, knowing that they knew he had discovered the Botticelli, though the likelihood of Lucy seeing photographs of him and Samantha excited him rather less.

When they reached the auction galleries Burnaby's uniformed doormen were keeping open a path through a crowd of spectators on the sidewalk. Even so they were jostled by cameramen, whose photo flashes exploded like star shells in their faces. Several men whistled appreciatively at Samantha. Then they were safely through into the lobby, and the waving to acquaintances and the cries of "Hi, good to see you" began, as if this were all a gigantic private party.

On the second floor the main auction room was filling up. The square room was dominated by a platform bearing the polished wood rostrum from which Alexander Tritton would conduct the sale. There were drawn curtains behind the rostrum. On each side a computerized digital display showed the amount of bids. Salesroom staff hovered around, distinctive in their

dark-blue uniforms with a gold "B" emblazoned on their breast pockets, ushering guests to their places in the long rows of chairs facing the platform.

"By God," muttered Charles as they entered, "Tritton certainly has packed them in." He recognized dealers from Italy and France. There was the spare, elegant figure of Sir Geoffrey Agnew just sitting down; Tom Hanson and Jack Lennox together; Clyde Newhouse talking to Jack Tanzer of Knoedler's; the famous Eugene Thaw; Klein; a trio of Japanese. "You see," he observed. "The Japanese are back in the market now."

Slowly they made their way to the third-row seats reserved for them, Samantha happily aware of the many glances she was attracting.

"Do you think they'll start on time?" she asked.

The clock showed 7:50 P.M. He looked around. People were lining the walls now. "If the closed-circuit TV to the other rooms is operating all right, Tritton will be appearing any minute."

One of those standing was Jim Gerrard, who wanted a view both of the auctioneer and the audience.

"You're dressed pretty smart this evening, sir," the senior attendant had commented with a polite smile as he came in.

"I guess it's justifiable." The detective smoothed down his tuxedo. He'd had his hair trimmed, was freshly shaved, had chosen a pair of slim, soft Italian shoes, and reckoned his appearance fitted the scene. A few here knew him. But when he made the move he expected to make he wanted the rest to imagine he was just another dealer with a query. He received a lot of cooperation from Burnaby's and had no intention of allowing a public drama to disturb their big night.

"Listen," he told the attendant. "I may want to slip in and out during the action. A person may call me. Could you make sure someone finds me?"

"Sure thing, Mr. Gerrard. You just come over here and I'll unlock this little side door we don't normally use."

So he was established by a secondary entrance, which was ostensibly closed and from which he could watch both the main door and the audience. He saw Raeder arrive, sweating and uncomfortable in a rented tuxedo, noticed that he was alone and that he had a seat at the very back. Raeder's eyes slowly swept the room until he saw Gerrard. He raised his hand in a confirmatory gesture, and the detective gave the shadow of a nod in return.

Suddenly the murmur of conversation was quieted as Alexander Tritton strode up to the rostrum. He looked about him, checking that all his minions were in position: the attendants, the sales clerk who noted down prices, two assistants manning the telephones to the other rooms. As he paused an excited buzz swept through the room. The tension was rising before he had spoken a word. He picked up the little wooden gavel, so small that it was barely visible when enclosed in his fist, and tapped two staccato beats on the rostrum top. Conversation died. He faced his audience, imposing, dignified, waiting for complete silence, as much a maestro as the conductor of an orchestra.

"Your Excellencies." A fractional hesitation to underline that foreign ambassadors were present, presumably giving moral support to their home museums' representatives. "Ladies and gentlemen. We have here tonight one of the most distinguished gatherings ever assembled in an auction house in this city. We are honored. We believe we have some equally remarkable paintings to offer. As is usual, I must call your attention to the Conditions of Sale displayed in the lobby and printed in the catalogue." He paused again, raising one hand slightly in a signal. "So now, let's not waste any more time. Lot One."

As he spoke, the curtains swept silently aside to reveal the stage behind him, where two attendants were placing a large gilt-framed landscape onto a mahogany easel.

"Dutch School. Attributed to Adam Willaerts. A very fine picture, this. I have a bid of ten thousand dol-

lars to start here." He glanced around at the faces before him. "Do I hear eleven? Thank you, sir. Twelve. Thirteen. Fourteen. Fifteen thousand." His eyes were darting around now, picking up the raised fingers and the nods of bidders in different parts of the room. One of the attendants, evidently retained by a client, shook his head, indicating that he was dropping out. Tritton frowned. "Well, I guess an auction has to start somehow, but this is a giveaway. Ah. Sixteen. Thank you again, sir. Seventeen, eighteen." A spurt of activity followed, though only an expert could have told which dealer was making the running, and Tritton was repeating figures like a machine gun, while the illuminated displays were clicking over, translating the dollar price into sterling, Swiss francs, yen, Deutschmarks, French francs and guilders. At $32,000 there was a momentary break, which Tritton swiftly filled.

"It's against you there in the front row. At thirty-two thousand now. Against the floor." He glanced at the telephone assistant, who was evidently transmitting this bid from one of the other rooms. "At thirty-two thousand. Fair warning. Down it goes." The gavel cracked on the wood once. The attendants removed the landscape, and a third brought a smaller picture. "Lot Two." There was a general shuffling and scraping as people settled in their chairs. The evening had begun well.

Half an hour later the David Teniers fetched $230,-000, a record price for the artist. Charles felt the adrenaline running in his stomach, as it always did when high prices were being achieved and he was about to bid. He squeezed Samantha's hand briefly.

"Things are warming up, my love. Alex is getting it moving."

She returned the pressure of his hand, then slipped her fingers away. She was enthralled by Tritton's style. He kept the bidding going with astonishing rapidity and countered any hesitancy with immediate *sotto voce* reprimands, as though he were admonishing old friends for reluctance to give to charity. "Come on, gentlemen,

what kind of a price is this? We can do better than that, I'm sure." Sometimes he demanded, sometimes he coaxed, but he always seemed to succeed.

At the back Raeder listened, only half understanding, aware both of the growing tension and that within another half to three quarters of an hour the Botticelli would be under the hammer. Yet his Waldhofen claim had still not been registered. Out of the corner of his eye he saw the door behind Gerrard open and the detective swing around to speak with an attendant.

"Call for you, sir," whispered the attendant in Gerrard's ear. "Sounds like a foreigner to me."

Gerrard slipped out of the room and was guided to an empty office. He picked up the phone, identified himself and then listened attentively, punctuating the monologue from the other end with only brief acknowledgments. "Yeah, yeah. I've got it," he said at last. "No sweat. Make it here as soon as you can, but don't let the taxi driver kill you. Tell him fast but careful. I can as easily put the picture in escrow after it's been sold as before. Makes no damn difference at all."

By the time Gerrard got back to the auction, Tritton had reached Lot 51. He was selling faster than an item a minute. The television arc lights were heating up the room despite adjustments to the air conditioning. There was a steady drift of people in and out, while in the far corner Herbert the press officer was trying to answer reporters' questions about the bidders and also to persuade them to lower their voices. In the back row Raeder's chair was empty, as Gerrard expected it would be. Presumably he had gone downstairs to wait.

Raeder returned as Lot 77 was being offered, Waldhofen trailing behind him. The two men immediately shouldered their way around, though with difficulty, because all the standing space had now filled up in anticipation of the big event.

"This is the paper," said Raeder quietly as Waldhofen held it out. Gerrard took it, quickly opened the door behind him and stepped out of the room.

"Come on," he said. "We don't want to make a noise."

"We have no time!" Waldhofen's tone was urgent and he did not follow. "You must stop the sale."

"Let me read it, will you?" said Gerrard, stopping in the doorway. "And keep your voice down." He perused the document quickly. "You might have provided a translation," he commented, though it looked genuine enough.

"The Foreign Ministry states in this letter that inquiries reveal that the official stamp on the 1948 receipt is a forgery," explained Waldhofen impatiently. "Our government did not authorize either the sale or the export of the picture."

"So you reckon this Botticelli indisputably belongs to you?"

"Yes. Now will you please prevent its being sold?"

People were beginning to turn in their seats to see what was going on in the doorway. From the rostrum Tritton glanced across in annoyance and signaled attendants to stop the interruption. "If I may be allowed to speak," he boomed, "we will continued with Lot Eighty."

Waldhofen was becoming increasingly agitated, while Raeder stood rocklike, square-shouldered and grim-faced.

"Quiet," Gerrard shushed the two men, apparently unconcerned at their anger. "I told you before," he said, almost only mouthing the words, "it makes no odds when I put the picture in escrow, before or after. The whole deal's frozen. If it's after, then when you prove your claim in court you'll have a choice, the money or the painting."

"We want the picture," said Raeder menacingly. "We want it now." They both began to move. Gerrard reached out quickly for Waldhofen's arm, not violently but firmly, and held it. As he did so two attendants appeared and positioned themselves in the German's way.

"I'll take action when I'm good and ready," Gerrard snapped, still in an undertone. "Understand? You in-

terrupt this sale and I'll arrest the both of you. Right here." He spoke to the attendants. "Keep these gentlemen company, will you? Until I say." As Raeder and Waldhofen were discreetly forced out into the corridor, Tritton's gavel came down on Lot 84.

In the fourth row Tom Hanson gave an energetic thumbs-up sign to Lennox, who grinned back confidently. Two yards from them Klein sat impassive, meditating tactics in the light of the high prices gained for earlier items. In the third row Samantha was unashamedly holding Charles's hand.

"Fingers crossed, darling," she whispered.

"Lot Eighty-five." Tritton gave an extra emphasis to the number, evoking an appreciative stir of excitement from his audience. More lights flicked on as the news cameramen focused for the big moment. There was a buzz of *sotto voce* comment and programs rustled.

"Quiet, ladies and gentlemen, please."

As Tritton spoke attendants were bringing out the Botticelli, which was too large for the easel and had to be held upright.

"This work scarcely needs eulogies from me," he remarked. "It's among the finest pictures we've handled in a decade, and I already have an opening bid of eight hundred thousand dollars." Again he paused for effect. The bid was genuine, received by cable from a Swiss collector. Both Klein and Lennox sat motionless, waiting for others to start.

"Eight hundred thousand dollars I am bid."

Abruptly Tritton dropped his conversational approach and swung into the chant which would race the price up. One of the attendants had nodded.

"One million dollars now. Do I have two hundred more?"

Over to Tritton's right the dealer acting for the Getty Museum raised his right hand with two fingers upright.

"One million two hundred thousand dollars, one million two I have." The tumult broke. At least four

dealers were in. Tritton's eyes swept the room, accepting signs.

"One million four. One million six. One million eight."

Charles relaxed. He had no need to intervene. There was a pause, two seconds that felt five times as long. Getty's dealer raised a single finger. Tritton looked hurriedly for alternatives, found none immediately and reluctantly took the bid. "One million nine hundred thousand now. One million nine on my right."

He had barely repeated the price when Lennox flicked his wrist up.

"Two million dollars now. Two million on the floor. Against you on the right." The Getty dealer shook his head. Tritton glanced at the telephone assistants. Nothing there. Then he realized Klein had come in. He knew the significance of that and played on it immediately.

"Thank you, Mr. Klein. Two million one hundred thousand."

Lennox's wrist flicked again.

"Two million two on the floor. Two million two hundred thousand now."

The figures on the digital displays were whirling. Then the Getty dealer was unexpectedly back, in the same moment as Klein. Presumably he had dropped out in the hope of the bidding dying. No matter, Tritton had seen him first and accepted.

"Two million three hundred thousand on my right."

Klein's face colored angrily, but again he was outpaced, this time by Lennox, on whom Tritton was keeping a weather eye throughout.

"Two million four hundred thousand now. Two million four hundred thousand on the floor."

Hanson involuntarily clenched his fists. The clock showed only fifty-one seconds as having elapsed, and already he was at his limit. Had he made the decisive bid? An old dealers' saying flashed through his mind: "Collectors who settle for second best fail." He was damned if he would let go now.

Tritton switched his gaze from one bidder to another. He could feel the audience's excitement. The Getty dealer shook his head again with unmistakable finality, but then Klein gave a curt nod.

"Two million five. Two and a half million dollars I am bid."

For perhaps two seconds there was silence. The entire room seemed to be holding its breath. Triumph was replacing anger in Klein's expression. Lennox leaned sideways toward Hanson, his eyes not leaving the auctioneer.

"Can I pre-empt them?" he asked. Hanson wavered.

Seeing their hurried confabulation, Tritton played for time.

"Two and a half million dollars I have now. It's against you, Mr. Lennox." Compelled to continue, he gave the caution: "Fair warning."

"Go on up," said Hanson softly. "Pre-empt."

For the first time Lennox spoke out loud, though even so the back rows could not hear.

"Two and three quarters."

"Two and three quarter million dollars I am bid." Tritton showed his delight by uttering each word distinctively. "Two million seven hundred and fifty thousand dollars now."

There was a gasp from the audience. If this was not the knockout, the picture could make three million.

"Against you, Mr. Klein," said Tritton but received only a faint shake of the head in reply. "Fair warning. At two and three quarter million." He raised his hand. "Down it goes."

With the crack of the gavel the tension broke. There was a sudden clamor of applause. The television arc lights swung onto Lennox and Hanson, who half rose in their seats and shook hands rather awkwardly. Samantha squealed with delight and kissed Charles. Like an accomplished actor, Tritton allowed time for the ovation by leaning down from the rostrum and telling the clerk, quite unnecessarily, "Lennox. A world

record for the artist." Then he straightened up and announced Lot 86.

From the back Gerrard made his way unhurriedly toward the clerk. He reached the desk as bidding finalized on the next lot.

"I'm putting the Botticelli in escrow," he said quietly. The clerk's face went white, and he glanced quickly up at the rostrum, as if seeking guidance, but the auctioneer blandly disregarded him.

"Tell Mr. Tritton I'll be around at his office straight after it's over. He'd better have the principals involved come too." Gerrard walked away, though not before one of the reporters who knew him had realized something was amiss. An arc light focused quickly on him, but the news cameras caught only his back as he vanished through the side door.

Outside in the corridor he found Raeder and Waldhofen, still effectively under guard.

"Joe," he said to the senior attendant, "find us an empty office where we can wait this one out, will you? And rustle up some coffee if you can." He turned to the Germans. "Your claim can be lodged as soon as the auction is finished. Let's get the hell out to an office and sort your documents before the reporters find us."

By the time the last lot came under the hammer and the auction finished it was after eleven. Tritton stepped down from the rostrum smiling. Apart from a short break when a colleague replaced him, he had carried the whole burden himself. He felt both elated and exhausted. Gerrard's intervention worried him. Nonetheless, Burnaby's had established a world record auction price for a Botticelli and, if the clerk's calculations were right, the value of all the lots sold exceeded the estimates by a magnificent $1,985,000. Nonetheless, he had agreed during his break to see Gerrard immediately, so after spending some twenty minutes shaking hands with well-wishers and answering reporters' questions, he had the detective and the two Germans sent

to his office and then went in search of Luttrell. He found him among the crowd in the lobby.

"Alex!" exclaimed Charles. "That was superb. Congratulations. And thank you." He was exuberant. Samantha's brilliant scheme had secured both the future of his firm and his own independence. If Lucy decided to divorce him she could go ahead. He had pulled off the coup of a lifetime.

"Our friend Dietrich won't know what's hit him, will he, sweetheart?" beamed Samantha, tactfully maintaining their story. Then she realized that Tritton wasn't even smiling. "Is something the matter?" she asked lightly. "I thought you'd come to tell us the champagne was flowing."

"I'm afraid your client has an unpleasant surprise waiting." Tritton felt no obligation to soft-pedal the situation. Luttrell's had beaten him into the ground over the sales commission, and if there was something wrong with the painting or its ownership, they could damn well answer for it.

"Would you mind coming to my office?" he said tautly.

Mystified and with a tight, empty feeling gripping his stomach, Charles followed.

"This is Detective Gerrard of the New York City Police," explained Tritton as they entered, but it wasn't the American who caught Charles's attention; it was the burly figure of Raeder.

"Don't tell me you're repeating that ludicrous claim here!" he said angrily. He turned to Gerrard. "Listen. This man tried pretending he was the dead Schneider's heir in London three months ago. It won't wash."

"No," said Raeder firmly, determined not to reveal any particle of the anxiety he felt. "I am not claiming. In East Germany we have found my friend Schneider had bought the picture illegally. The true owner we have also found." He indicated his colleague. "Herr Claus von Waldhofen, nephew of the old Count."

Samantha was the first to recover from this shock. "But that's absurd. Not only are the Waldhofens ex-

tinct as a family, there was no proof they would be the owners if they were still alive."

Gerrard eyed her, saw an archetypical tycoon's mistress and used appropriate language. "I'm sorry, lady. There is proof. Mr. Raeder here has brought the letters from the Vienna Museum acknowledging receipt of the Botticelli on loan from Count Waldhofen in 1938. What with the East Germans denouncing the 1948 sale as illegal, in a document I only received two hours ago, there is no doubt in my mind that legitimately this picture belongs to any surviving relative of Count Waldhofen. So I'm putting it in escrow. That picture doesn't leave here until any civil claim is settled. Nor does any money change hands."

Charles's face was set, but he maintained his poise. "I understand all that," he said. "What I question is whether this man"—he pointed at Raeders' companion—"is genuinely a Waldhofen. Claus von Waldhofen, did you say?" he demanded. "Von? You should have checked the Almanac de Gotha. Waldhofen was plain Count Waldhofen. He never used the prefix."

The quick glance that Raeder and Waldhofen exchanged was enough to tell him that he had struck a nerve. Charles addressed Gerrard. "In my opinion this man is an impostor."

Immediately both the Germans protested. The detective smiled and to the others' surprise walked across to the door, opened it and called out, "O.K. You can bring my visitors up now, Joe." He paused in the doorway, waiting, and spoke to Charles.

"You know something, Mr. Luttrell? I checked the Almanac de Gotha too, and I believe you're right. This guy"—he jerked a thumb at Waldhofen—"not only has no 'von' to his name, but he died in infancy in December 1944."

There was complete silence for a second. Samantha looked at Charles beseechingly. "Darling, what's happening? I don't understand."

"Is this some kind of a game, Mr. Gerrard?" demanded Tritton, responding to Samantha's genuine

confusion with an eruption of anger latent in his voice. "Because if so, it's in poor taste."

Before the detective could reply the senior attendant, Joe, appeared, escorting Karin Schumann and a man in his mid-thirties.

"Some of you already know Miss Schumann from Vienna," Gerrard announced. "The gentleman has just flown in from South Carolina. He is Mr. Edwin W. Packard. I believe you may all just be able to guess what that 'W' stands for. He is the grandson of the last Count Waldhofen. Leastways a reliable attorney just put the idea that he was to a judge down there and the judge agreed."

Packard grinned nervously. He was a thin man with a freckled face. "Being an engineer, I don't know much about art. My mother never left any note about paintings at all. Of course I knew my grandpa's name and that he was dead, so there wasn't any point searching out relations in Europe. But when I saw the story in the Charlotte *Observer* about a Count Waldhofen's title waiting to be claimed, I guessed that could mean me and contacted the attorney they named in the paper."

"This is a plot," shouted Claus Waldhofen and lunged toward the desk where the documents were lying. But Gerrard was too fast for him and got there first.

"Give them to me," said Waldhofen, squaring up to Gerrard aggressively.

Raeder felt a sickening lurch in his stomach. He had failed. There might not be another opportunity to neutralize this Stasi watchdog and secure his own future. As always, he responded with instinctive certainty to the chance, leaping forward and pinioning his erstwhile colleague's arms. He struggled briefly, cursing Raeder in German, then capitulated and became silent as Gerrard produced a slim pair of handcuffs from a pocket and snapped them neatly on his wrists.

"Well, thank you," said the detective to Raeder, sur-

prised and grateful. "That was real considerate. I half thought he might have a gun."

"I also. He is stupid enough."

"Say, what's your angle? You're a cop, aren't you?"

Raeder shrugged his broad shoulders. He understood Gerrard's expression more than his words.

"We all reach turning points." He drew himself up and spoke with unaccustomed formality. "I wish to ask for political asylum," he said.

Gerrard nodded. He had an agile brain and didn't need to take advice. If this guy was an East German colonel and Wates over in London had been categoric that he was, then there was going to be a warm welcome for him from the CIA.

"O.K.," he said. "I sure never had a defector before, but there has to be a first time for everything. Why don't you go wait downstairs?" He turned to Joe. "Lock this phony up some place, will you, and phone the police department. I could use help. I have other business to finish right here."

Meanwhile, another confrontation developed, this time between Charles Luttrell and Karin, with Charles vigorously disputing every facet of the claim. Eventually the detective intervened.

"There are no two ways about it," he declared. "Under New York State law a painting can be recovered whether it was lost or stolen, without limit of time. In the view of the police department lawyers, Edwin Packard here has a substantial enough claim for me to take action. Personally I think he's on home base with it. So as of now this picture is frozen, totally and absolutely. What's more, I can keep it that way up to ten years."

"Charles," said Tritton calmly, "I'd appreciate your friend Dietrich coming to a decision out of court if he can. We don't like this escrow business." He turned to Karin and Packard. "It would help me a lot if I knew what you intend doing if the claim succeeds. Will you accept the sale or do you want the Madonna?"

"You tell them," said Packard nervously. "I'm out

of my depth here. Anyway, it was you hunted the picture down."

"We would have liked it to go back to Vienna," said Karin, a wistful note coloring her words. "We really would. But Edwin's trying to build up an engineering company of his own. He can't refuse the money." She smiled, more to herself than anyone there. "I think the Count would approve. He had a strong sentiment for his family. It nearly broke his heart never finding his daughter."

"My folks moved around a good deal," explained Packard. "Must have had ten different homes before my mother died, and that was quite a few years back." He sounded apologetic, as though he was somehow to blame for his father's restlessness. "Anyways, I guess this Westhampton College would look after the picture better than I could."

"At least it will be where people can appreciate it," added Karin. "The Count would have wanted that too. In fact I can give Westhampton a parting blessing from him."

Charles and Samantha both stared at her, amazed. Even the imperturbable auctioneer looked surprised.

"Here," said Karin, handing Tritton an envelope. "The letter Bernard Berenson wrote authenticating the Madonna. I saw no reason to let those two have it."

This was too much for Samantha. Not only did she feel grossly cheated and angry with Charles for their being outwitted, the way Karin talked about Waldhofen as if he were alive and important infuriated her.

"Just how do you know what he would or wouldn't want?" she demanded. "For God's sake, are you psychic or something? Anyway, what's it to do with you? Your wretched museum had no right to the picture."

"You might not understand." Karin felt emotionally drained, but she wasn't going to let this pass. "Our country was ravaged twice, first by the Nazis, then by the war. Some people tried to preserve our heritage. Count Waldhofen was one of them. He felt very deeply about it, just as he did about his family."

"I guess that makes sense," remarked Tritton, trying to avert an open fight between the two women.

"I don't think it does!" blazed Samantha, all the bitterness of defeat in her voice. "His family were dead and gone. Why all this trouble to resurrect them?"

"Because he asked me to," said Karin quietly. "He was my godfather. He brought me up after my parents were killed by the Gestapo. You wouldn't understand that, I suppose." She turned back to Tritton. "Now, if you don't mind, I'd like to make a telephone call to Germany. I want to tell a friend what has happened."

"You know it'll be almost five in the morning in Europe?"

"He won't mind." Karin smiled happily. "We have a date in Vienna. I want to tell him we can celebrate."

"I'll show her to a phone," offered Gerrard. "I guess I've said my piece. Miss Schumann deserved a break. That was a really smart idea, sending out a wire-service story about an unclaimed nobleman's title. It ran in almost every local paper in the Southern states. Well, so long, Mr. Tritton. Keep me posted." He ushered Karin out, waving a casual farewell.

"Why did you try it, Luttrell?" demanded Tritton contemptuously, underlining his feelings by dropping the use of the Christian name. "You know damn well there's wartime loot surfacing all the time and you know we steer clear of it. Any reputable auction house or dealer does. What the hell were you playing at?"

Samantha watched the two men. In spite of her fury with Karin, she had been fascinated by Tritton's *sangfroid*. And she was still angry, but with Charles. Not only had he failed to back her up in her final effort to destroy Karin's case; he was the self-proclaimed expert on the European nobility and should have known that the Schumann woman was connected with the Waldhofens and that there could be a Waldhofen heir. She wondered how he would answer Tritton.

"We thought Schneider's title was good, didn't we, Samantha?" he said at last.

Before she could reply, Tritton turned to her.

"Please," he said in a far more friendly tone. "Don't start telling me about executors. I guess you did your best for Luttrell's. We can drop the pretenses now."

"Samantha researched the provenance," cut in Charles quickly. "There was nothing questionable in it."

"Yes, there was!" Her anger rose again at this crude attempt to keep her involved when Tritton was giving her the benefit of the doubt. The bastard. He could at least be man enough to protect her reputation. She no longer cared that auctioning the Botticelli had been her idea. If Charles thought he could sacrifice her for the sake of Lucy's firm, he was very wrong.

"I warned you," she went on. "After the trip to Belgium I told you I had doubts about Dietrich." She turned appealingly to Tritton, her mind made up on the role she would play. "Don't be too hard on Charles," she begged. "He was desperate to save Luttrell's and took one chance too many. And after all, you still have plenty to celebrate." She smiled, her eyes assuring him that she was definitely available for tonight's party. "After all, Luttrell's may have come unstuck, but you've made a world auction record."

"She has a point there. A fair one." Tritton could rely on Gerrard to be discreet. Packard would keep his mouth shut. So from the sound of it would Karin Schumann: her museum had evidently sailed close to the wind.

"Listen, Charles," he said. "Forget what I said just now. You've taken enough of a beating. I guess it'll be best for all of us if we just hush the details up. The detective won't object. He's after seeing justice done, not newspaper headlines. Anyway, the German colonel defecting will provide enough of those. We'll stick by the theory of Luttrell's innocence. That way maybe you can salvage matters somehow."

"That's good of you," said Charles mechanically.

"It really is," added Samantha. She smiled warmly at Tritton. "What's more, if you'll forgive my saying so, there's no need for you to stick to the commission

arrangement. I'm sure Mr. Edwin Waldhofen Packard won't mind being charged the normal rate."

A slow grin spread across Tritton's face, and he nodded appreciatively. Charles certainly picked women who were both bright and sexy.

"You know," he said to her, "you're persuading me I really do have a lot to be pleased about."

Charles stood bemused. He had lost Samantha and, unless he was somehow to retrieve the firm's position, he could not return to his wife.

As if reading his mind, Samantha threw him a shred of consolation. "At least you have the Memling. Can't you recoup something on that?"

"True," he admitted. "I can probably get a good price for it." Once again his mind started whirring. The Belgians seemed unlikely to pursue a minor work that was in poor condition. But to many lesser American museums a Memling would still seem desirable, the proven work of a master, a showpiece.

"I probably should stay on a few days and phone some contacts," he said.

"I'm sure you should," she said. The moment had come to detach herself. She certainly wouldn't be working for Luttrell's after this. "I'll probably do the same myself. Some friends invited me for the weekend." It was a fiction and there was the potential embarrassment of her clothes being in Charles's hotel room. Never mind. The evening was far from over. She smiled at Tritton.

"If the party at Regine's is still on, why don't we leave?"

Her dress swirled, ice-blue and silky, and she was gone.